DRACOPEDIA
Legends

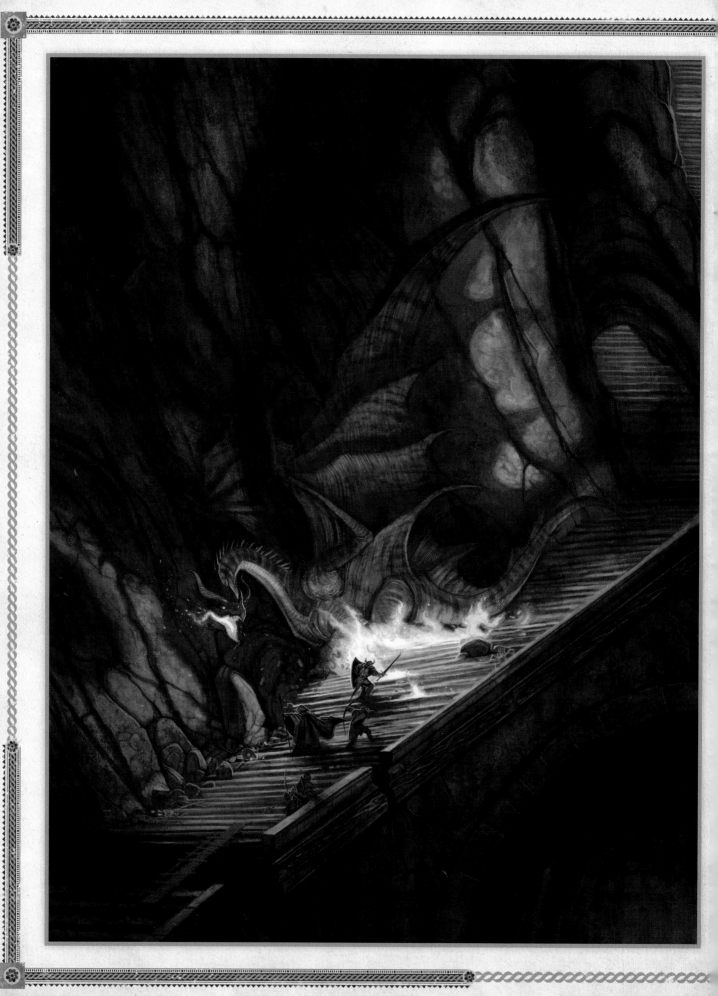

DRACOPEDIA Legends

An Artist's Guide to drawing dragons of Folklore

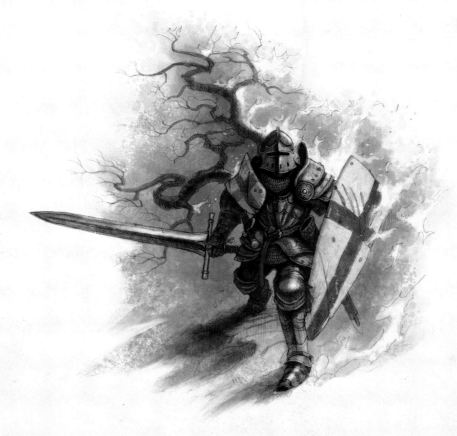

William O'Connor

IMPACT

CINCINNATI, OHIO

IMPACTUniverse.com

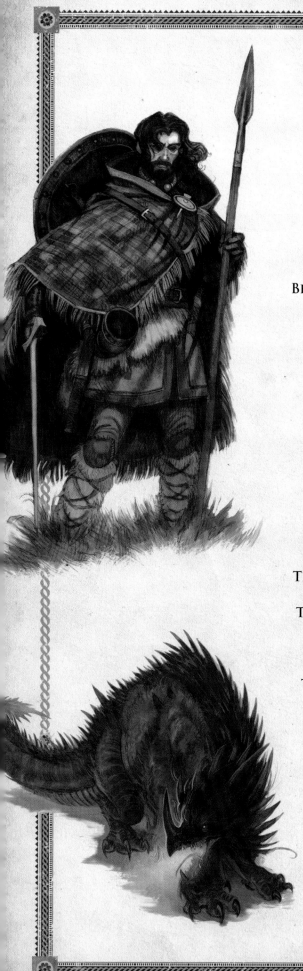

CONTENTS

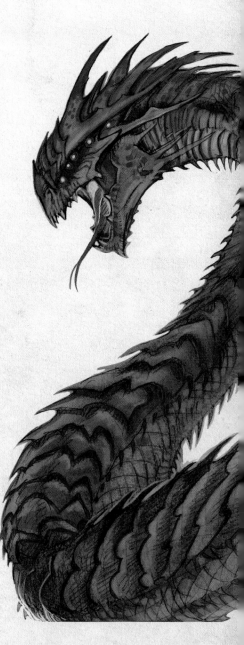

MATERIALS

As with all of the *Dracopedia* books, the most important materials needed for this edition are your creativity and imagination. All of the art you see in this book is created using nothing more than the simplest drawing tools: pencils and paper. Always remember that your work is limited only by the scope of your imagination. Work as big and as frequently as possible.

Here is a brief list to get you started. Refer to pages 8–11 for further explanations of the materials.

DRAWING TOOLS

0.5mm F pencil lead

Block eraser

Clutch pencil with 2mm lead

Eraser pen

Mechanical drafting pencil

Mechanical pencils (0.3mm, 0.5mm, 0.7mm, 0.9mm leads)

Wooden pencil with extender

SURFACES

Bristol paper

Bristol vellum

Drawing paper (11" × 14" [28cm × 36cm] and 18" × 24" [46cm × 61cm])

Kraft paper

Sketchbook (spiral-bound)

Toned drawing paper

Watercolor paper

DIGITAL PAINTING TOOLS

Adobe Photoshop

ArtRage (app)

Corel Painter

Digital camera

Digital tablet

Pixarra (app)

Scanner

ZBrush (app)

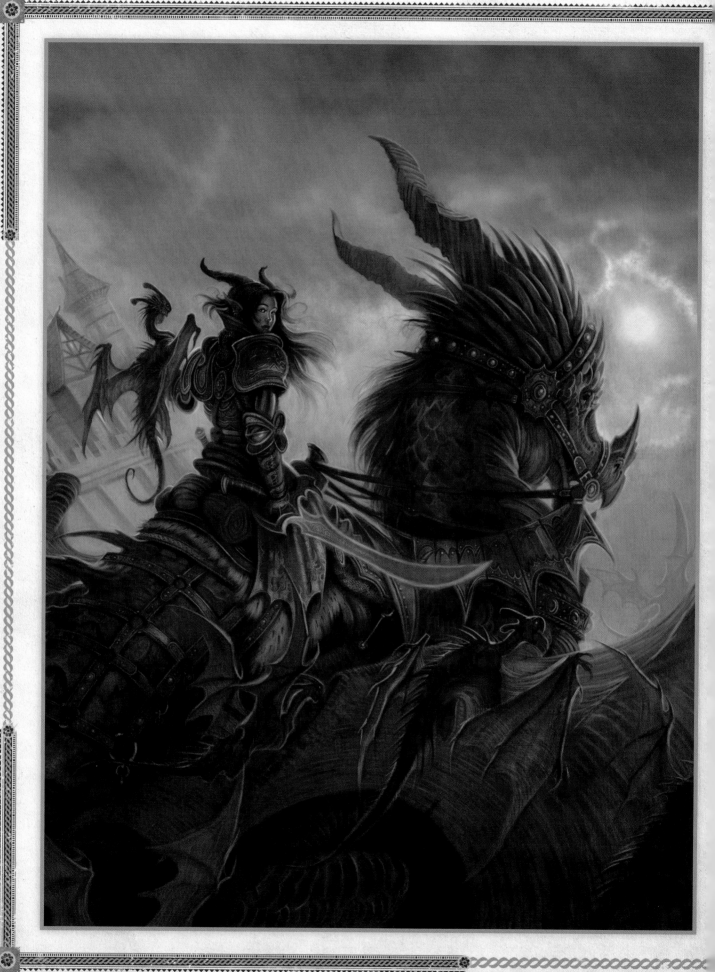

INTRODUCTION

"Come not between the dragon and his wrath."
—William Shakespeare, *King Lear*

DURING MY TRAVELS studying dragons in northern Wales, a storm rolled in off Caernarfon Bay, and I and my apprentice, Conceil, had to take shelter in an old stalker's cottage. The peat fire was lit, and our guide, Sir Geoffrey Guest, regaled us with ancient stories of dragons while outside the gale battered the coastline. It occurred to me that these stories had been told, in one fashion or another, in this very cottage for centuries, and the traditional stories that dragons had inspired were as varied and colorful as the myriad species of dragons themselves.

In my wanderings all over the world to research dragons, I have had the opportunity to meet some amazing people and hear their wondrous stories. In Iceland and Wales, Scandinavia and China, there are tales of dragons. As far north as the frozen tundra of the Inuit or the tropical rain forests of the descendants of the Incans, I have found stories and lore where dragons play an integral part in the culture's mythology. In some legends the dragons are good, and in others, evil. In all of the tales, however, they play a large part in the cultural identity of the people, filling the role of a mighty nature spirit or a god that must be tamed or appeased or vanquished by the hero. In many of these legends, the hero is called to leave his home on a magical quest, travel to a strange land where a dragon lives, face the dragon and either be victorious or perish in the attempt. The dragon represents the hero's greatest challenge, both internal and external, and only through courage, faith and intelligence can the dragon be overcome. The hero assumes the dragon's power and returns home to his people victorious and ready to lead them to a better life. Dragons teach wisdom through the trials of fire.

This book retells some of the dragon stories that have been imparted to me over the years. Some of these legends you may know and some may be new to you. There may even be other versions of these tales. And for every story I have been able to record, there are a hundred more waiting to be discovered and passed on.

HOW TO USE THIS BOOK

Dracopedia Legends is both a storybook and an art guide. In each chapter, there is a retelling of a classical dragon myth accompanied by illustrations. Following the story, the chapter goes in depth into the conceptualization, research and design of the dragons and artwork for the lore. I hope these stories inspire you to do further research into dragon myths and fables and create your own creatures of legend. The stories that will be told in the future are those learned today.

Panoply of Dragons
9" × 12"
(23cm × 30cm)

DRAWING MATERIALS

There are a variety of drawing materials available to artists today, and with a little bit of online exploration, what were once rare or specialty items are now as accessible as something from your local convenience store. Drawing supplies are generally inexpensive, so feel free to explore different materials until you find a drawing system that works best for your needs. The following setup makes it simple to travel with my drawings.

PENCILS AND ERASERS

1. *Clutch pencil.* Sometimes called a lead holder, clutch pencils hold 2mm lead and require a barrel sharpener. Lead is available in all weights, but HB is the most common. These pencils are sturdy and reliable. I've had mine for more than twenty years.

2. *Mechanical pencil.* Available in 0.3mm, 0.5mm, 0.7mm and 0.9mm leads, the mechanical pencil is an inexpensive and effective drawing tool that never needs sharpening. I keep several 0.5mm pencils handy and loaded with different grades of lead.

3. *Mechanical drafting pencil.* Mechanical drafting pencils like the Pentel Graph Gear 500 are more expensive but can offer a more enjoyable drawing experience. They use the same lead as standard mechanical pencils.

4. *Wooden pencil with extension and cap eraser.* Placing a wooden pencil into a pencil extender can make a normal pencil as long as a paintbrush, allowing for a wide range of expressive marks to your drawing. Plastic eraser caps always come in handy.

5. *Eraser pen.* Plastic eraser pens are inexpensive and available at any office supply shop.

6. *Block eraser.* For bigger jobs, a block eraser is useful.

7. *0.5mm F pencil lead.* HB lead is the most common lead available in stores and is a good all-purpose lead grade. For more detailed work, however, I like a slightly harder F lead. Specialty lead of any grade and size is available online.

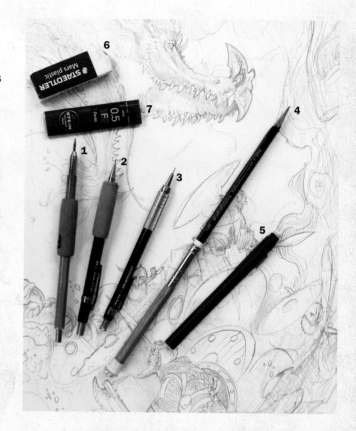

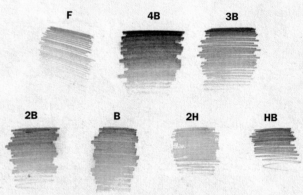

Pencil Lead Hardness
Leads with different grades of hardness will give you different effects. The softer the lead, the darker the strokes you can obtain.

PAPER

The pencil is only half of any drawing system. Depending on the effects you want to achieve with your drawings, the paper is equally important.

For my purposes, I like to use drawing paper for both my sketches and finished work. It's affordable, usually has a bright white surface, has enough texture to take pencil, and is thick enough to handle vigorous drawing and erasing without tearing, yet smooth enough to handle a lot of detail.

I like to work as large as possible while still maintaining portability, so I typically use 11" × 14" (28cm × 36cm) paper. I work in spiral-bound books or on loose sheets. I never work in hardbound books, as these make it almost impossible for me to photograph, scan or reorganize the artwork. I create the finished drawings in my studio on 18" × 24" (46cm × 61cm) vellum.

Here are some commonly available drawing papers and their weights, as shown:

1. Drawing paper, 70-lb (150gsm)
2. Watercolor paper, 135-lb. (290gsm)
3. Bristol paper, 32-lb. (82 gsm)
4. Toned drawing paper, 98-lb. (260 gsm)
5. Bristol vellum, 157-lb. (350 gsm)
6. Brown kraft paper

REFERENCE

The vast world of mythology and legends that was once the province of academics and remote libraries is now available to every person in the world through local libraries and the Internet.

As you prepare to draw, collect stories and images that inspire you. These will help you develop your own creations and drawings.

Paper Sizes
An 11" × 14" (28cm × 36cm) sketchbook is useful for portability, but larger work is usually drawn on 18" × 24" (46cm × 61cm) paper.

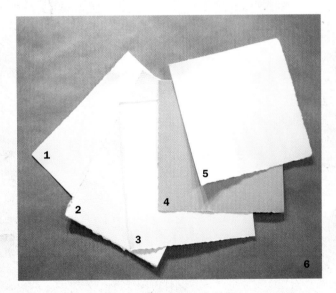

The Author's Illustrated Classics Collection
I've been collecting illustrated antique storybooks since childhood. Books by Pyle, Rackham, Browne and Wyeth provide endless inspiration.

DIGITAL DRAWING AND PAINTING

These days, drawing and painting software is so common-place and inexpensive that most novice artists have some kind of drawing app on their computers or tablets. No longer is the digital artist limited to the expensive Corel Painter or Adobe Photoshop programs. ArtRage and Pixarra are affordable digital painting software options, as is the Essentials version of larger programs like Corel Painter. Try to stay away from freeware, as the sophistication level of some of these apps will not give you enough creative freedom. In addition, 3-D rendering programs like ZBrush are now available in student versions and no longer require professional-grade hardware to operate.

The technology of tablets and cameras has accelerated as well. Today, touch screen tablets are as good for a beginning artist as some specialty drawing tablets, and the cameras on most smartphones are better than the top of the line SLR cameras from just a few years ago, making a separate flatbed scanner and digital camera unnecessary.

For the purposes of this book, I painted most of my illustrations in Adobe Photoshop and Corel Painter, but I use terminology and techniques that are universal to most painting apps, such as layers, opacity and modes.

DIGITAL PAINT MODES
Here I've placed a bright green brushstroke on top of a dark red background, using various modes to achieve different effects.

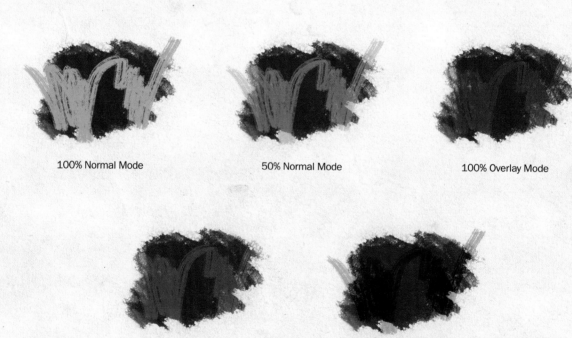

100% Normal Mode

50% Normal Mode

100% Overlay Mode

50% Soft Light Mode

100% Multiply Mode

DIGITAL BRUSHES

One of the great freedoms given to digital artists is the limitless variety of brushes available. With the custom brush tool, it's possible to create an endless number of wild brushes. Experiment with what works best for your style and create your own unique brush sets. Here are a few examples of my own.

Sketch Brush
A simple, all-purpose drawing and sketching brush

Sponge Brush
A texture brush used to block in large areas of texture

Splatter Brush
Used to create a splatter effect of water or fire embers

Hair Brush
A hair filbert or flat brush used to render fur, grass and other natural textures

Texture Splatter
A coarse stippling brush used for rough texture on rocks

Scumbling Brush
A rough texture brush for rendering a thick scumbled effect on rocks and trees

Watery Mop
A large wet brush is excellent for filling in clouds or sky

BASIC TUTORIALS

TREES

Drawing trees becomes simpler when you begin to see patterns in their design. The structure of a tree is a form copied throughout nature in the flowing of rivers and the growth of veins. I use the same design principles that are taught in Japanese bonsai technique:

- The form of tree branches follows the form of the tree trunk.

- A curved trunk should have curved branches while a straight trunk should have straight branches.

- Branches get thinner and closer together as they move up the tree.

- Branches almost always grow from an outside curve in the trunk.

- Two branches should not grow directly opposite from one another.

Using these basic points, the forms of trees can be used in each of the examples to help the viewer's eye move through the composition and accentuate the narrative.

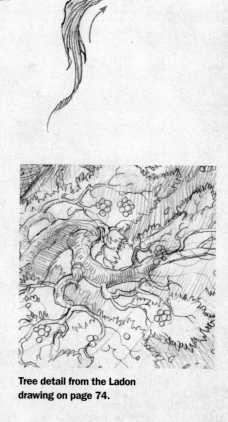

Enhance Movement
Using pencil lines that follow the shapes of branches helps accentuate the tree's movement and growth.

Tree detail from the St. George drawing on page 157.

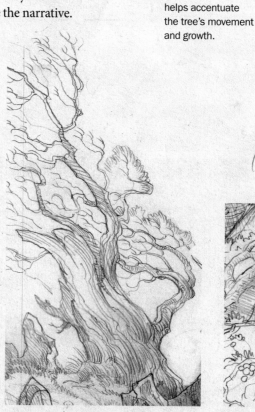

Tree detail from the Mabinogion drawing on page 86.

Tree detail from the Ladon drawing on page 74.

ROCKS

When drawing rocks, the thoughtful use of line will help establish form and texture. Curvy lines work best for rounded or soft objects, and hard, straight lines work best for rough or sharply edged objects. The direction of the lines will accentuate the shape of an object.

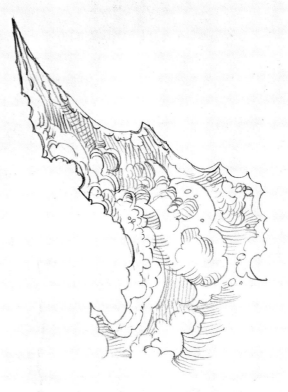

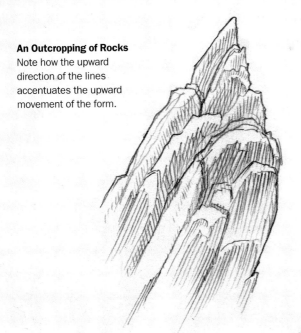

An Outcropping of Rocks
Note how the upward direction of the lines accentuates the upward movement of the form.

A Piece of Lava Rock
Pocketed and pitted, this lava stone has serrated edges and lines that enhance those serrations.

Rock detail from the Ladon drawing on page 74.

Rock detail from the Python drawing on page 109.

WAVES

When drawing waves, use sweeping lines and jagged edges to represent the rolling layers of water. Drawing waves is a lot like drawing mountains—draw overlapping ridges that extend into the background. Remember to mix it up and vary your shapes.

Suggest Movement
Directional marks enhance the form and movement of water.

Vary your marks and the position of the waves. Don't create waves that are perfectly parallel to one another.

Detail of waves from the Jörmungander drawing on page 50.

SCALES

The rendering of scales is very important when drawing dragons. There are many different kinds of scales on many different animals, including lizards, fish and even mammals. Primarily, scales give an animal protection, but they should not interfere with its ability to move in its environment.

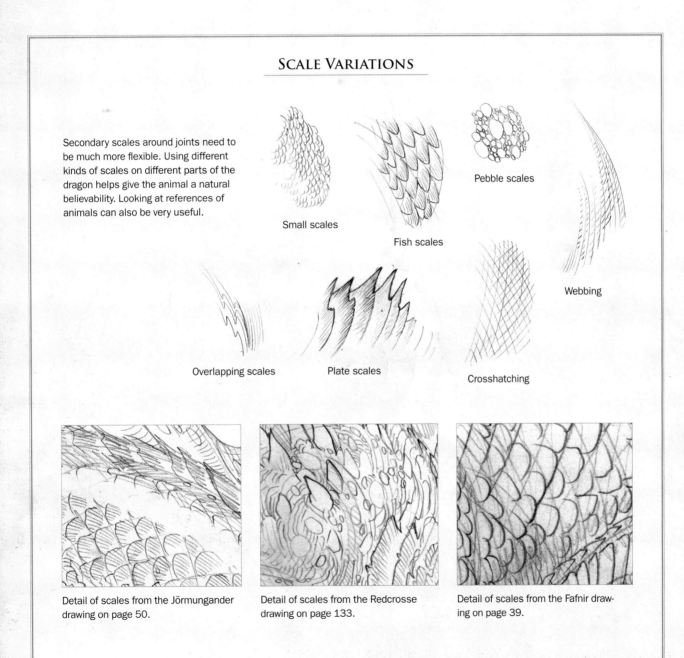

SCALE VARIATIONS

Secondary scales around joints need to be much more flexible. Using different kinds of scales on different parts of the dragon helps give the animal a natural believability. Looking at references of animals can also be very useful.

Small scales

Fish scales

Pebble scales

Overlapping scales

Plate scales

Crosshatching

Webbing

Detail of scales from the Jörmungander drawing on page 50.

Detail of scales from the Redcrosse drawing on page 133.

Detail of scales from the Fafnir drawing on page 39.

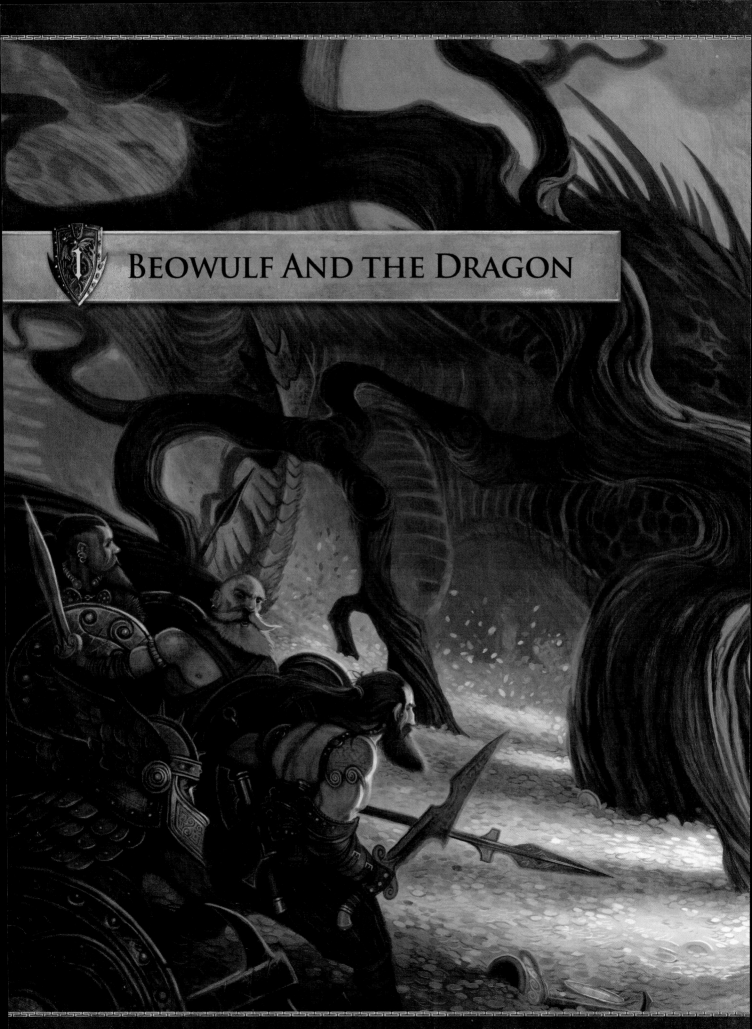

1 BEOWULF AND THE DRAGON

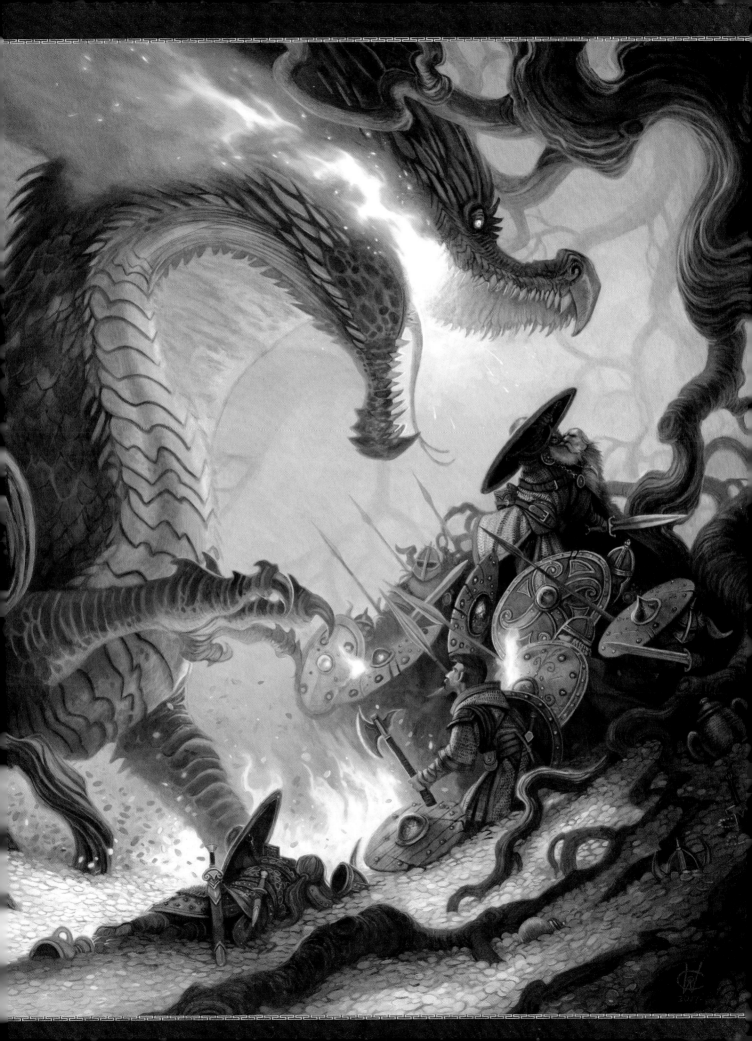

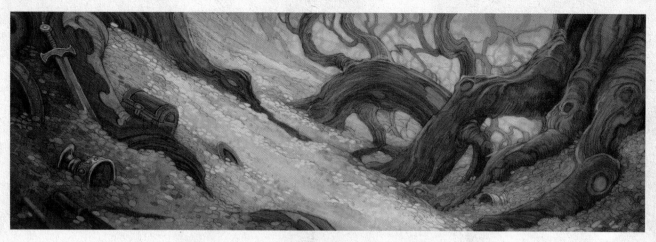

The Legend of Beowulf

NORSE

NCE UPON A TIME, the mighty king Beowulf ruled over the ancient kingdom of Geatsland in a time of great peace. As a young warrior, Beowulf had been summoned to the court of the Danish king Hrothgar to defeat the monster Grendel and his mother, who had terrorized the Danes. Beowulf's victory over Grendel became the subject of epic poems told far and wide. Upon his return to Geatsland, Beowulf united the thanes and clans under his banner as king, bringing peace for fifty years.

It came to pass that, one day, a young servant boy wandered far outside the halls of Beowulf's castle and discovered a cave in the cliffs by the sea. He became lost in the underground labyrinth and wandered into a vast cavern filled with a treasure horde of crowns, jewelry, coins and platters, all of the most glittering gold. High atop the mound of riches, he spied a dragon, coiled and sleeping, its wings folded under its massive scaled body, which rose and fell with each breath. Afraid to venture into the cavern and wake the dragon, the boy plucked a golden goblet from the pile, for

surely no one would miss a single bauble, and hid the goblet in his jerkin. He then made his way out of the cave and back home.

What the little thief did not realize was that, as the guardian of the treasure hoard,

Studies for the eleven lairds of Beowulf

18

the dragon was attuned to every ring and bracer, every torq and helmet, and he awoke in a rage. The terrible creature raced out of the cave where he had slept for centuries to seek revenge on the thief.

The dragon's fury was devastating. He swept over the Geatsland on his powerful wings and rained fiery destruction on the villages and hamlets of the kingdom. The people fled to the safety of Beowulf's castle, where they begged the king to save them.

King Beowulf was old but no less brave than in his youth. He ordered his young nephew Wiglaf to summon all the thanes of the kingdom to join him, and he called for his arms and armor. Clad in his ancient golden chainmail and shield, Beowulf brandished the mighty sword Naegling, sharpened and polished to a golden shine.

When the thanes of Geatsland had assembled, Beowulf spoke to them. "Brave warriors! Today we ride out to do battle with an ancient threat that has awoken in our lands. With your bravery we will save the people from this terrible scourge."

The assembled lords rode out to slay the dragon, with Beowulf at their head and brave Wiglaf by his side. They rode through the countryside of Geatsland, which had been razed by the dragon's fire, and passed farms and villages

burned to ashes. When Beowulf and his men arrived at the seaside cliffs, they dismounted and entered the cave leading to the dragon's lair. Navigating the labyrinthine tunnels, they at last emerged in the cavern of the Golden Hoard, where they found the dragon waiting.

Beowulf at once attacked the dragon, wielding Naegling high over his head. The furious

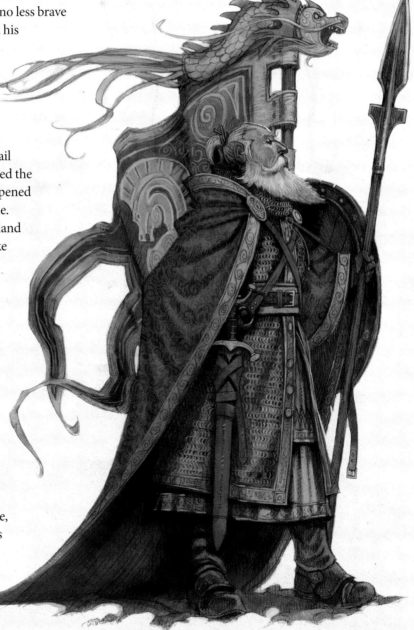

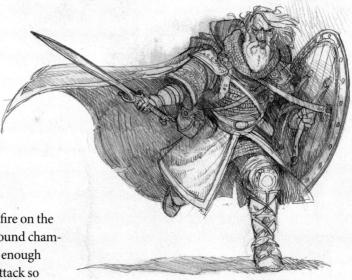

dragon unleashed a torrent of fire on the warriors, turning the underground chamber into a flaming furnace hot enough to melt the gold. The blazing attack so terrified the thanes that they fled from the cave. Beowulf commanded them to return, but only faithful Wiglaf remained at his side. The king and his cousin circled the dragon, striking from two sides, while like a serpent, the dragon snapped its massive jaws at the warriors but failed to hit. Wiglaf's stout sword glanced off the dragon's gleaming scales. Beowulf launched an attack, dealing a mighty blow to the underside of the dragon with Naegling that staggered the beast but could not pierce the dragon's hide. The dragon reeled high on its back legs, spread its wings and expelled a cloud of flame. The warriors hid behind their shields to protect themselves from the firestorm. Beowulf's shield, the companion to Naegling, withstood the attack, but Wiglaf's oaken shield caught fire and was thrown aside. Though the shield saved the warrior from death, Wiglaf's arm was badly burned, and he was without protection.

Likewise, the dragon had exposed his chest in his fury. Beowulf saw his chance. The aging king gathered all his strength and charged the blazing beast. Falling upon the dragon, Beowulf plunged Naegling between the dragon's scales, and when the blade struck,

it shattered. The dragon lashed out in pain and slashed at Beowulf with its razor-sharp talons. Both the dragon and the king were flung across the gold treasure cavern.

Wiglaf saw the wound Naegling had made in the dragon's armor, and at once, with both hands, brought his own blade down upon the creature, stabbing the beast through the heart. The titanic serpent writhed in anguish, thrashing and flailing its head and tail in its death throes. Then, finally, it collapsed atop the mound of treasures and was still. Wiglaf had slain the dragon.

Beowulf lay nearby, mortally wounded. The warrior raced to his king's side and cradled his head in his lap. "My lord, be strong. You cannot die. What will we do without our king?"

"Fear not, my good Wiglaf," Beowulf whispered. "You will not be without a king, for you will lead the people after me."

Then the king of Geatsland died. Wiglaf carried his lord's body back to the castle where the great Beowulf was placed on a funeral pyre. Wiglaf, who took over the throne, erected a great barrow in Beowulf's memory.

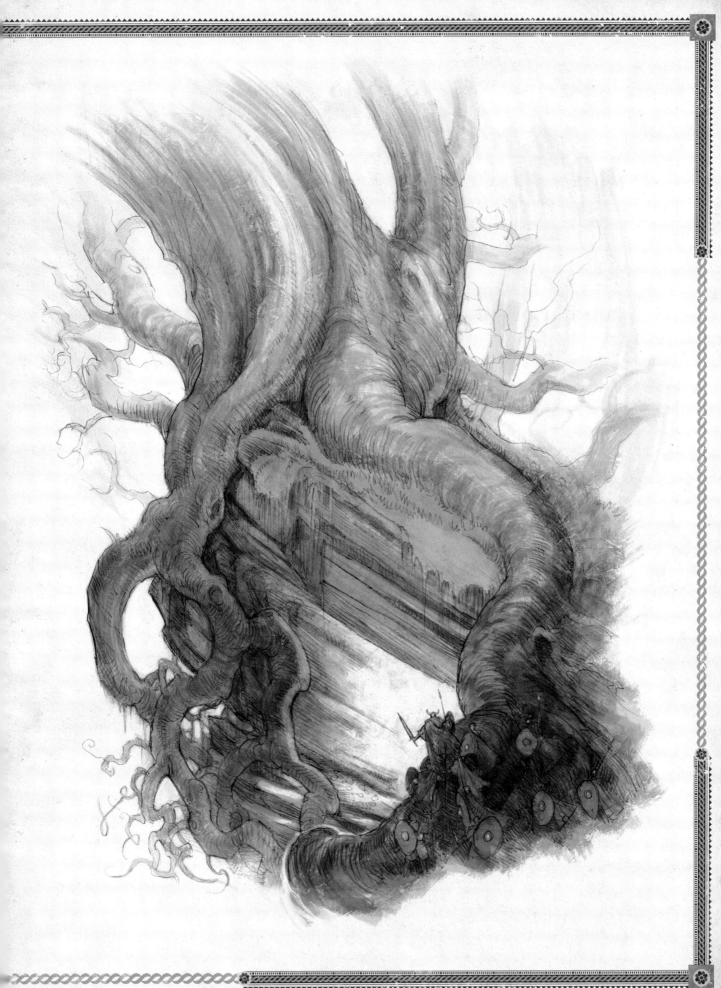

DEMONSTRATION
BEOWULF AND THE DRAGON

STAGE ONE: RESEARCH AND CONCEPT DESIGN

Written during the Dark Ages in Anglo-Saxon England, the epic of *Beowulf* is a classic tale of Viking heroism. Brought to England from Scandinavia during the Saxon invasions after the fall of the Roman Empire, it is one of the oldest written English poems and has gone on to inspire famous English writers like J.R.R. Tolkien, who clearly drew upon the *Beowulf* story when writing Smaug in *The Hobbit*.

When imagining the dragon that battles Beowulf, my first thought is of the region where the story takes place. Referencing *Dracopedia: The Great Dragons* leads me to the Great Scandinavian Blue Dragon *Dracorexus songenfjordus* (pages 44–59).

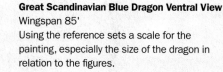

Great Scandinavian Blue Dragon Ventral View
Wingspan 85'
Using the reference sets a scale for the painting, especially the size of the dragon in relation to the figures.

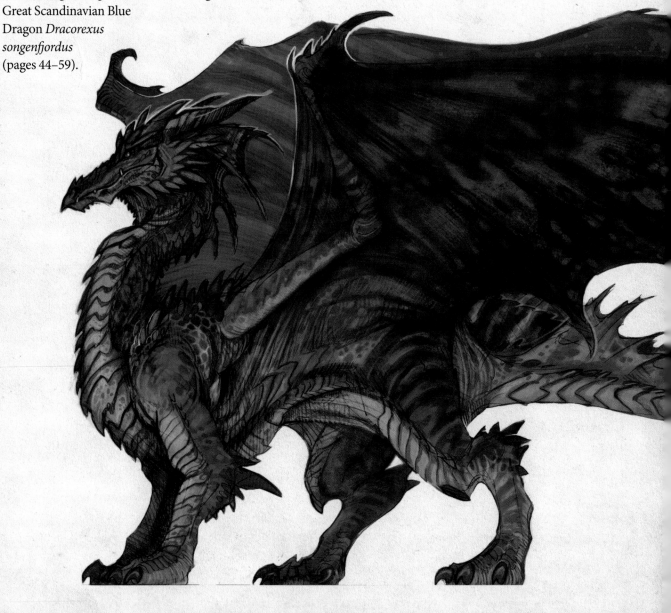

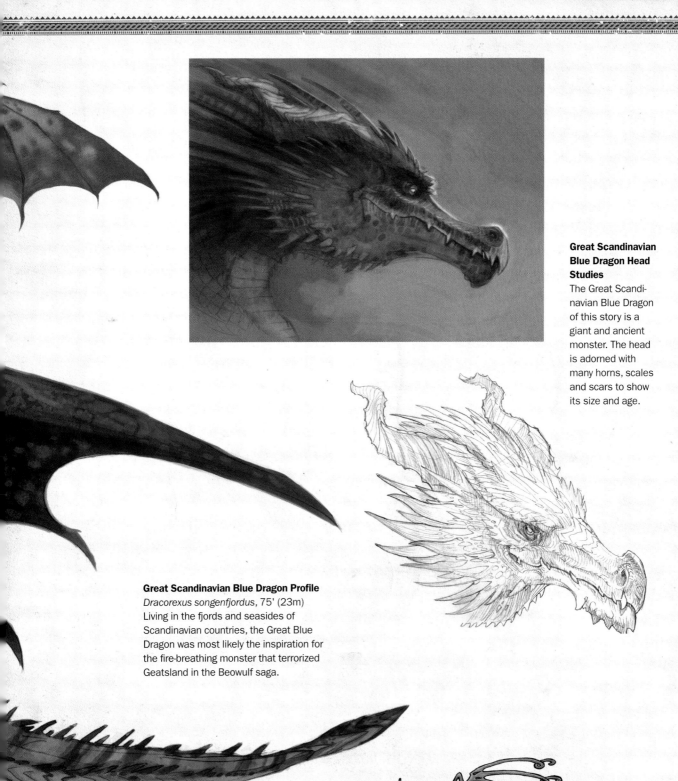

Great Scandinavian Blue Dragon Head Studies
The Great Scandinavian Blue Dragon of this story is a giant and ancient monster. The head is adorned with many horns, scales and scars to show its size and age.

Great Scandinavian Blue Dragon Profile
Dracorexus songenfjordus, 75' (23m)
Living in the fjords and seasides of Scandinavian countries, the Great Blue Dragon was most likely the inspiration for the fire-breathing monster that terrorized Geatsland in the Beowulf saga.

Dark Ages Scandinavian Dragon Broach
The image of the dragon plays an important part in Viking culture. Dragon iconography was a common symbol of strength and power.

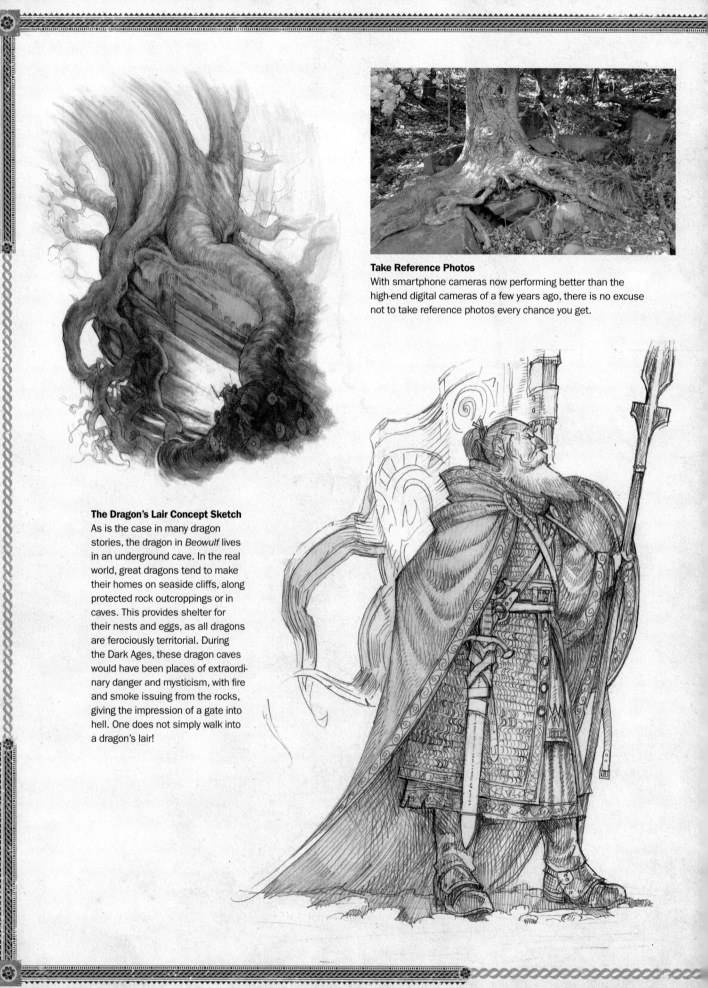

Take Reference Photos
With smartphone cameras now performing better than the high-end digital cameras of a few years ago, there is no excuse not to take reference photos every chance you get.

The Dragon's Lair Concept Sketch
As is the case in many dragon stories, the dragon in *Beowulf* lives in an underground cave. In the real world, great dragons tend to make their homes on seaside cliffs, along protected rock outcroppings or in caves. This provides shelter for their nests and eggs, as all dragons are ferociously territorial. During the Dark Ages, these dragon caves would have been places of extraordinary danger and mysticism, with fire and smoke issuing from the rocks, giving the impression of a gate into hell. One does not simply walk into a dragon's lair!

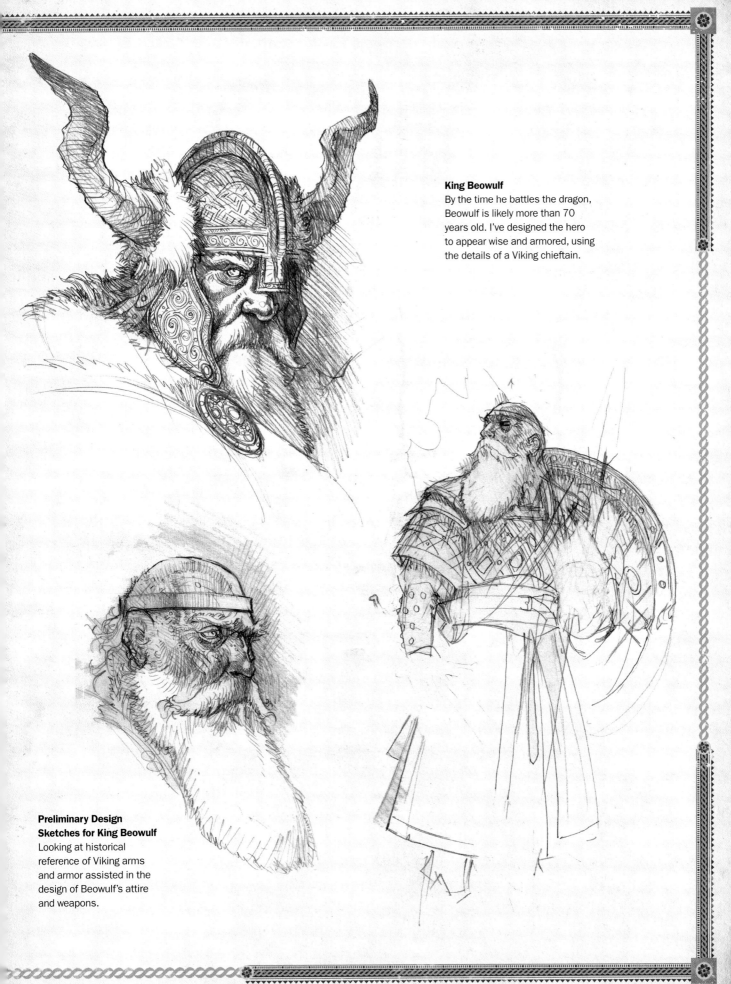

King Beowulf
By the time he battles the dragon, Beowulf is likely more than 70 years old. I've designed the hero to appear wise and armored, using the details of a Viking chieftain.

Preliminary Design Sketches for King Beowulf
Looking at historical reference of Viking arms and armor assisted in the design of Beowulf's attire and weapons.

STAGE TWO: THUMBNAILS

Refine Ideas

Using the reference and development art from stage one, create quick concept sketches to explore the design of a finished large-scale painting. Although there will be numerous elements and a high level of detail in this painting, the design is kept simple at this stage.

The three main elements of this painting are the warriors, the dragon and the treasure cave. The thumbnails above allowed me to experiment with the placement of each element.

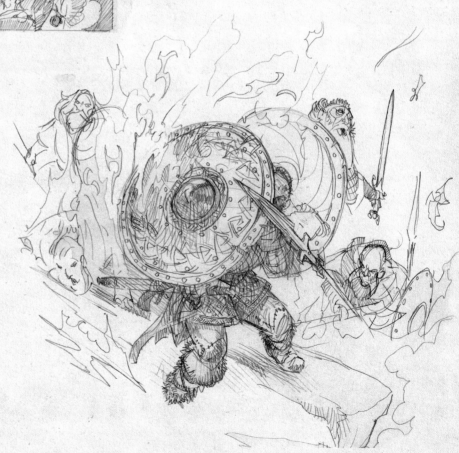

STAGE THREE: DRAWING

 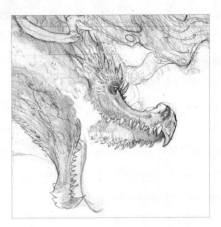

Develop the Drawing
Working from the general to the specific allows me to quickly establish the placement and pose of the dragon.

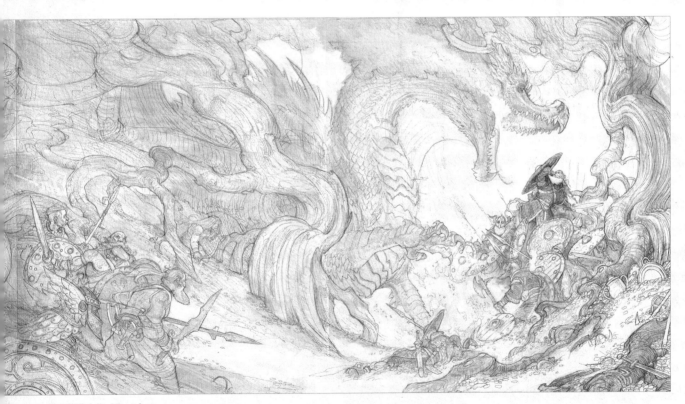

Beowulf Finished Drawing
Because of the large number of figures and the high level of detail in this painting, this drawing is almost twice as large as the drawings in other chapters.

Pencil on paper and digital
21" × 34" (53cm × 86cm)

STAGE FOUR: PAINTING

For a painting of the scale and complexity of Beowulf, I decided that an oil painting would produce the best effects and visual impact for the subject matter.

Most young or beginning artists may not have the space or equipment to work in oil, but I have been oil painting for more than 30 years, and it's my favorite medium, though for the purposes of speed and ease, I do most of my commercial work digitally. You will see, however, that the technique is the same: drawing, underpainting and finished painting. Although this example may be extreme in size, I encourage you to experiment with oil on some smaller works.

I digitize the drawing by taking multiple scans and piecing it together in a photo-editing program. I make any additional edits needed with my digital drawing tools before taking the file to a printshop and getting a 24" × 36" (61cm × 91cm) black-and-white print made on heavy stock paper. I then mount this print to hardboard using acrylic matte medium.

PALETTE

Beowulf Color Palette
I used a warm palette to render the effects of firelight reflecting on gold coins.

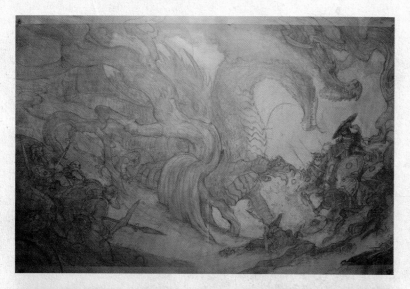

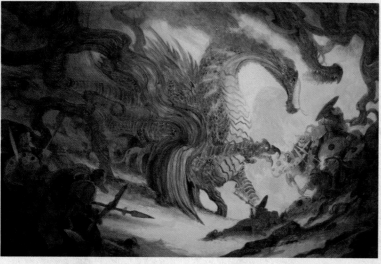

Underpainting
Once the mounted drawing has dried to the board, begin with a tonal underpaintng in acrylic. This technique is the same as in my digital paintings, but here I use watered-down, transparent paint to allow the drawing to show through. I use acrylic because it dries quickly with no fumes, and the acrylic seals the paper for subsequent oil painting. Almost all of this underpainting will be painted over later, so there's no need to paint any details. I chose a warm yellow tone because the room will be filled with shimmering gold, and that color will shine through all layers.

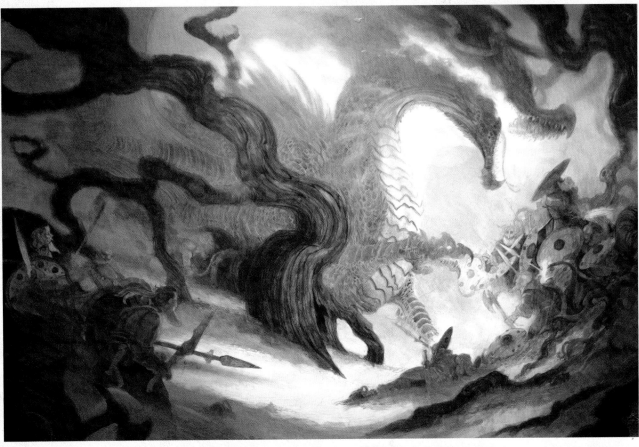

Add Local Color
Using broad strokes, I used oil paint to loosely block in the local color of the objects and forms. This establishes color, light and atmosphere in the painting. Again, no details just yet.

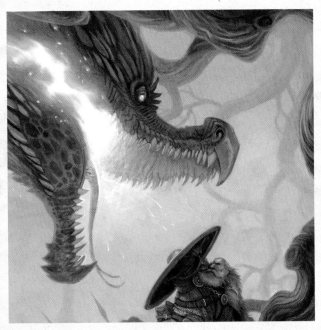

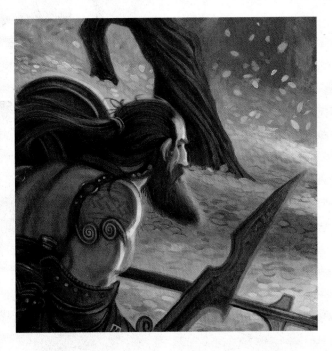

Details of Beowulf Finished Painting
After several weeks of painting, adding detail and color to the canvas, it is ready for the finishing touches. Because of the painting's size and detail, I photograph the painting to bring it back into the computer, where I finish the details digitally.

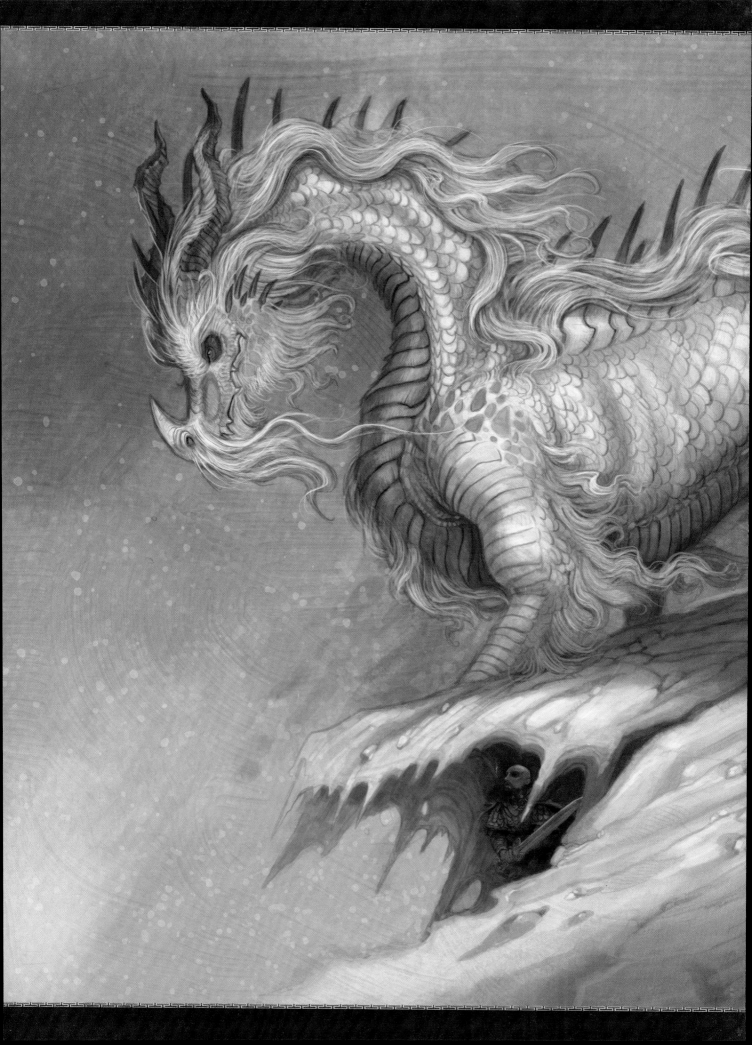

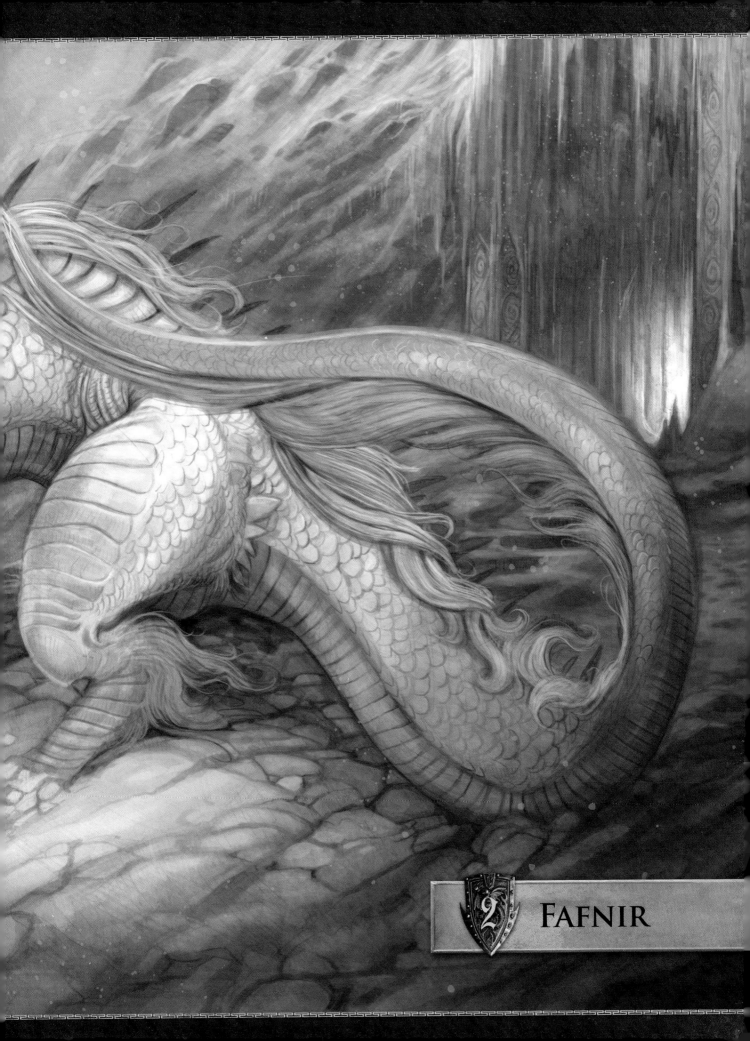

FAFNIR

The Legend of Fafnir

NORSE

 HE SWORD GRAM was no ordinary weapon. It was forged long ago from the rich mines of the Dwarf King Hreidmar, whose son Prince Regin was a talented smith able to shape any armor or sword from gold or bronze. His skill made Hreidmar's other son, Fafnir, wrathful with jealousy.

When the mighty bronze Gram was shaped on the dwarven prince's anvil, Regin knew at once that this was a blade of unequaled craftsmanship and unmatched power. The god Odin decreed that only one worthy of the blade should be allowed to wield it, and he bestowed the sword to Sigmund, king of the Volsungs, who brandished Gram for many years, vanquishing his enemies and becoming a mighty lord. Eventually, however, Odin decided that Gram and Sigmund had become too powerful, so during a battle, he caused Gram to shatter,

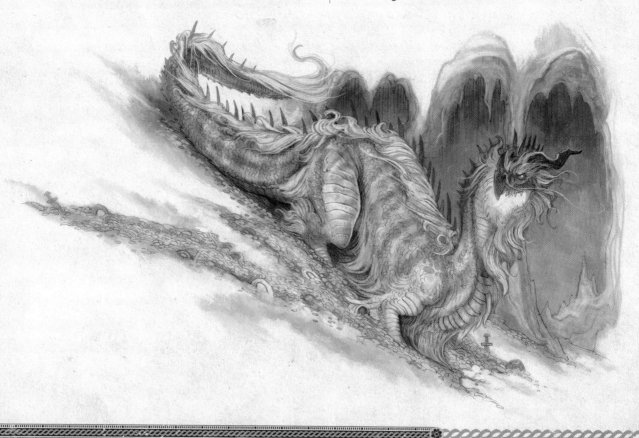

and Sigmund fell to his enemies. The kingdom of the Volsungs was lost, and the queen and her son, Sigurd, fled to the countryside.

During this time, Fafnir's jealousy toward his father Hreidmar and brother Regin had grown, and he coveted the Golden Dwarven Hoard for his own. Twisted and tormented by his greed, Fafnir transformed into a powerful dragon that breathed poison and fouled the lands of the dwarves in perpetual winter, driving the dwarves from their ancestral halls.

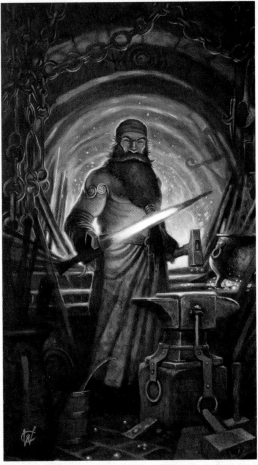

King Hreidmar confronted his son. "Fafnir, what have you done?"

"I have taken what is rightfully mine, Father! Now I will be the king of the Golden Hall!" Fafnir then fell upon his father and slew him.

Prince Regin and the dwarves of Hreidmar fled the Golden Hall and went into hiding far away from the wrath of Fafnir, but Regin vowed to return one day to avenge the king and take back their homeland. While taking refuge in the wilderness, Regin met the exiled Prince Sigurd, also on the run from his enemies, and together they plotted to kill Fafnir and share the golden horde. Sigurd revealed that he had the shards of Gram, which was once wielded by his father. The dwarven prince took the shards and reforged the legendary sword, perhaps the only weapon powerful enough to kill Fafnir.

Bearing the sword Gram, Sigurd set off into the frozen mountains to seek out the lair of Fafnir. After many treacherous days of traveling, Sigurd came upon the icy dwarven halls and entered the great chamber filled with the golden treasure that Fafnir had stolen from his father and brother. Coiled atop the piles of gems and coins, the dragon woke from his slumber at the arrival of the warrior.

"So my brother has sent a mortal man to try to slay the great Fafnir!" the great dragon hissed. "My father and my brother conspired against me.

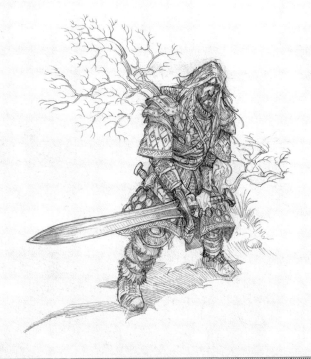

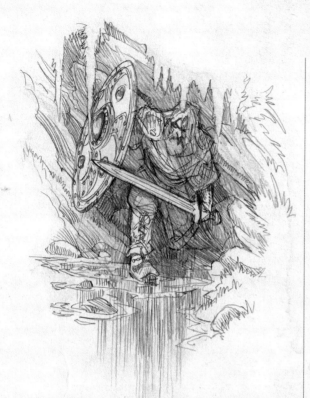

struck, and with every powerful swing of the sword Sigurd failed to scratch the mighty dragon, much less pierce his hide. Fafnir then belched a cloud of smoke over the warrior. Choking and eyes burning, Sigurd stumbled away from Fafnir and ran hastily from the hall, back to the icy windswept mountain cliffs. Fafnir laughed and taunted Sigurd as he fled. "You cannot run, Gram wielder! You cannot escape the mighty King Fafnir!"

Blinded by Fafnir's poisonous breath and the forceful wind, Sigurd stumbled and fell into an unseen crevasse in the ice. He was not injured too severely in the fall, but when Fafnir emerged from the cave searching for him, Sigurd realized that he was concealed within the icy crack.

"Come out, little man. Hiding will do you no good," Fafnir snarled.

They wished to keep the treasure of the dwarves for themselves, but I was too powerful for them. The gold is now mine and no mortal man shall take it from me." The great monster reared up to his full height, his skin flecked with scales that shimmered gold.

Sigurd drew Gram from its sheath and brandished it before Fafnir. The dragon seemed to recognize the blade and he suddenly hunched down, wary of the intruder in his cave. "You know this blade!" Sigurd shouted. "The sword Gram, wielded by my father, reforged by your brother Regin."

Fafnir hissed and snapped his jaws at Sigurd, who stepped aside just in time to evade the bite. The warrior and the beast carefully circled one another, each searching for an advantage. The warrior swung the blade, catching Fafnir along the side, but so thick and powerful were his scales that even the enchanted blade of Gram glanced off his armor. Over and over the two combatants

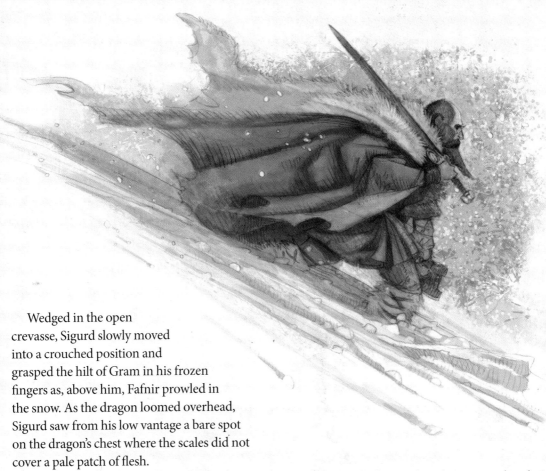

Wedged in the open crevasse, Sigurd slowly moved into a crouched position and grasped the hilt of Gram in his frozen fingers as, above him, Fafnir prowled in the snow. As the dragon loomed overhead, Sigurd saw from his low vantage a bare spot on the dragon's chest where the scales did not cover a pale patch of flesh.

Fafnir suddenly swung his head around and spied Sigurd in the crevasse. "There you are. I found you, little man." Fafnir bared his teeth to finish Sigurd, but the warrior thrust the blade upward with all his might. The magic blade of Gram found its spot and sank hilt-deep into Fafnir's chest.

The mighty dragon let out a terrible scream of anguish and toppled into the snow. Sigurd pulled himself from the crack and stood ready to strike again, but the dragon was in his death throes.

"What is your name, Gram wielder?" Fafnir choked.

"I am Sigurd, son of Sigmund, king of the Volsungs," the young man proclaimed.

Fafnir laughed, a hideous sound from the beast's throat. "Do not think that by killing me you are safe, princeling. Do you think my brother will let you live and share his gold?" With that, Fafnir let out a last breath and did not move again.

Having vanquished the terrible serpent, Sigurd returned to his homeland with Gram and golden treasures from the hoard, and reclaimed his father's throne to become king of the Volsungs.

DEMONSTRATION
FAFNIR

STAGE ONE: RESEARCH AND CONCEPT DESIGN

The story of Fafnir and Sigurd is one of the most iconic dragon tales in world literature, related in the medieval *Volsunga Saga* and *The Song of the Nibelungs*. This legend, once again, tells of a dragon who covetously hoards gold treasure. Unlike other dragon stories, however, Fafnir is actually a dwarf who transforms into a dragon to represent the affliction of greed and power. As in *Beowulf*, the dragon Fafnir needs to be vanquished by the hero using his cunning and bravery.

For my depiction of Fafnir, I consider that he was once a dwarf, and that the story is a Norse legend taking place in the north. Both of these observations inform me in the design of the dragon Fafnir. It's apparent that Fafnir could easily be a member of the Arctic dragon family of *Draco nimibiaquidae* (discussed in *Dracopedia*, pages 22–33).

This storytelling choice alludes to the northern environment of the legend and allows for dragon designs that can incorporate dwarven features, like beards and hair into the concept for Fafnir.

It is easy to recognize the story of Fafnir as one of the inspirations of Glaurung in J.R.R. Tolkien's *The Silmarillion*, who is slain by Turin, as well as Smaug in *The Hobbit* who covets the dwarven gold of Erebor.

Arctic Dragon Woodcarving, circa 5th century
The Vikings were renowned for their intricate woodcarving skills, which they incorporated into their architecture and shipbuilding.

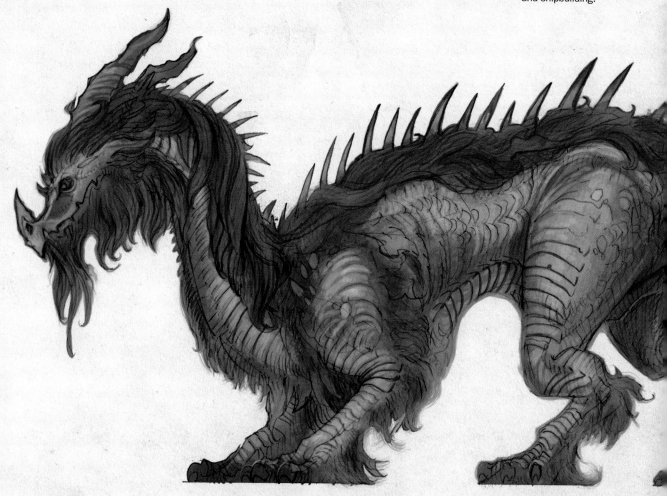

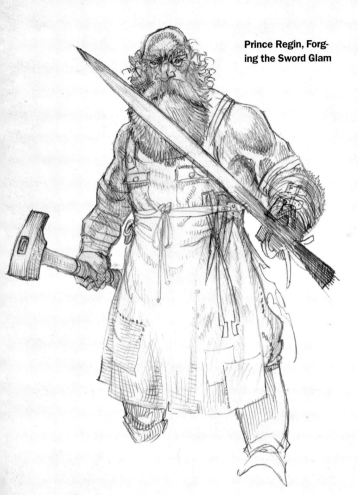

Prince Regin, Forging the Sword Glam

Fafnir Head Study
Because Fafnir was originally a dwarf, I wanted to incorporate facial hair and humanoid eyes to convey his personality and intelligence.

Fafnir Profile
Nimibiaquidus nebulus-fafnirii, 75' (23m)
Based on descriptions in the story of Sigurd and Fafnir, it is likely that Fafnir was an Arctic dragon. This design of *N. nebulus* is based on the Cloud dragon (*Dracopedia*, pages 30–33).

Glam Design
The sword Glam is a powerful dwarven-forged weapon. This design is based on Germanic Iron Age swords.

STAGE TWO: THUMBNAILS

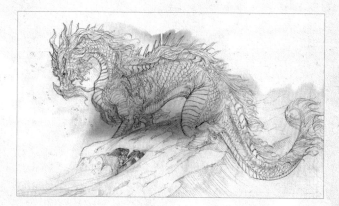

Refine Ideas

Interpreting the story and concept art into a single painting is done through a series of small, quick pencil sketches. Here I was trying to capture the tension of Fafnir hunting for Sigurd after pursuing him into the snow. You can see the progression from rough thumbnail to finished concept.

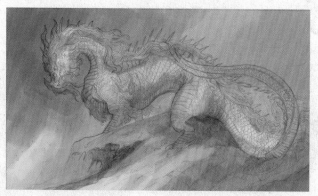

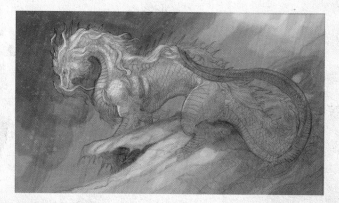

Create Color Comparisons

Experiment with quick color and lighting sketches to work out your final painting. Here a spot-light effect of warm light is used to accentuate Fafnir's face against a dark, cool background. A spot of bright orange light in the background (seen in the second image) lends visual interest to an otherwise cold, barren landscape of snow.

STAGE THREE: DRAWING

Develop the Drawing

Using your concept art for reference, begin a finished detail drawing based on the thumbnail sketches. Begin with a basic wire frame to capture the desired movement and placement, then proceed by building volume and adding details.

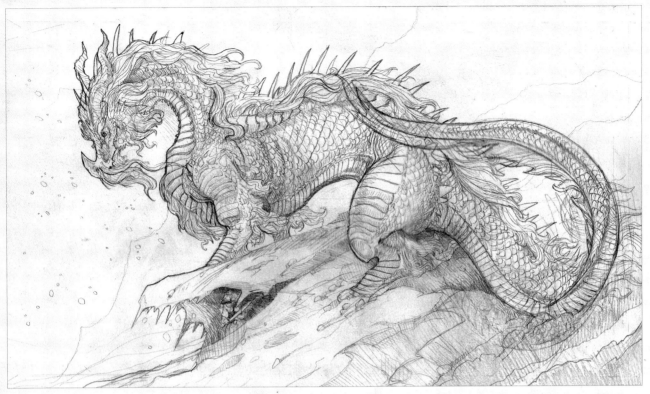

Fafnir Finished Drawing
Pencil on paper
13" × 22" (33cm × 56cm)

Details of Fafnir Finished Drawing

STAGE FOUR: PAINTING

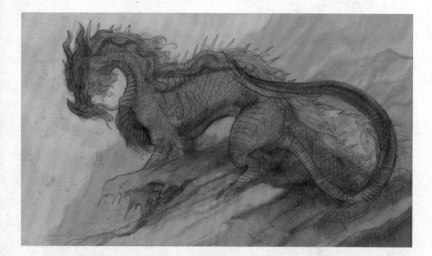

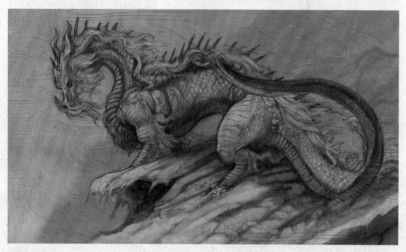

Underpainting
Photograph the drawing and open it in your editing software for painting. Add a Multiply layer over the original and create a tonal underpainting to establish lighting and shapes. Next apply a paint texture at 25% opacity in Multiply mode.

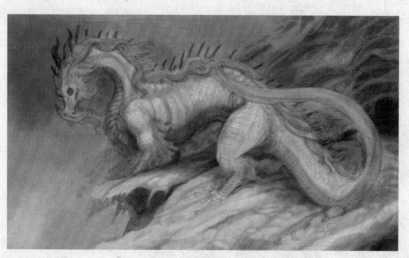

Background
With very little color variation, the use of texture and value becomes more important. Every element in the painting—snow, rocks, sky, dragon—all have their own texture.

PALETTE

Fafnir Color Palette
For the arctic setting, I chose a cool palette of blues and greens to give the painting a sense of cold and ice.

Texture
This texture was applied to the painting to create more variation.

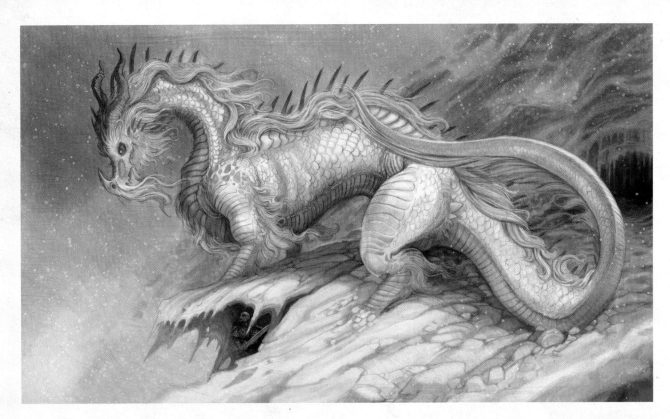

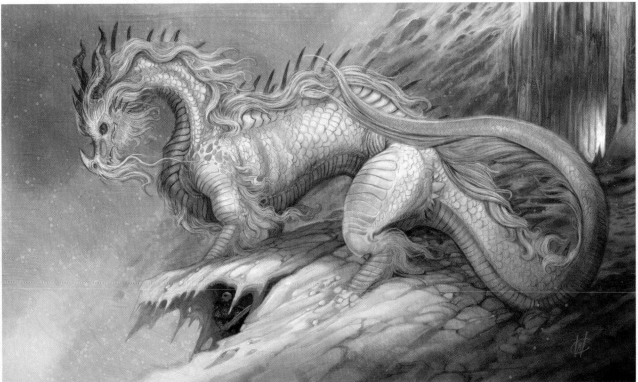

Foreground and Finishing Details

The cave is illuminated to better depict Fafnir's Golden Hall and to provide a spot of color and light. Use small, opaque detail brushes to finalize the painting with crisp, dark shadows and bright highlights.

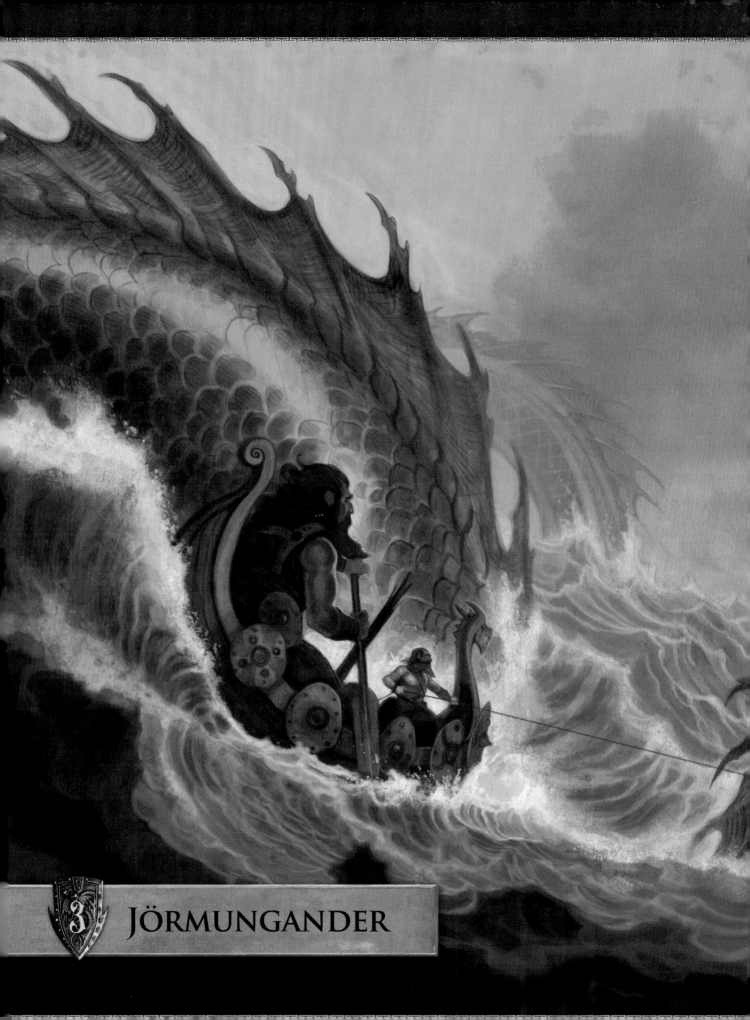

3 Jörmungander

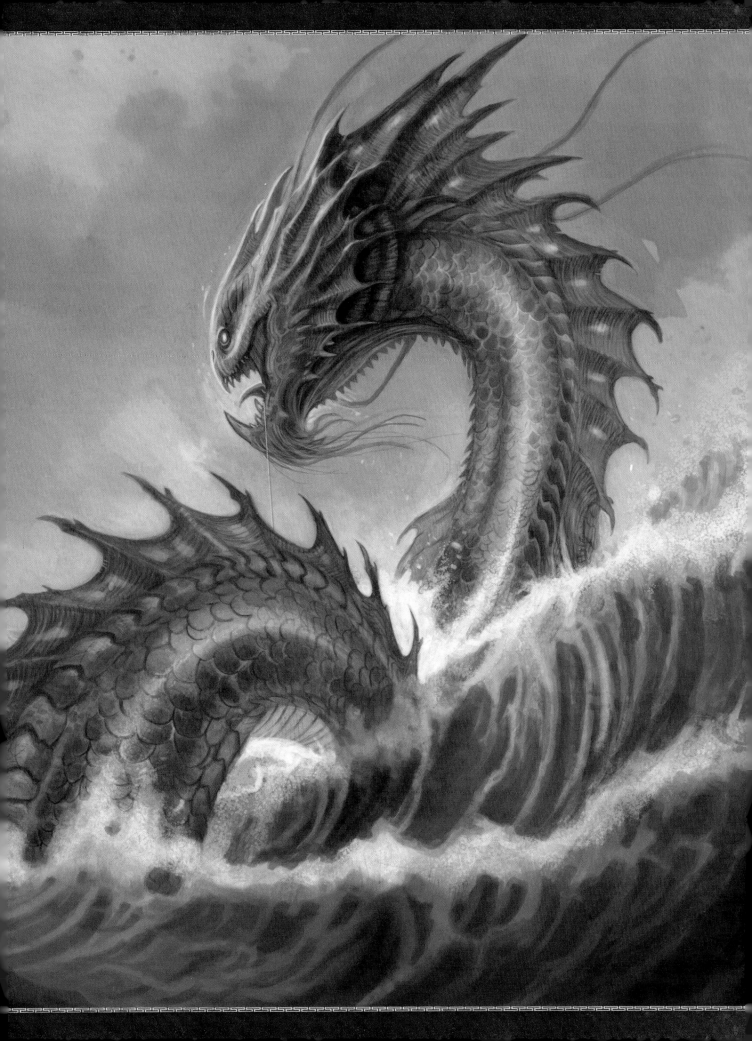

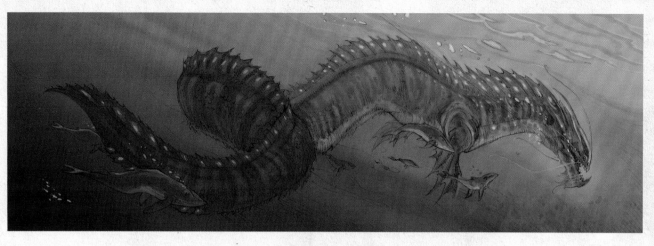

The Legend of Jörmungander

NORSE

N THE TIME OF LEGENDS, the giant Aegir threw a great celebration in Valhalla, attended by all the gods of Asgard, and a great feast was had. Odin's hall was filled with laughter as all partook of Aegir's mead from a giant cauldron. Among the merry was Thor, the god of thunder, and he, deep in his cups and drinking the last of the cauldron's brew, boasted to the assembled in the hall, "Aegir! Your mead is sweet and the cauldron deep, but there is no cauldron in all the realms that could satisfy the thirst of all the gods of Asgard."

"Not so, Thor," replied Aegir. "My brother, the giant Hymir, has a cauldron so big that even you could not finish its contents. Bring it here, and I will fill it with mead for you."

Thor took up the challenge and rode his chariot through the fjords of Midgard to seek the giant Hymir. Thor's quest found the titan hidden away deep in the seaside cliffs. Hymir was an ancient and powerful giant from the founding of the world, and he was now the sea shepherd, keeping pods of whales that grazed the seas around the fjords. Alongside his home was the titanic cauldron described by Aegir, large enough for the giant himself to bathe in and, indeed, large enough to water the celebrations in the halls of Asgard.

"Greetings, Hymir!" Thor called cheerily, alighting from his chariot.

"What business does the son of Odin have with me so far from the halls of Valhalla?" croaked the old giant.

"I have a favor to ask," said Thor. "I wish to take your cauldron back to Asgard with me to feed the guests of Valhalla."

Hymir stroked his gray beard and thought. "I propose a deal," Hymir said. "In exchange for the cauldron, you can help me. For ages I have shepherded my whales along the sea, but I am plagued by that terrible sea serpent, Jörmungander. Every day he lies in wait and devours my flock if they stray too far from the protection of the fjord. If you help me destroy Jörmungander, the cauldron is yours."

Thor knew the sea serpent. Since the making of the realms, Jörmungander had plied the depths of the seas that encircled the world. It was said that when Jörmungander was killed it would signal the beginning of Ragnarok, the ending of the world. But Thor was not afraid of such prophecies, and the bargain was struck. Thor took up an anchor from an old ship, then slaughtered an ox and baited his makeshift hook with its meat, and took a hundred fathoms of line and chain.

"Let us go fishing then, Hymir, and catch this devilish eel," Thor declared.

Together, they cast off from the shore in Hymir's boat, an ancient longship that to the giant was no more than a skiff. With the giant rowing, they set forth to catch the sea dragon, Jörmungander.

As they sailed out of the safety of the fjords, Thor laid out a long line behind them and trawled the swelling seas, but still he was troubled. If the World Serpent were slain, then it might bring about Ragnarok and the end of the world.

After days of navigating the tumultuous seas, there was, at last, a sharp tug as the line

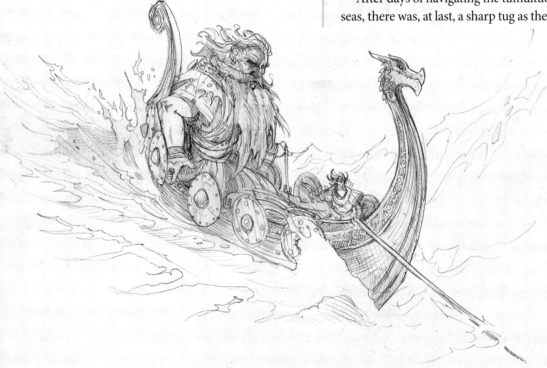

pulled tight. The mighty dragon was hooked. Thor and Hymir pulled at the line for hours as the titanic Jörmungander fought ferociously. Hours turned to days. The duo struggled for three days and nights, taking turns rowing the ship and hauling in the line. At long last, Jörmungander breached the water and the mighty serpent spouted gouts of steam and poison, gnashing its razor-sharp teeth the size of broadswords. The ocean churned from the thrashing of the serpent, but Hymir and Thor held fast to their quarry.

When it seemed that Jörmungander was finally spent and could fight no more, Thor pulled out his hammer, Mjolnir, and raised the powerful weapon to deal a deathblow to the sea dragon. All of a sudden, Hymir leapt forward with his axe and slashed the line that held the dragon. Freed from his impending doom, Jörmungander splashed and leapt, nearly capsizing the boat, and dove back into the murky depths of the sea.

Thor was furious with Hymir and demanded he explain himself.

"I am sorry, my friend," Hymir said. "But at the last moment I had a change of heart,

for I feared the prophecy might come to pass if Jörmungander were to be destroyed. What if our actions were to bring about the end of days and begin Ragnarok? I could not allow that to happen."

"But what of your whales and our bargain?" Thor asked.

"My whales will be safe enough in their fjords, and a sacrifice of a few to Jörmungander to save the world is a small price to pay," Hymir said. "Fear not. I will still honor our bargain. The cauldron is yours."

Thor would not admit that he had harbored the same fears and simply admitted that it was a good fight. Together, Hymir and Thor rowed the ship back to the safety of the fjords, and the great Jörmungander continued to prowl the seas for many ages more.

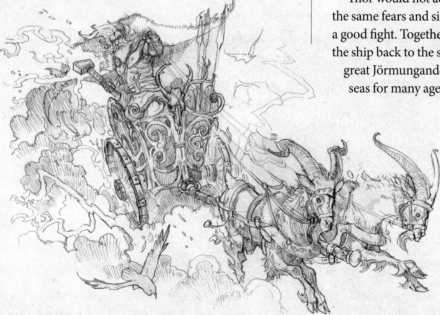

JÖRMUNGANDER

STAGE ONE: RESEARCH AND CONCEPT DESIGN

The sea was sacred to the Vikings. When you travel through Scandinavia in the fjords and seas where the Norsemen once plied their longships, it is apparant how they relied on the water to provide food, transportation, protection from and trade with the outside world. Venturing beyond the sight of land would have been as dangerous to them as space travel is to us today.

Jörmungander is a giant sea serpent of legend, so I began by referencing the sea orc family *Dracus orcidae*, specifically the species *Dracanguillidus faeroeus* from *Dracopedia* (pages 124–135). This huge ocean dragon, commonly called the Faroe sea orc, lives in the Northern Atlantic Ocean off the coast of Scandinavia. It would have been well known by Viking sailors, sighted as they ventured forth in longships and giving rise to the myths and legends of Jörmungander. Jörmungander is bigger and more iridescently colored than a normal sea orc, making him appear more epic than his commonplace cousin.

Mjolnir, Thor's Hammer

Antique Woodcarving of a Sea Serpent
Research into Nordic artforms reveals an aesthetic common to the Vikings to help in the design of costumes and characters.

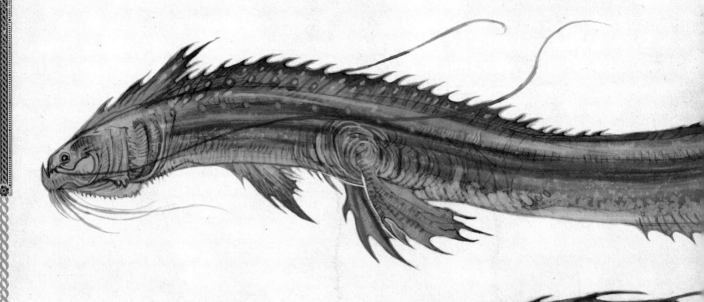

Faeroe Sea Orc
Dracanguillidus faeroeus,
200' (61m)
The Faeroe sea orc would
have been a well-known
threat of the northern seas
of the Vikings.

STAGE TWO: THUMBNAILS

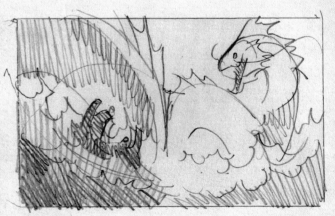

Refine Ideas

With each of the elements established—the serpent, the sea, the ship and the figures—you can begin to build the designs of each. Remember that when designing an image, whether for a book, video game or film, it's important that all of the elements are included in the thumbnail. It's up to you, the artist, to decide the importance of each

of these elements. Some may think that the figures are the focus of the story, while others may feel that Jörmungander is central to the narrative. Whatever you choose, creating a relationship to establish the story is important.

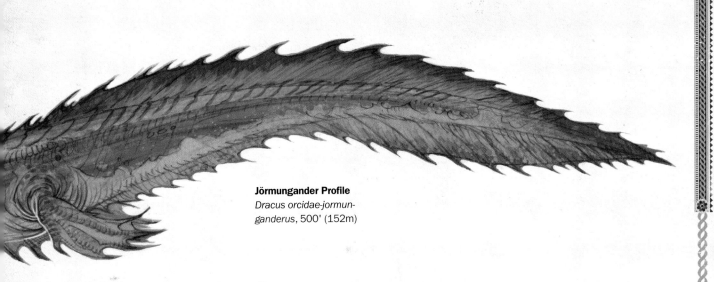

Jörmungander Profile
Dracus orcidae-jormun-
ganderus, 500' (152m)

STAGE THREE: DRAWING

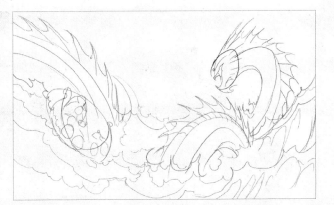

Develop the Drawing
Block in the design so that the elements are worked out in relation to
one another before adding details.

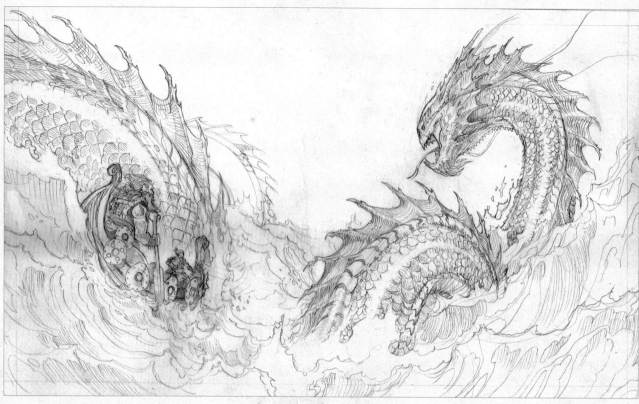

Jörmungander Finished Drawing
Pencil on paper
13" × 22" (33cm × 56cm)

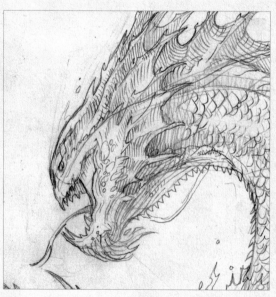
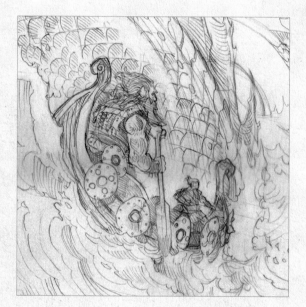

Jörmungander Finished Drawing Details

STAGE FOUR: PAINTING

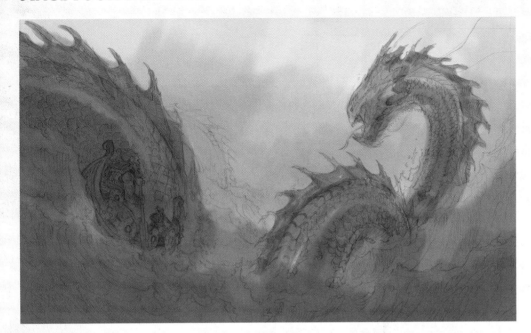

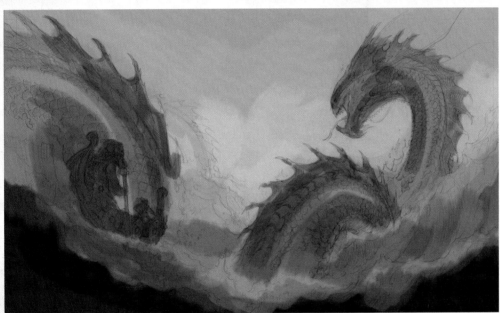

Color Comparisons
Creating a couple of quick color designs on the computer can help inspire the look of the painting. In this example, the first comparison explores a warm sunset palette. In the second, I tried a cold, sea green palette. After finishing these samples, I felt the cold, dark greens worked better to describe the frightening scene.

PALETTE

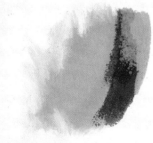

Jörmungander Color Palette
I used a rich, dark green palette to reflect the seascape of Jörmungander.

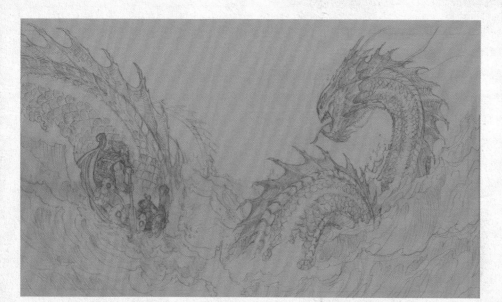

Underpainting
Scan or photograph your detailed drawing and import it into your editing software. Create a new Multiply layer on top of the drawing, then create a monochromatic tonal painting over the top. This stage establishes light, form and texture.

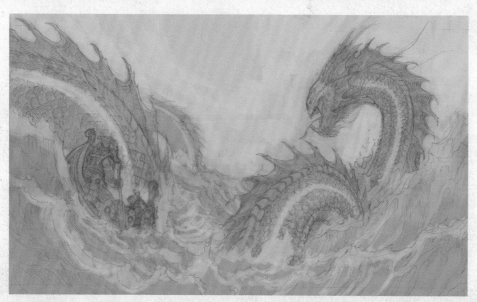

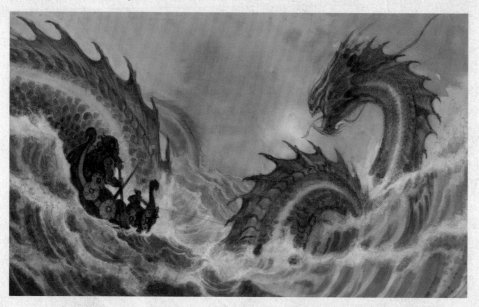

Background

In a new Normal layer, render the background details. For inspiration, go online and find references for water and waves to study how they behave and to understand their shapes.

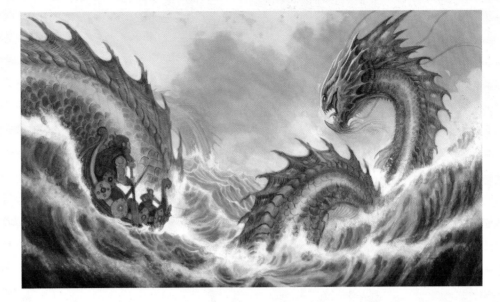

Foreground

Work on the details of Jörmungander, such as the scales. In this image, I'm rendering iridescent scales while looking at pictures of marlins and other sport fish in order to understand the colors and shimmer of the armor. Using splatter texture brushes here is helpful in rendering splashing water (see the brush options on pages 11).

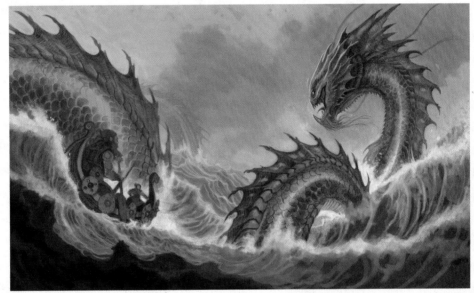

Finishing Details

For the final stages of the painting, use the smallest brushes to render the details of the figures, boat and dragon and to add dimension to the image.

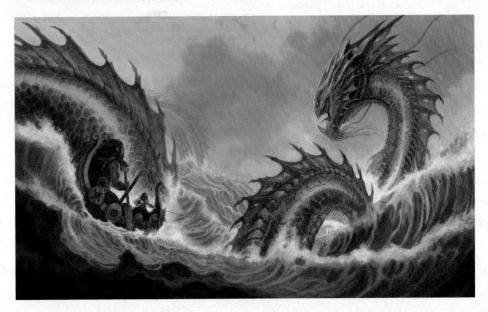

THE LAMBTON WYRM

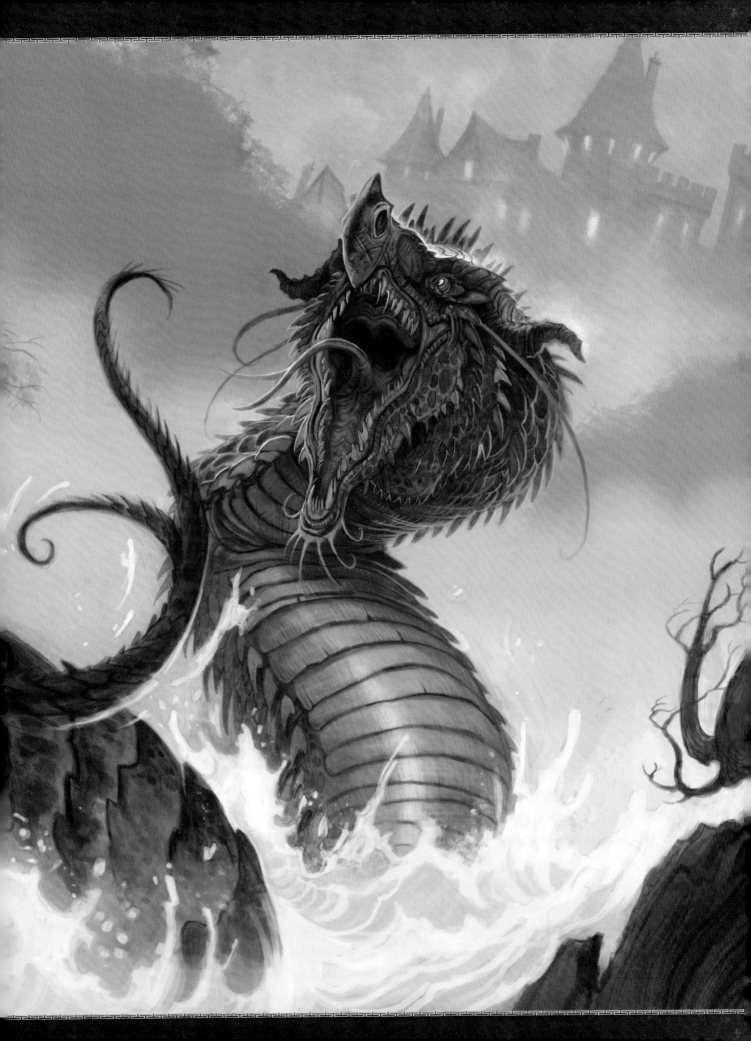

The Legend of the Lambton Wyrm

ENGLISH

 ASTLE LAMBTON STOOD BESIDE THE RIVER WEAR in the green valleys of Durham, England. The family of Lambton had lived in this valley for generations, and they flourished along with the villagers. The pride of Lord Lambton was his young son, John. One beautiful spring day, John raced through the village carrying his fishing pole and cut through the garden of an old cottage. The old witch who lived there stopped him.

"Where are you off to in such a hurry, young Master John?" the witch asked.

"I'm off to the river to catch my supper," John replied.

"Be wary, young master," she said. "For what you catch today will bring ruin to your family."

Young Master John ran from the witch and came to the river where he waded into the rocky eddies. He baited his hook and cast his line into the stream. Before long the rod was tugged and John snapped the line fighting the fish. He pulled and pulled and after a long struggle brought his catch up on the rocky banks. But instead of a fat perch, he found a long ugly creature. At first he thought it might be an eel or a snake, but it looked like nothing he had ever seen before. Remembering the warning he had received from the witch, John did not want to let the creature free, so he took the slimy serpent and dropped it into a well.

In time, Master John grew into a handsome young man and became a knight like his father

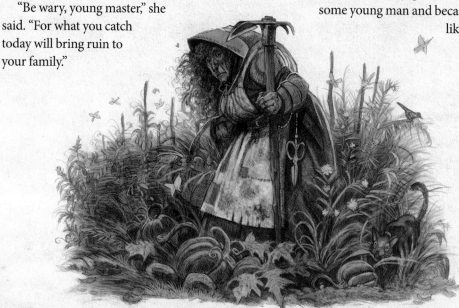

before him. He then went out into the world to seek adventure. When his quests were over, Sir John returned to Lambton. Arriving at his home, he was dismayed at what he found. The village was in ruin, the fields were scorched, and the castle that had been his family's home for so many generations was crumbling. John raced to the castle, through the empty halls to his father's room, where he found the old man in bed.

"Father, what has happened to you?" John cried.

"A dragon has come to Lambton and nearly destroyed us all," Lord Lambton croaked. "I am all that remains of our knights. We tried to destroy the beast, but he was too much for us. I fear that all may be lost."

"Fear not, Father," Sir John said. "I will slay this demon dragon."

Sir John clad himself in his battle armor with his sword and shield. Mounting his powerful charger, he rode to the river to do battle with the dragon. When he arrived on the banks of the River Wear, John was thunderstruck. There among the rocks was a wyrm coiled and smoking its poisonous fumes, scales along its flanks and razor-sharp teeth in a maw large enough to swallow a cow. John recognized it at once—it was the

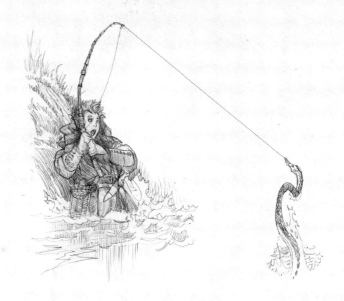

same little wyrm he had caught all those years ago and thrown into the well. It had grown and was terrorizing Lambton.

Spurring his horse, John charged the dreadful wyrm. His lance struck the beast with a powerful blow, but the wooden shaft was driven into slivers upon striking the wyrm's armored scales. The dragon unleashed a fiery plume of smoke at the knight. Choked by the ash, Sir John's horse collapsed, and the knight was thrown into the river. The giant wyrm was lightning fast, and before John could gain his footing, the beast coiled itself around the stricken horse and squeezed it to death. Sir John drew his sword and struck the wyrm, but as before, its hide was too strong and the knight's mighty slashes were futile. The wyrm's tail whipped the knight back into the water like a horse swatting a pesky fly. Beaten, Sir John climbed the banks of the River Wear and retreated to the castle.

Later that night John was surprised to find the old witch from the village at the door to his quarters.

"I know how to slay the wyrm," the witch said. "On one condition."

"Anything," Sir John responded. "I will pay any price you ask."

"Very well, but it is not money I require," she said. "Once you have slain the wyrm, you must then kill the first living thing that you find when you return to the castle and deliver it to me. If you do not do this, your family will be stricken with a terrible curse. The family of Lambton will have no sons for nine generations."

John agreed to the sorceress's terms, and she told him the secret to killing the wyrm. "Go to the blacksmith and have him fashion for you a suit of armor covered in spikes. Then, confront the wyrm again."

John raced to the courtyard and roused the blacksmith from his sleep. The knight told him what to do and the smith began his work in great haste. In a fortnight the armor was completed. John strapped on the thick armor bristling with dagger spikes. Before he left the castle, he explained to his father, "Once I have slain the wyrm, you must stay hidden and only allow the hounds in the castle to greet me upon my return. If I am to keep my pledge to the witch, I will slay a hound and deliver it to her, then no harm will come to you."

Sir John staggered to the river clad in his spiked armor as the witch had told him. There he found the fuming wyrm, coiling and writhing its scaly body. As John approached, the dragon hissed and bared his teeth, but Sir John held his ground. In a flash the beast was upon him and encircled the knight in his powerful coils. The great wyrm began to squeeze the knight, trying to crush his bones, but the armor the blacksmith had made tore into the wyrm. The tighter the dragon constricted, the deeper the spikes stabbed into the creature. The wyrm tore itself to pieces and fell life-less into the river.

Having watched the battle from the high tower of the castle, Lord Lambton was so relieved for his son that he raced to greet him. Sir John threw off his armor and came into the great hall with his sword and found his father waiting for him.

"Father!" John cried. "You were to stay hidden. Have you forgotten my promise with the witch?"

Father and son hatched a plan to fool the witch, and John slew one of the castle hounds and delivered it to her, telling the hag it was the first living creature to cross his path upon his return to the castle.

"Lies!" scolded the witch. "You must know that you cannot fool me, young Master John, and so I place a curse upon you and your family. For nine generations no male heir of Lambton shall be born."

And so it came to pass that the family of Lambton disappeared. In time the castle that bore their name fell to ruin, but the village of Lambton lived on, and to this day the people of Lambton live in peace along the River Wear.

DEMONSTRATION
THE LAMBTON WYRM

STAGE ONE: RESEARCH AND CONCEPT DESIGN

The story of the Lambton Wyrm is one of the classic myths of England involving a young hero who must use his wit and courage to defeat a powerful dragon. Although there are Welsh dragons in Britain, the wyrm is most commonly associated with England and Ireland. The *Draco ouroboridae* family of dragons (see *Dracopedia*, pages 137–145) is one of the most common, with species all over the world, and presents a danger to riverside cultures. This story demonstrates the classic habitat of the wyrm, its coiling and constricting behavior and the poisonous breath it uses to incapacitate its prey. In some versions of the story told in northern England, the wyrm is a European lindwyrm (*Ouroboridus pedeviperus*, *Dracopedia*, page 138) and has vestigial legs.

European King Wyrm Profile
Ouroboridus Rex, 100' (30m)
Closely related to the American banyan wyrm and a cousin of the European lindwyrm, the European king wyrm (or great wyrm) went extinct, sometime in the 15th century. Skeletal remains exist of some specimens believed to have reached over 100' (30m) and are most likely the basis of the Lambton Wyrm legend.

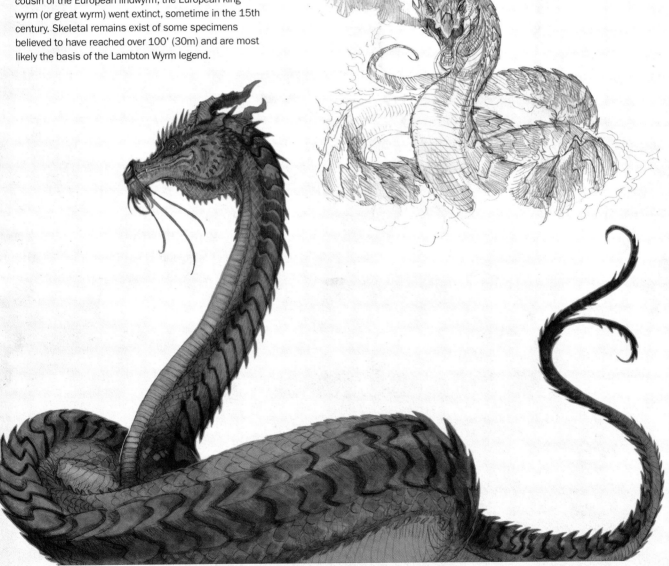

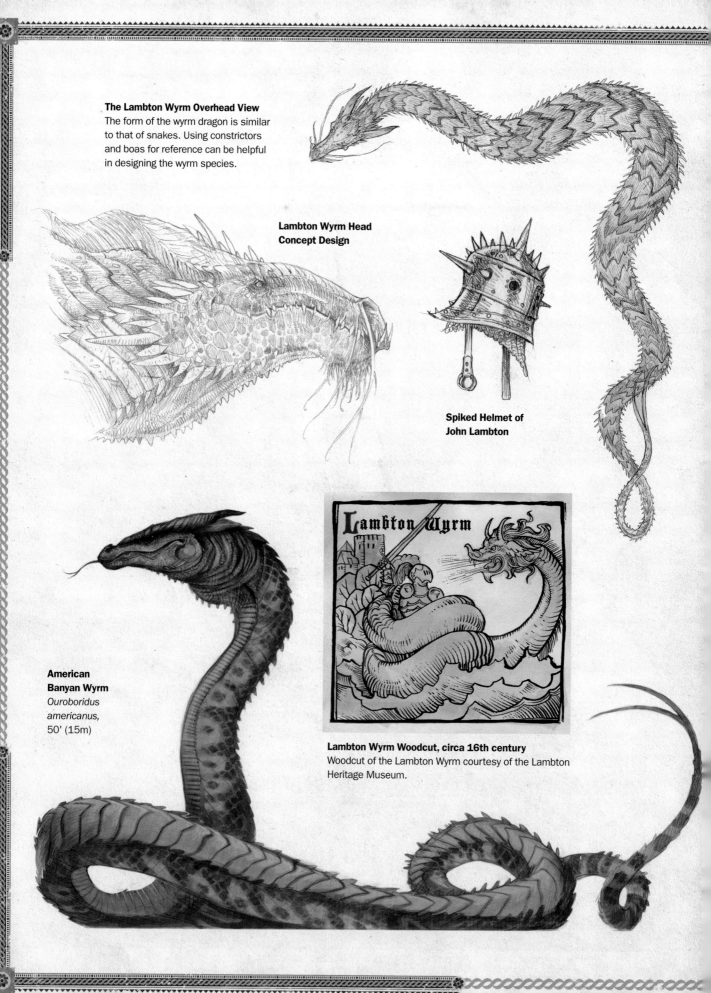

The Lambton Wyrm Overhead View
The form of the wyrm dragon is similar to that of snakes. Using constrictors and boas for reference can be helpful in designing the wyrm species.

Lambton Wyrm Head Concept Design

Spiked Helmet of John Lambton

American Banyan Wyrm
Ouroboridus americanus, 50' (15m)

Lambton Wyrm Woodcut, circa 16th century
Woodcut of the Lambton Wyrm courtesy of the Lambton Heritage Museum.

STAGE TWO: THUMBNAILS

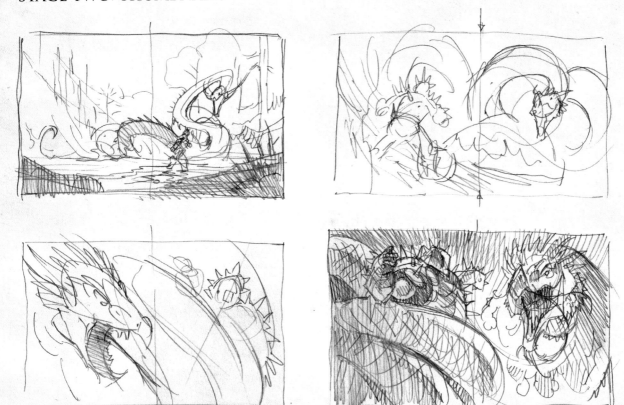

Refine Ideas

I used pencil to work up several quick thumbnail sketches to lay out the design of my illustration. I wanted to make sure I included all the elements and gave the composition a swirling, splashing effect. These design ideas range from moving the point of view far away to zooming in on the action to make the scene more intense.

STAGE THREE: DRAWING

Develop the Drawing

Working from the thumbnails and collected references, begin working out the elements of the drawing.

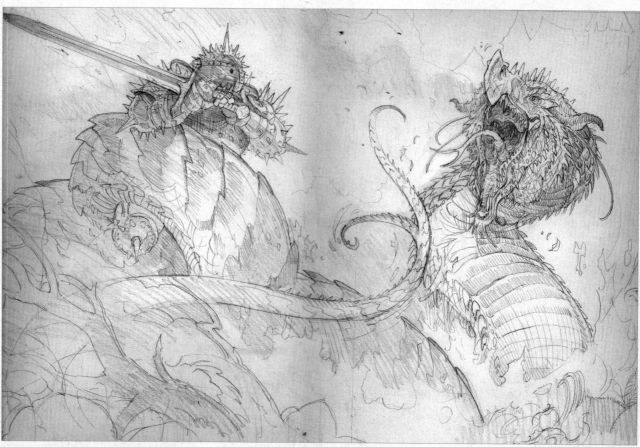

Lambton Wyrm Finished Drawing

Using my reference of wyrms from *Dracopedia,* along with the early thumbnails and concept development art, I completed a detailed, fully rendered pencil drawing. I worked from the general to the specific, leaving the details for last.

Pencil on paper
13" × 22" (33cm × 56cm)

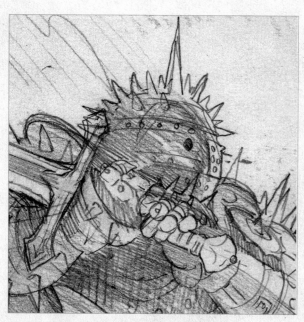

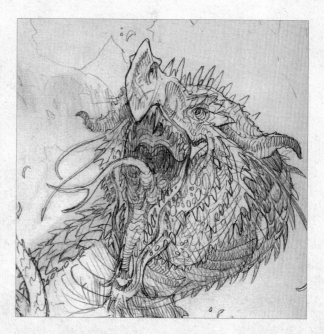

Details of the Lambton Wyrm Finished Drawing

STAGE FOUR: PAINTING

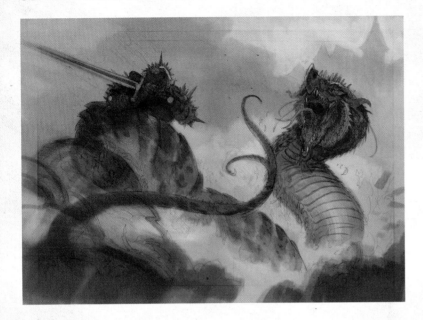

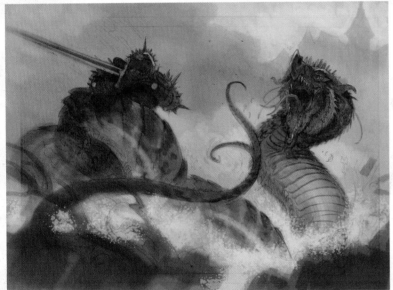

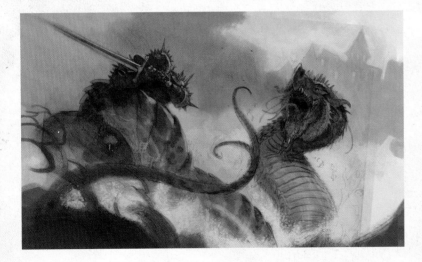

Underpainting

Begin the digital underpainting using broad brushes and local colors in a new Multiply layer placed on top of the drawing. This stage is important for rendering. It also establishes the basic forms and lighting. To create more movement in the image, rotate it slightly.

PALETTE

Lambton Worm Color Palette
A cold, sickly green is chosen to infuse the painting with a poisoned palor.

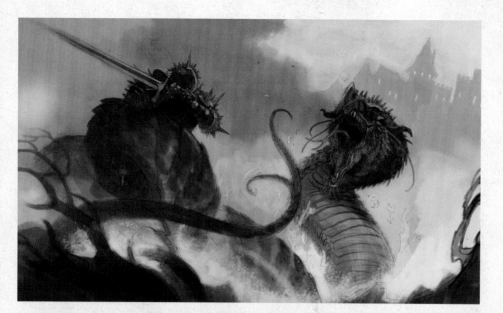

Background
Beginning with the background elements, render the details. Remember that background objects in a foggy scene will be obscured by atmosphere and will have muted color and contrast. Use large area brushes to add texture to the painting (see the digital brushes on page 11).

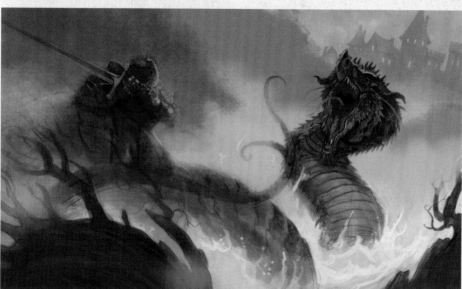

Middle Ground
Adding another Normal layer, render the dragon using finer brushes, rich color and detail. This is your focal point, so pay attention to detail, color and contrast.

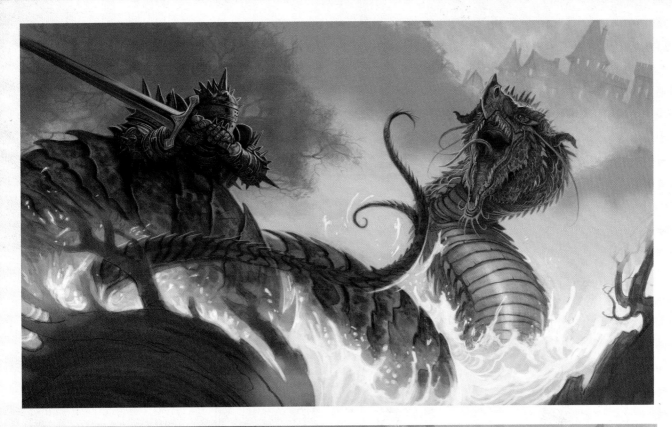

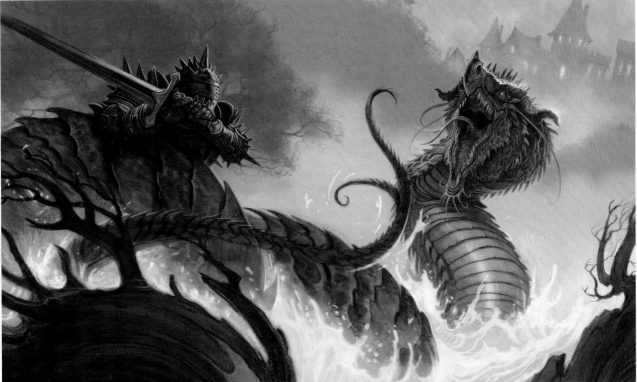

Foreground
Like the background, the details in the extreme foreground should not distract from the focal point. The dark log in this image creates a sweeping, framing device to anchor the composition and draw the viewer into the picture.

Finishing Details
Because the overall color scheme of the painting is green, select key points, such as the eye, mouth and sword hilt, to paint in red tones. Since red is the complementary color of green, this will help the selected elements pop at the focal point.

LADON

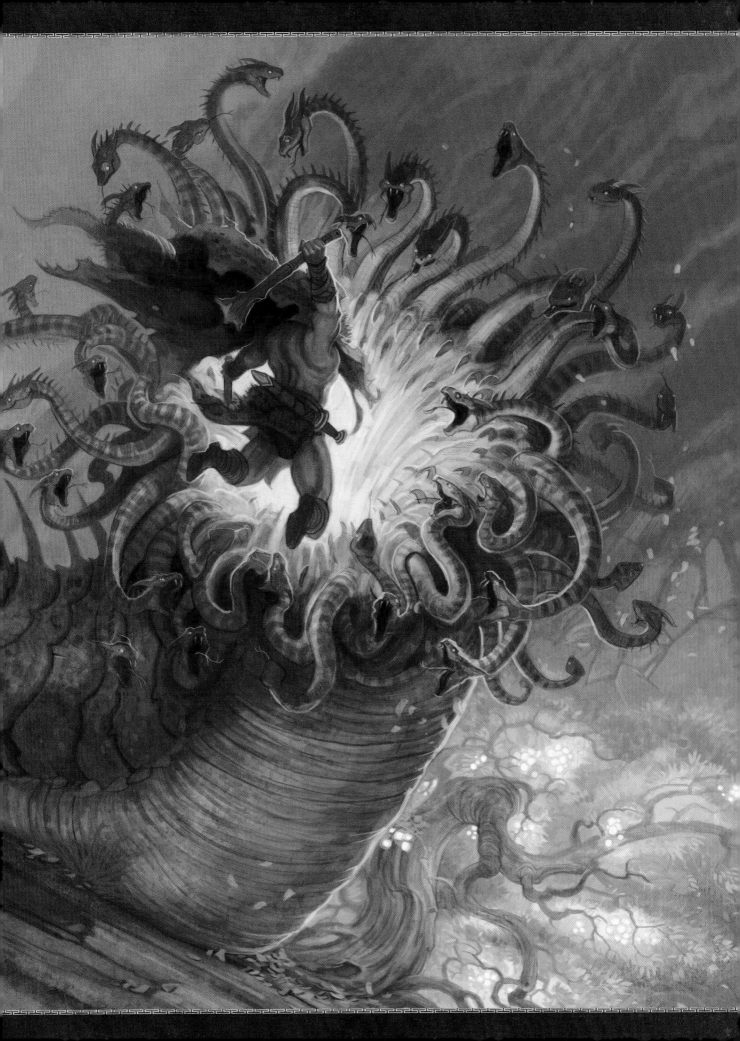

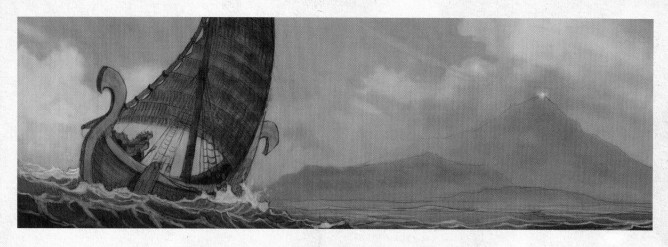

The Legend of Ladon

GREEK

 N THE KINGDOMS OF ANCIENT GREECE, Hercules, the son of Zeus and his mortal mistress Alcmene, was famous for his strength and prowess in battle. Hercules was married to Megara, and they had three beautiful children that Hercules loved dearly. The happiness of Hercules angered the goddess Hera, the wife of Zeus who, in her jealousy of Hercules's mother, cast a terrible spell upon her husband's child. Hercules was stricken with a furious madness, and in a rage, he slew his own wife and children. When the madness passed, Hercules looked upon the destruction he had wrought and fled in anguish. Eventually, he came to the temple of the Oracle of Delphi on the slopes of Mount Parnassus.

"Oh, great oracle," Hercules cried, "tell me what I should do."

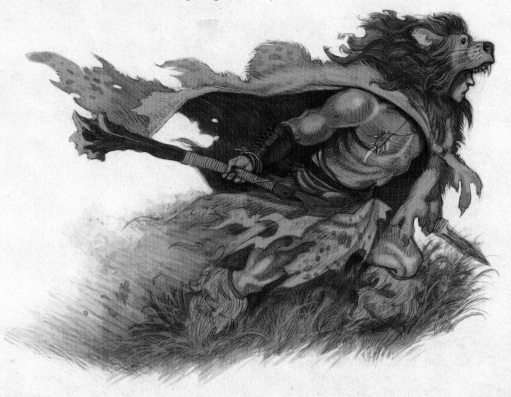

The oracle spoke: "Hercules, son of Zeus, you shall travel to the land of Mycenae, there you will find King Eurystheus. You will pledge yourself to his service for twelve years and fulfill ten labors."

So Hercules sought out King Eurystheus of Mycenae for his twelve-year penance and was challenged with ten labors. Hercules slew the Nemean lion and the Lernaean hydra in his journeys, along with other challenges put on him by the king of Mycenae. When Hercules had successfully completed his ten labors, he returned to the king, but was told that he would need to complete yet another adventure to fulfill his penance.

"Far to the west on the mythical island of the three Hesperides sisters, there is a magical garden where there grows an enchanted apple tree of Hera," the king explained. "The tree's golden fruit will give anyone who eats it immortality. You must find the island and return with a magical golden apple. But beware—the tree is guarded by the terrible dragon Ladon, whose one hundred heads never sleep. The dragon is under the control of the three sisters: Aegle, Erytheia and Hespere."

Hercules was eager to steal the golden fruit since the goddess Hera had been the author of his despair. So he set out on his quest searching the kingdoms for the island with the golden apple tree. He traveled through the world and to the end of the ocean in the west where he came upon an island of perpetual twilight—the island of Hesperides. There he met the three beautiful guardians at the gate of the gardens.

"What brings you to our garden, brave Hercules?" they sang.

"If you know my name, then you know why I am here," Hercules said. "I come for the forbidden fruit that grows in this garden."

"The golden apples are not for mortal man," trilled the Hesperides nymphs. Their voices echoed like the most beautiful song, and their melody made Hercules dizzy.

"I am no mortal man," said Hercules. "I am the son of Zeus."

The three sisters continued to sing as they surrounded Hercules. His senses were fogged and the singing lured him into the fragrant

ancient garden beds where he fell into a deep
sleep without memory.

How long Hercules lay slumbering, he did
not know, but day had turned into night and
the pink sunrise loomed on the horizon as
his mind woke. He found the nymphs sleep-
ing nearby, unaware that Hercules was
now alert. Slowly he rose, took up his
mighty cudgel, and stole away from
the sleeping nymphs, careful not to
wake them.

Having passed the Hesperides
sisters, Hercules wandered through the
verdant paths of the garden until he
came to a clearing with a hill. All
the land around the hill had been
scoured of life and only barren
rock and bones remained. Atop
the tor an ancient apple tree
glowed with golden radiance.
Coiled around the hill was the
massive one hundred headed hydra
Ladon writhing like a pit of vipers.

Hercules boldly attacked the
dragon, leaping to deal a swift and
deadly blow to the beast with his
mighty cudgel. The thick armored hide
of Ladon caused Hercules's powerful blows to
bounce off harmlessly. Hercules tried to use
his speed to get past the dragon to steal an
apple off the sacred tree, but Ladon was faster
still and his one hundred adder heads saw
every move Hercules made. The only course
left to Hercules was to slay each of Ladon's bit-
ing serpent heads one by one. He rained down
blow after blow pummeling the beast, evading
its countless snapping jaws and crushing each
of the treacherous viper heads. At last Hercu-
les swung his powerful club and crushed the
last of the hydra's heads, and, with a crash, the
terrible dragon Ladon dropped to the ground,
thrashed in its death throes and lay still. Tri-
umphant, Hercules stepped up to the ancient
apple tree and plucked a golden apple from the
branches.

The three sisters had awoken by the
clamor of Hercules's battle with the dragon,
but arrived at the tree too late. Hercules had
departed the garden of Hesperides and raced
back to King Eurystheus with the magic apple.
The sisters cried out to the gods, "Hera's apple
has been stolen!"

When Hercules arrived at the palace of
Eurystheus with the enchanted fruit, he found
the goddess Athena waiting for him. "Brave
Hercules," the goddess said, "your quest has
been valiant, but it is forbidden for any man
to eat the fruit from the magical tree of Hera."
Athena took the apple and returned to the
island of Hesperides. King Eurystheus laughed
at Hercules. "You still owe me one more labor."

DEMONSTRATION
LADON

STAGE ONE: RESEARCH AND CONCEPT DESIGN

The adventures of Hercules are some of the oldest and most beloved legends of all time. Over time, the labors of Hercules became so popular that both Greek and Roman poets and writers created stories, songs and plays about the great hero. These days, we even have movies.

Upon reading the description of Ladon, we know that right away it's a hydra. Referencing the chapter on hydras in *Dracopedia* (pages 114–115), I learn that it's, more specifically, a Lernaen hydra (*Hydra lernaeus*). The Lernaen hydra commonly lives in trees, which fits the description of Ladon living around the golden apple tree. While working on the concept, I added a few qualities of the Medusan Hydra (*Hydra medusus*) as well.

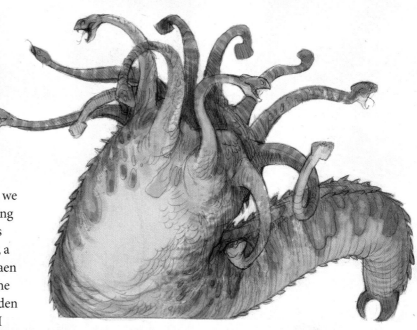

Medusan Hydra
Hydra medusus, 10' (3m)
Known to bury itself in tidal swamps or sand, the Medusan hydra captures its prey by surprise using its multiple heads to drag food into its central mouth.

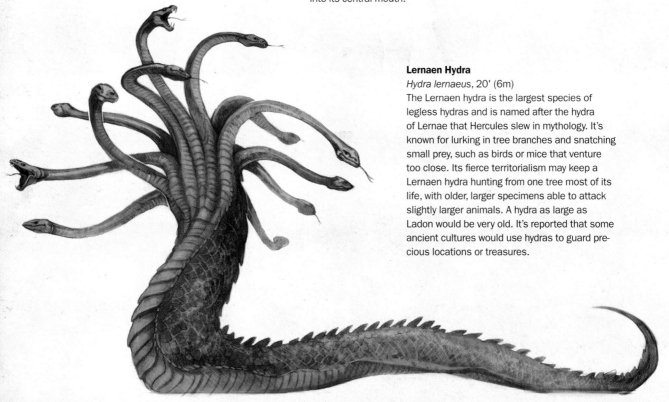

Lernaen Hydra
Hydra lernaeus, 20' (6m)
The Lernaen hydra is the largest species of legless hydras and is named after the hydra of Lernae that Hercules slew in mythology. It's known for lurking in tree branches and snatching small prey, such as birds or mice that venture too close. Its fierce territorialism may keep a Lernaen hydra hunting from one tree most of its life, with older, larger specimens able to attack slightly larger animals. A hydra as large as Ladon would be very old. It's reported that some ancient cultures would use hydras to guard precious locations or treasures.

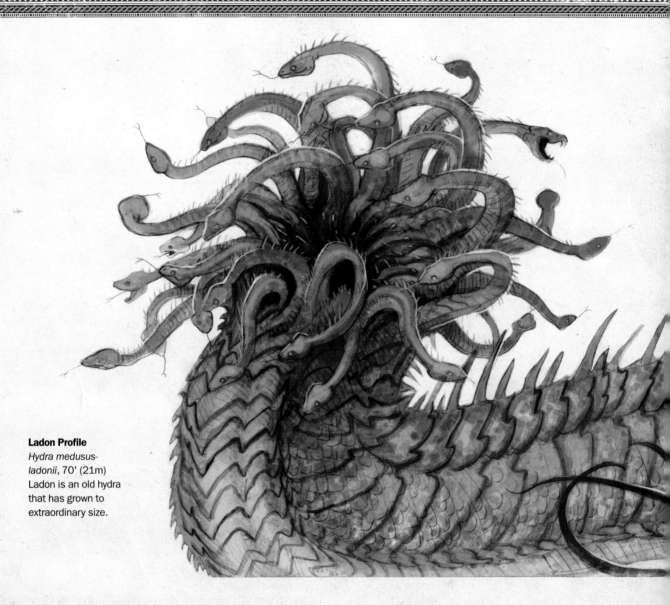

Ladon Profile

Hydra medusus-ladonii, 70' (21m) Ladon is an old hydra that has grown to extraordinary size.

STAGE TWO: THUMBNAILS

Refine Ideas

Using the concept sketches and the text as guides, I developed quick design concepts in my sketchbook. Where the first design shows the size of Ladon, I felt the image lacked the action of the story. In the second version, I created a swirling whirlpool of Ladon's one hundred heads, adding motion to the composition.

**Lernaean Hydra,
circa 3rd century**
Classical depiction
of the hydra from a
Grecian urn.

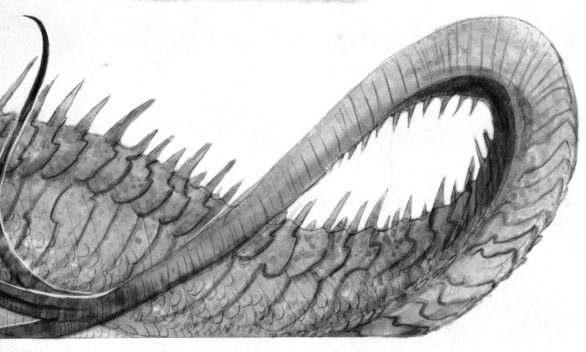

STAGE THREE: DRAWING

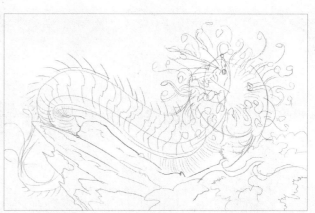

Develop the Drawing
Using basic forms and thumbnails as a guide, begin the full-sized
drawing with quick, simple shapes. This allows easy adjustments to
be made as you work.

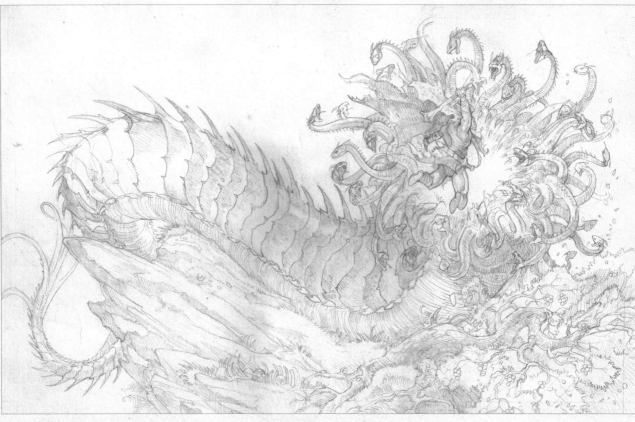

Ladon Finished Drawing
Based on my thumbnail sketches and references, I work up a completed drawing that includes all the necessary details and textures.

Pencil on paper
13" × 22" (33cm × 56cm)

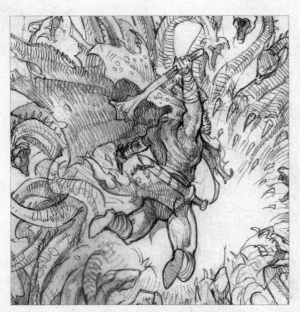

Details of Ladon Finished Drawing

STAGE FOUR: PAINTING

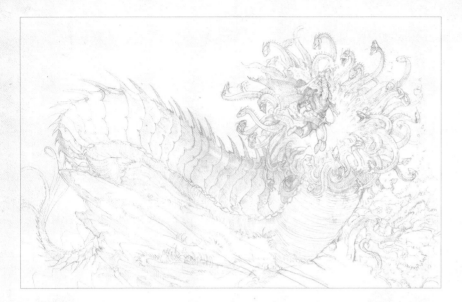

Underpainting

Bring the finished drawing into your painting software and create a new Multiply layer on top. Using a warm, monochrome tonal palette, use broad strokes to establish the light and dark forms, and the overall atmosphere.

PALETTE

Ladon Color Palette

For the Ladon painting, I chose a warm gray and orange color palette to enhance the lighting effect of the glowing golden apple tree.

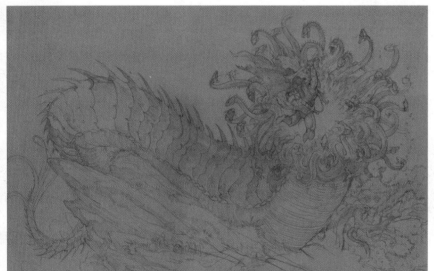

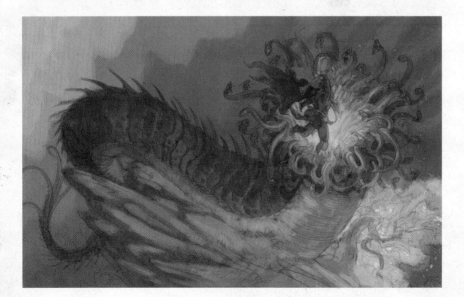

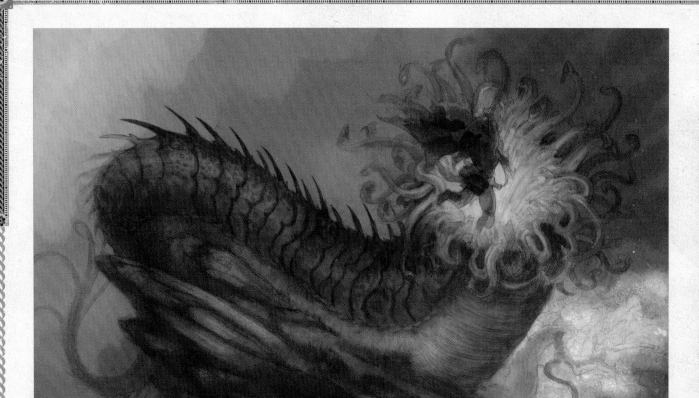

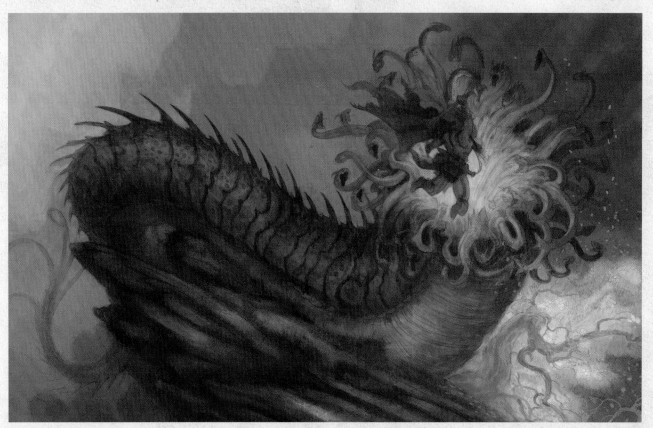

Background
A new Normal mode layer is created to add color and detail to the background.

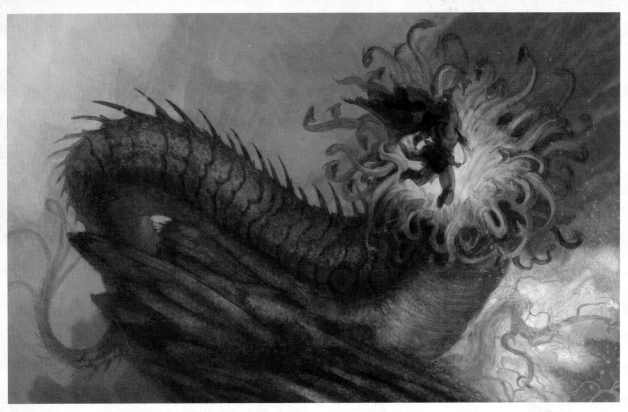

Foreground
Refining the painting with new layers in Normal mode allows me to add small details in opaque, saturated colors using detail brushes.

Finishing Details
Create the strongest contrast at the focal point to draw the eye.

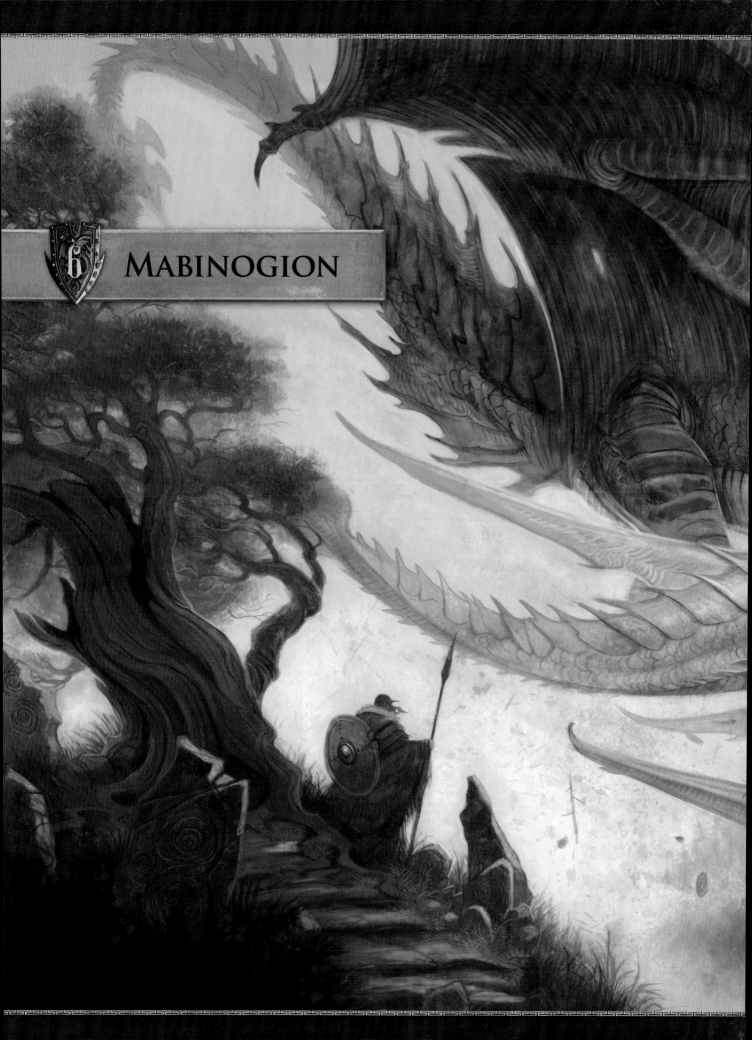

MABINOGION

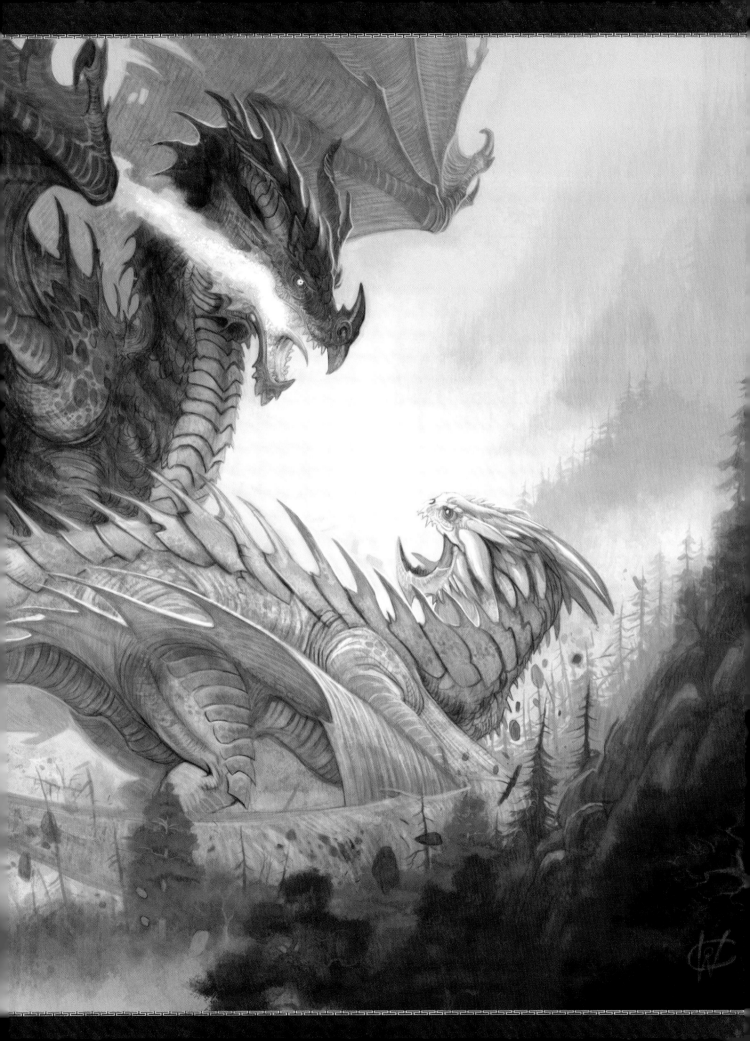

The Legend of Mabinogion

WELSH

 HE PEOPLE IN ANCIENT WALES lived during a time of great prosperity under the wise and noble King Lludd, but it came to pass that the lands of Britain and Wales were set upon by a terrible cataclysm. The earth shook with violent tremors, causing rocks and boulders to crash into homes. The air boiled with smoke, and the heat devastated the crops and livestock. Even the king's castle shook so terribly that walls crumbled. The Welsh people begged their king to save them.

King Lludd listened to their cries and ventured out into the mountains to discover the source of the tremors. In a valley at the foot of Snowdonia, he came upon two titanic dragons battling one another, one white and the other red. The mighty red dragon was the symbol and pride of Wales, but there in the valley, the red dragon was embroiled in a terrible battle with a white dragon of the north, a scourge from the icy lands over the sea. Together the two titans shrieked and bellowed, spewing gouts of flame all around them in massive swaths and tearing up the land. At night the two monsters would fall exhausted to sleep in the valley below, only to resume their combat again in the morning.

The king was dismayed by the warring of the great dragons. The fields where the people grew crops were burned by dragon fire and gouged by tearing claws. Black smoke choked the landscape.

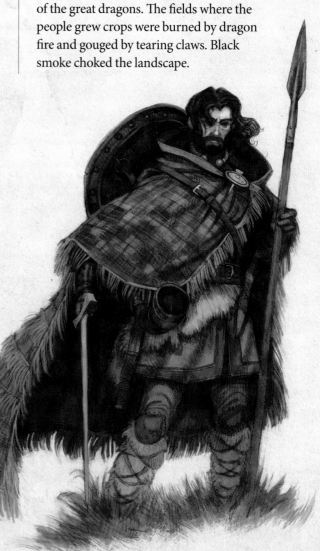

Children cried in their cribs while their parents starved, and the walls of the villages crumbled from the terrible quaking of the earth. "Great King Lludd," the people begged, "save us from the dragons!"

Lludd was a brave and noble lord. Mounting his horse and bearing his shield and spear, he rode out with his best champions to try to stop the dragons. The land all around the monsters was torn and broken, the fire and smoke from their battle made the earth quake so that no warrior could stand, and the air was so choked with sulfurous smoke that they could not breathe. Many warriors were crushed by the beasts' flailing claws and strangled by the dragons' fumes. At night, the two beasts fell exhausted into a restless sleep in the valley of the mountains allowing Lludd and his knights to escape.

Nothing the knights did could stop the beasts, so King Lludd sought out the sage counsel of the ancient wizard Merlin. Lludd traveled throughout the many kingdoms of Britain trying to find the sorcerer, but wizards who do not wish to be found are rarely discovered. At long last, deep in a cave, Lludd came upon the venerable seer.

"Merlin, I beseech you," Lludd said. "The lands are beset by a terrible war of dragons, and the people are suffering. Please tell me how to rid the kingdom of this plague."

Merlin stroked his long gray beard, and his eyes seemed to glow with mischief from under his dark hood.

"I shall tell you, great king," Merlin said in a gravely voice. "First, you must dig a great pit in the center of the valley, and then you must fill the pit with honey mead. When the dragons come next to do battle they will crawl into the pit, drink the mead and fall into a stupor and be unable to rouse themselves. Once the dragons are asleep, you must bury them deep in the earth so that their wrath should not destroy all the land."

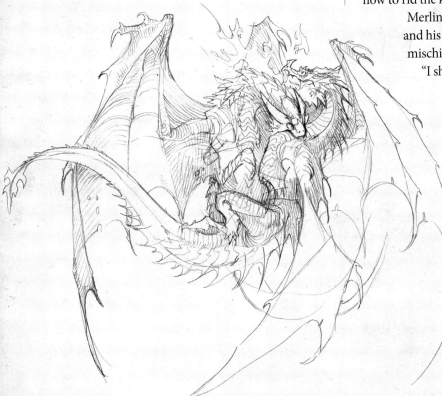

King Lludd thanked the old sage and raced back to his people. He did as the wizard instructed and gathered all his knights and soldiers to dig the pit in the valley. A thousand wagons brought kegs of honey mead from all over the kingdom to fill

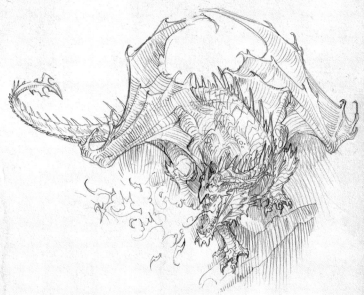

the hole so that it looked like a lake. Once again, the red and white dragons came to the valley to do battle. Before they could begin to fight, the two terrible lizards spied the pool of honey mead and went to the edge to drink. Lludd and his men watched as the dragons drank and then crawled deep into the pit to reach the last of the sweet brew. Before long, the dragons had fallen asleep at the bottom of the pit.

All together, the king and his men used shovels and spades to bury the great dragons. By morning, the pit had been filled, and the dragons' battles no longer plagued the kingdom of Wales. The king decided to commemorate the great battle by emblazoning the red dragon on his coat of arms; today that same dragon embellishes every flag of Wales. As the years passed, the people were no longer troubled by dragons, although smoke can sometimes be seen issuing from the earth where the dragons lie buried.

DEMONSTRATION
MABINOGION

STAGE ONE: RESEARCH AND CONCEPT DESIGN

In Wales, the great red dragon is a symbol of pride. Emblazoned on the national flag, the dragon banner of Wales waves in the breeze and is stamped on almost every building. Some legends say that the dragon banner traces its creation to King Arthur Pendragon himself. Wales is dragon country!

The story of King Lludd and the dragons comes from the 12th century medieval Welsh text known as *The Mabinogion*, which was originally a collection of stories passed down through the oral tradition in *The Tales of the Mabinogi*. The dragons in the story are described in detail in *Dracopedia: The Great Dragons* under the Great Welsh Red Dragon (*Dracorexus idraigoxus*, pages 60–75) and the white dragon (*Dracorexus reykjavikus*, pages 28–43). The Great Icelandic White Dragon is native to Iceland, while the

red dragon is native to Wales and the Northern British Isles. Both are extremely territorial, and it has been documented how the territories of these two dragons would often come into conflict resulting in horrible battles. Additionally, these battles metaphorically represented the threat of Viking raids from the north that often invaded Wales during the time of the original tellings of the Mabinogion myths.

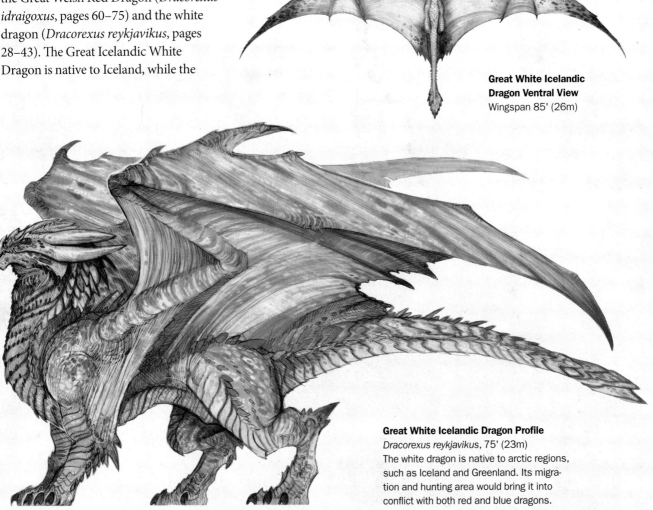

Great White Icelandic Dragon Ventral View
Wingspan 85' (26m)

Great White Icelandic Dragon Profile
Dracorexus reykjavikus, 75' (23m)
The white dragon is native to arctic regions, such as Iceland and Greenland. Its migration and hunting area would bring it into conflict with both red and blue dragons.

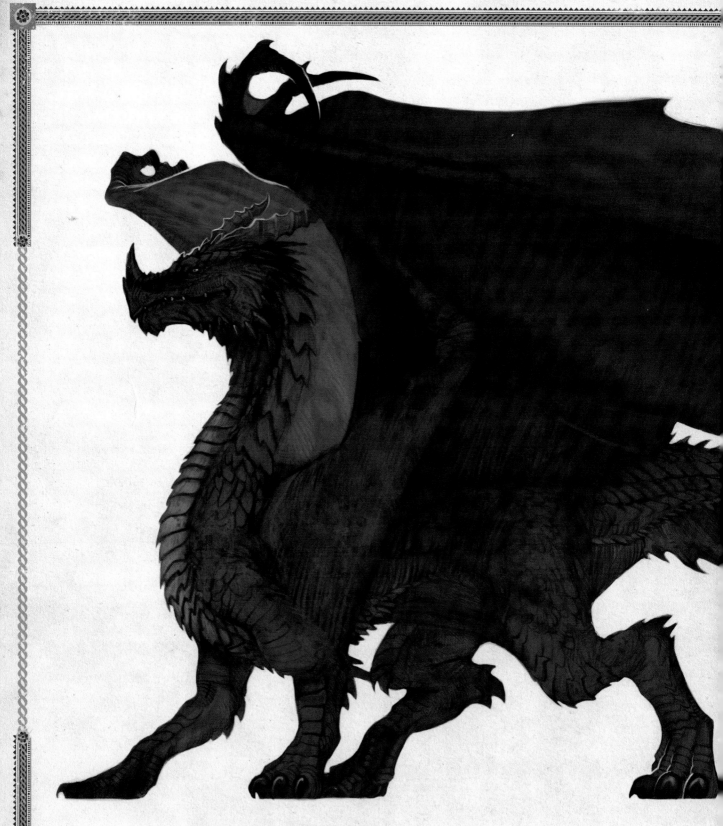

Great Welsh Red Dragon Profile
Dracorexus idraigoxus, 75' (23cm)
Commonly found in the northern British Isles, the
red dragon or Welsh dragon is the national animal of
Wales, made famous by the story of the Mabinogion.

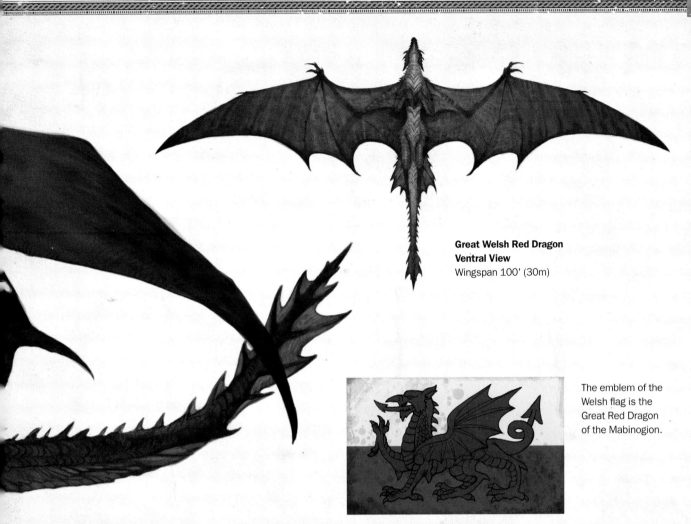

Great Welsh Red Dragon
Ventral View
Wingspan 100' (30m)

The emblem of the Welsh flag is the Great Red Dragon of the Mabinogion.

STAGE TWO: THUMBNAILS

Refine Ideas
While creating my thumbnails, I envisioned two dragons locked in mortal combat using the Celtic knotwork image (on page 95) as a starting point. I then used the golden spiral to guide the action.

Spiral Composition
This graphic demonstrates the compositional design known as a golden spiral. The spiral is found in the spiral of nautilus shells, pinecones and galaxies. It has been used by artists to design paintings and architecture since Ancient Greece.

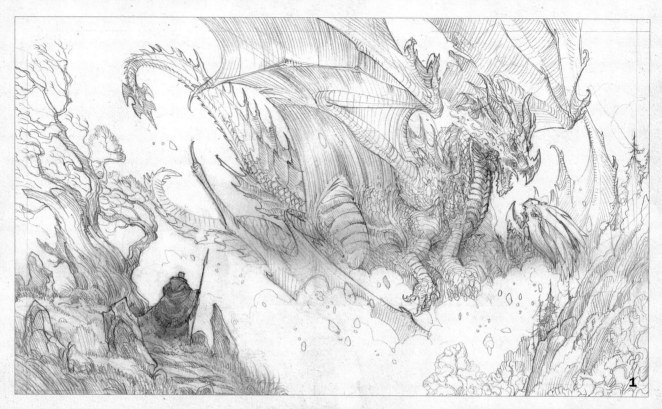

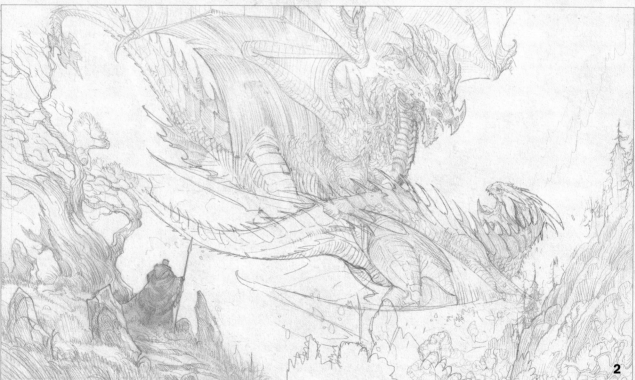

Develop the Drawing

After completing the thumbnails and creating the final image (image 1), I decided the action did not re-create the interlocked Celtic knotwork design as much as I would like. I decided to draw the second image (image 2) to better illustrate the conflict between the dragons.

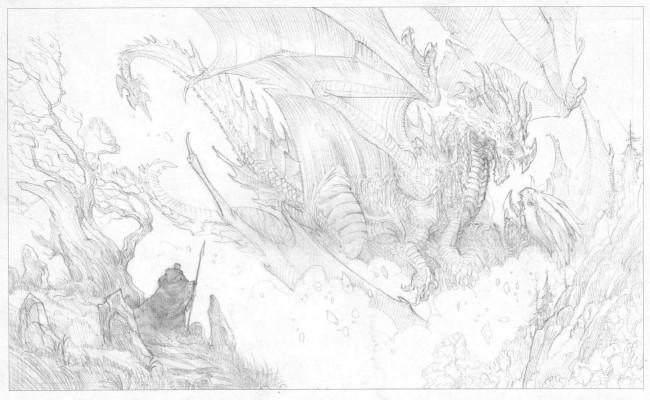

Mabinogion Finished Drawing
Once I settled on a design for the finished drawing, I created a fully
rendered pencil drawing with all the necessary conceptual details.

Pencil on paper
13" × 22" (33cm × 56cm)

Details of Mabinogion Finished Drawing

STAGE FOUR: PAINTING

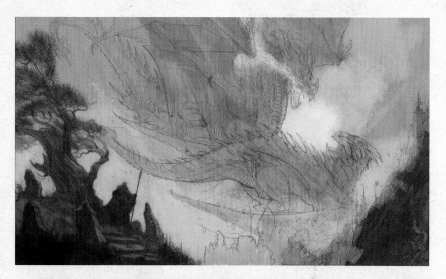

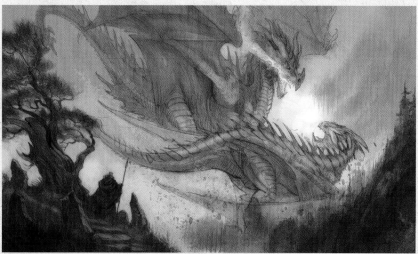

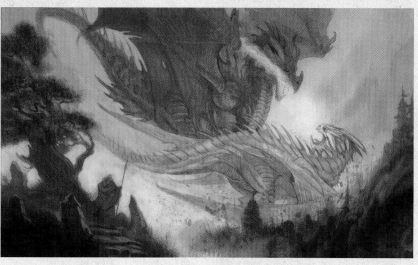

Underpainting
Open the drawing with your painting and create a new Multiply layer. Using textured brushes, lay in broad shapes of shades and lighting. Render the background using low contrast, light values and tonal color.

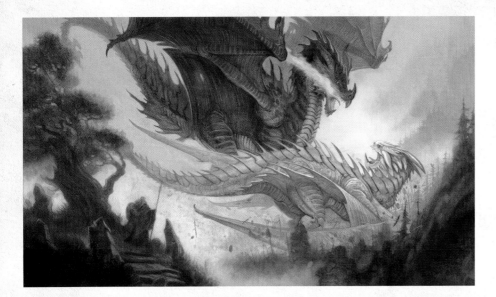

Middle Ground

Using more saturated colors and smaller, more opaque brushes, work on the dragons in the middle ground. These dragons will be the focal point of the painting and should represent the highest levels of color, contrast and detail. Adding splatter detail to the dragon fight creates texture and motion in the design.

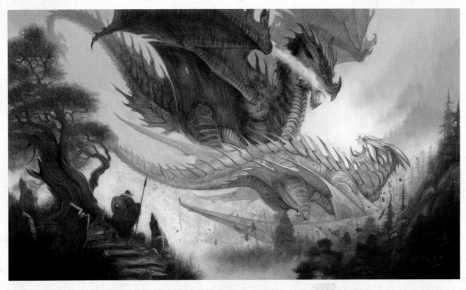

Foreground

I rendered the grass, stones, figures and leaves of the foreground in a new Normal mode layer. These details are low contrast with dark tones opposite to the background. This anchors the composition and creates a framing device in the foreground that leads the viewer into the painting. The figure establishes scale.

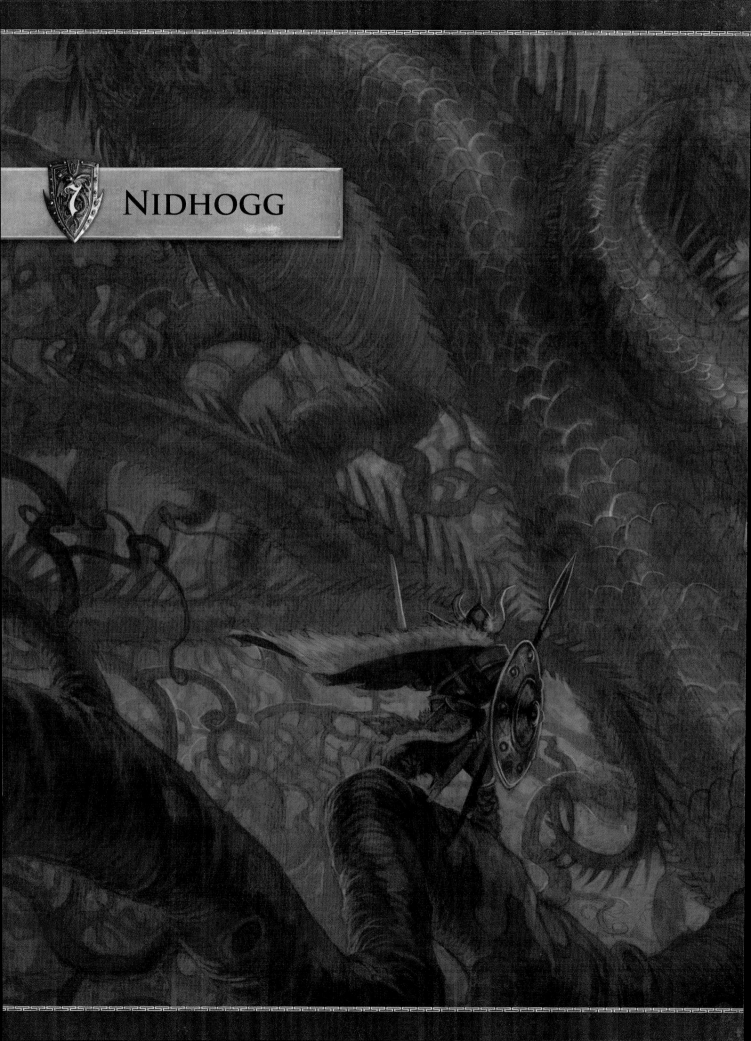

NIDHOGG

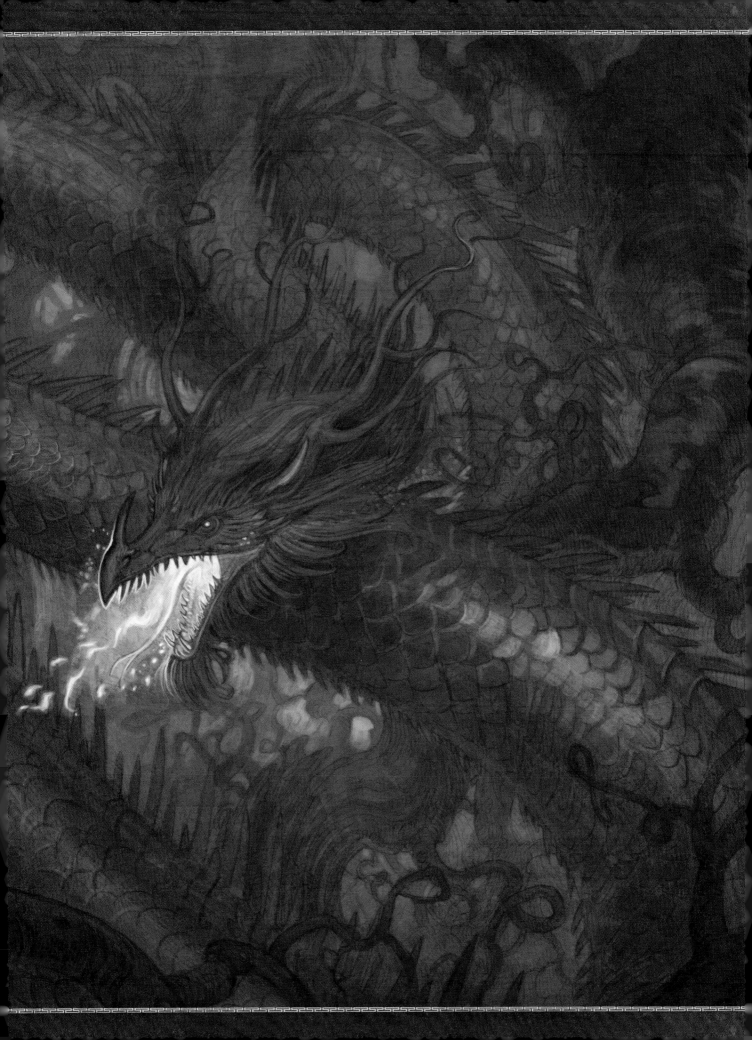

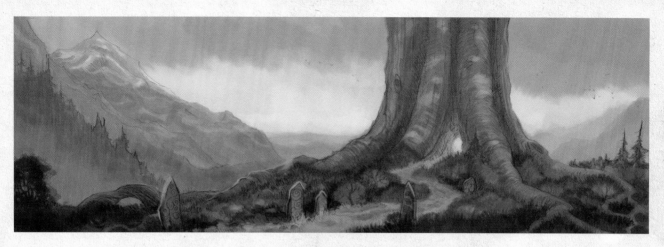

The Legend of Nidhogg

NORSE

 ANY AGES AGO, in the lands of Scandinavia, there lived a fisherman named Gunnar. Gunnar worked hard tending to his nets, making offerings to the gods, being a proud father to his children and a loving husband to his beautiful wife, Astrid. Gunnar and Astrid were happy living in the blessings of the gods.

It came to pass that Astrid fell ill. Doctors and priests from the village came to visit her, offering medicines and prayers, but Astrid grew weaker every day.

"My wife, my love," Gunnar cried at her bedside. "Please do not leave me. I will not be able to live without you."

"Do not cry, my husband," Astrid croaked. "Be strong for our children, and remember that one day we will be reunited in Valhalla, where we will live in the eternal life of the gods together."

Gunnar was soothed by her words, and quietly, Astrid closed her eyes and did not wake again.

Everyone from the village gathered for Astrid's funeral along the banks of the fjord, where she was laid in a barrow and honored with offerings of jewelry and jugs of mead.

Seven days later, the village held a great feast to celebrate Astrid's life and her arrival in Valhalla. Songs were sung and stories were told as the ceremonial mead horn was passed.

All at once, the door to the great hall opened, and the old village priest staggered in. "Wait!" he croaked to Gunnar. "I bear terrible news. I have been praying these past seven days for the spirit of Astrid, guiding her soul to Valhalla. Evil spirits have led her astray, and, instead, Astrid's soul has been taken below to the underworld, in Hel!"

The great hall fell silent at the priest's pronouncement. Hel was a realm of torment, where the souls of the wicked were sent to be punished. How could this happen to Astrid, an honored and loyal mother and wife, loyal friend to everyone in the village?

"We will all make offerings to the gods," the priest explained. "We will all pray for the gods to intercede and rescue Astrid's spirit from Hel and bring her to her rightful place in Valhalla."

Gunnar stood before the gathered village in the hall. "I will go to Asgard myself," he declared, "and bring my beloved Astrid to her rightful resting place. But I do not know the way."

The old priest explained to Gunnar that he would need to travel to the great ash tree Yggdrasil, whose branches grew up to the heavens, and whose roots grew down into Hel. There he would need to descend the roots, find the spirit of Astrid and rescue her from the clutches of the dragon Nidhogg, who ensnared all souls in the underworld.

Gunnar gathered his shield and armor, girded on his sword and helmet and set out at once for the Yggdrasil tree. Traveling for many days, Gunnar at last arrived at the tree. The great trunk of the mighty ash was as big as a mountain, and its branches spread high into the sky and disappeared into the heavens. Birds flew in flocks about its branches and nestled in its boughs, which hung heavy with ivy and mistletoe. Around the great trunk, herds of deer and warrens of rabbits darted among its buttressing roots.

Approaching the tree, Gunnar could see a knotted whorl in the roots that opened to its interior and smoldered with a sulfurous fume. "This must be the entrance to Hel," Gunnar thought. Fear halted him, but his love for Astrid forced him to continue. Crossing the threshold of the gate, Gunnar descended into the dark and coiling roots below the tree. As he climbed lower, he found serpents wrapping themselves around the branches and gnawing at its roots. Everywhere Gunnar looked, the figures of lost souls lay entwined in the ropy tendrils. He looked at every pleading face in search of Astrid, but he could not find her. The roots clutched and snagged at Gunnar's legs and arms like vines, but he fought these off with slashes of his sword. The serpents that lived in the roots snapped at him with their fangs, but he batted them away with his shield and skewered many with his spear. Onward he went, going deeper and deeper into the

roots of Yggdrasil until at last
he came to a vast chamber that
opened in the clutching roots. There, coiled
in the spiraled branches, was an immense
serpent whose eyes and jaws glowed like a
furnace. Gunnar could see Astrid trapped in
the tangles.

He raced to his wife and began to hack at
the ensnaring branches. The great serpent
Nidhogg saw what the man was doing and
attacked. Gunnar leapt away from the dragon's
snapping jaws and pulled Astrid free from
the roots. Enraged, Nidhogg struck again, but
Gunnar was able to escape with Astrid over his
shoulder. Nidhogg's serpent minions chased
the pair up the roots of the great tree, and
Gunnar slashed at them with his sword until,
at last, he could see daylight at the entrance.

Bursting into the daylight, Gunnar
breathed the fresh air under the boughs of
Yggdrasil, and sprawled in the grass holding
Astrid. Gunnar gazed at his wife, joyous to be
able to hold her and see her face again. "My
beloved Astrid, you are home again, and I will
never let you go."

"Husband," Astrid whispered, "this
place is no longer my home. I cannot stay here
with you." Her eyes wandered up the high
branches of Yggdrasil to the heavens beyond.

Gunnar followed her gaze and knew that
she was right. "I cannot follow you, my love,"
he said sadly.

"Yes, I must go alone," Astrid said. "You
must stay here and raise our children and
defend our village. In time, after a good long
life, you will join me, and we will be together
forever in Valhalla."

With that, Astrid rose and kissed Gunnar,
then she began to ascend the great tree,
climbing into its branches. She turned to
wave one last time before she slipped into the
clouds above.

Gunnar waited for a long time at the base of
the tree, gazing at the heavens above. At long
last, as the sun began to set over the fjords, he
turned and headed home where his village and
his children were waiting.

DEMONSTRATION
NIDHOGG

STAGE ONE: RESEARCH AND CONCEPT DESIGN

When traveling through Iceland and Scandinavia, it's enjoyable to hear the stories of the Vikings. These stories of gods and giants and other monsters mentioned in the *Poetic Edda* are as fascinating today as they must have been generations ago. The dragon Nidhogg, in the tale of Gunnar and Astrid, is a giant serpent that entwines itself around the roots of the great world tree, Yggdrasil. After researching the various dragon species in *Dracopedia*, it

is apparant that Nidhogg is a member of the wyrm family *Draco ouroboridae* (pages 136–145). Both the physical description of Nidhogg and its behavior—living in the roots of an ancient tree—match ancient descriptions of Celtic folklore. My design begins with a wyrm but expands the concept by adding great horns that grow like branches to blend into the curling roots and branches of Yggdrasil.

Knotwork Origins
The coiling and interlacing forms of vines and serpents are thought by some archeologists to have inspired Celtic knotwork as well as the design of the ouroboros eating its own tail. The latter symbolizes eternity and lends the family of wyrms the name *ouroboridae*.

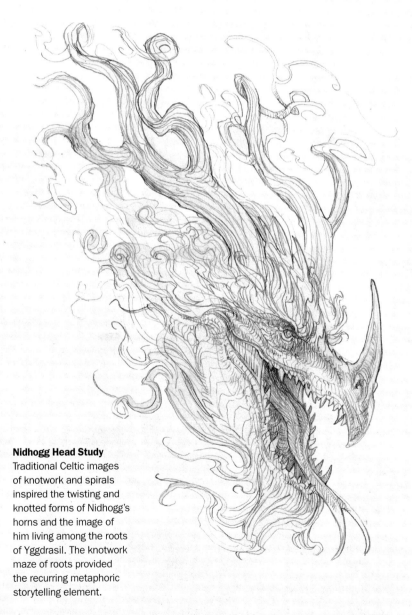

Nidhogg Head Study
Traditional Celtic images of knotwork and spirals inspired the twisting and knotted forms of Nidhogg's horns and the image of him living among the roots of Yggdrasil. The knotwork maze of roots provided the recurring metaphoric storytelling element.

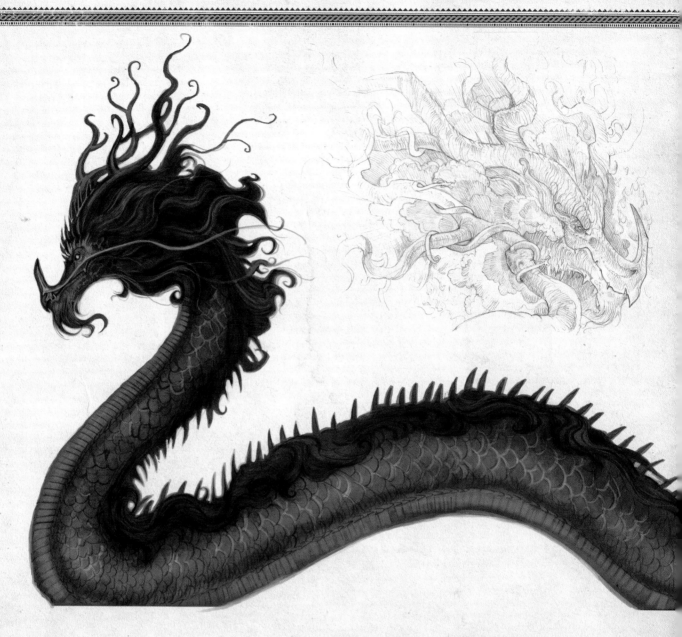

Nidhogg Profile

Ouroborudus yggdrasilus, 500' (152m)
A titanic specimen, Nidhogg possesses the characteristic behavior of many wyrms, coiling deep in the roots of a large tree and feeding upon the animals that wander into its lair.

STAGE TWO: THUMBNAILS

Refine Ideas

Working with pencil and paper, I designed a sketch that embodies all the coils of vines and serpent, and that develops the character of the Viking hero.

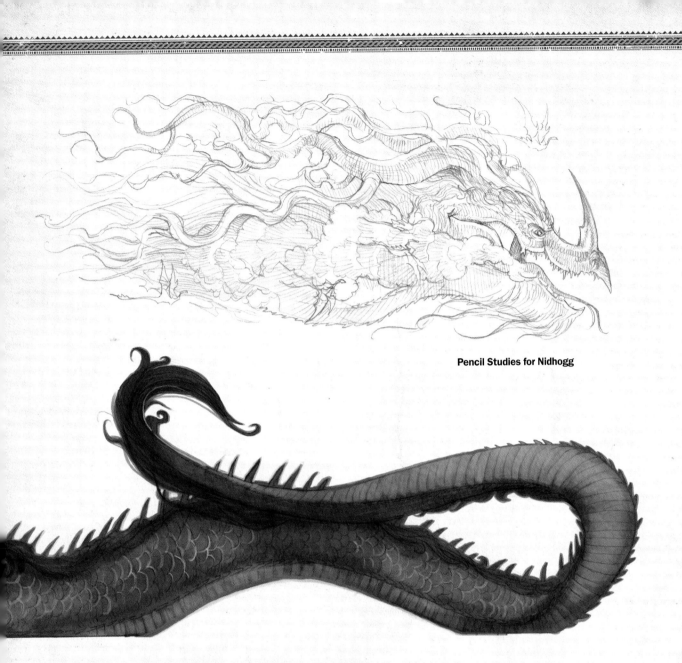

Pencil Studies for Nidhogg

STAGE THREE: DRAWING

Develop the Drawing

Simple curved lines establish the coils of Nidhogg and the twisting branches. Create them quickly without any details at first, then build on the framework.

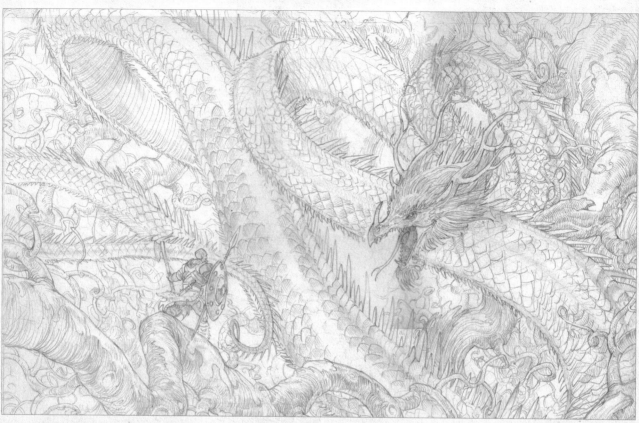

Nidhogg Finished Drawing
Using my references, concept sketches and illustrations, I develop a large final drawing that gives life to the heroic action of the story.

Pencil on paper
13" × 22" (33cm × 56cm)

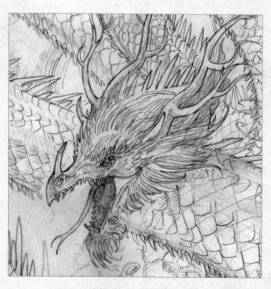

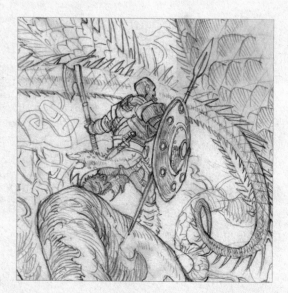

Details of Nidhogg Finished Drawing

STAGE FOUR: PAINTING

Underpainting
Bring the drawing into your painting software and, beginning with an earth tone palette, lay in broad shapes and forms to establish the dark, gloomy light of the underworld. This image should be very dark with the strongest light source being the fiery glow from Nidhogg's mouth.

PALETTE

Nidhogg Color Palette
I chose a warm-toned palette to give the painting an earthy feeling.

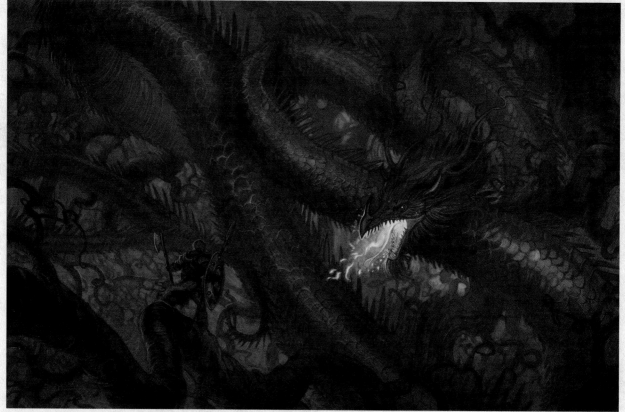

Middle Ground
Use subtle cool gray tones to paint the negative spaces between the branches, but keep the painting dark to simulate the interior of the Earth.

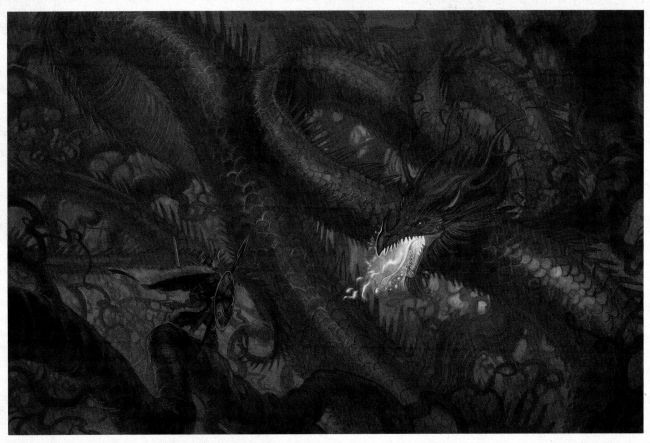

Foreground

This painting is quite minimal and, in the end, the underpainting becomes the finished painting with minor details added to the scales.

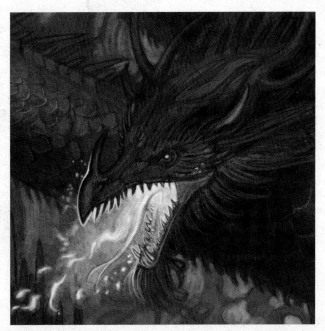

Details of Nidhogg Finished Painting

The foreground figure of Gunnar is detailed with small, cool accent colors. The fiery hot mouth and eye of Nidhogg is achieved with the Color Dodge tool.

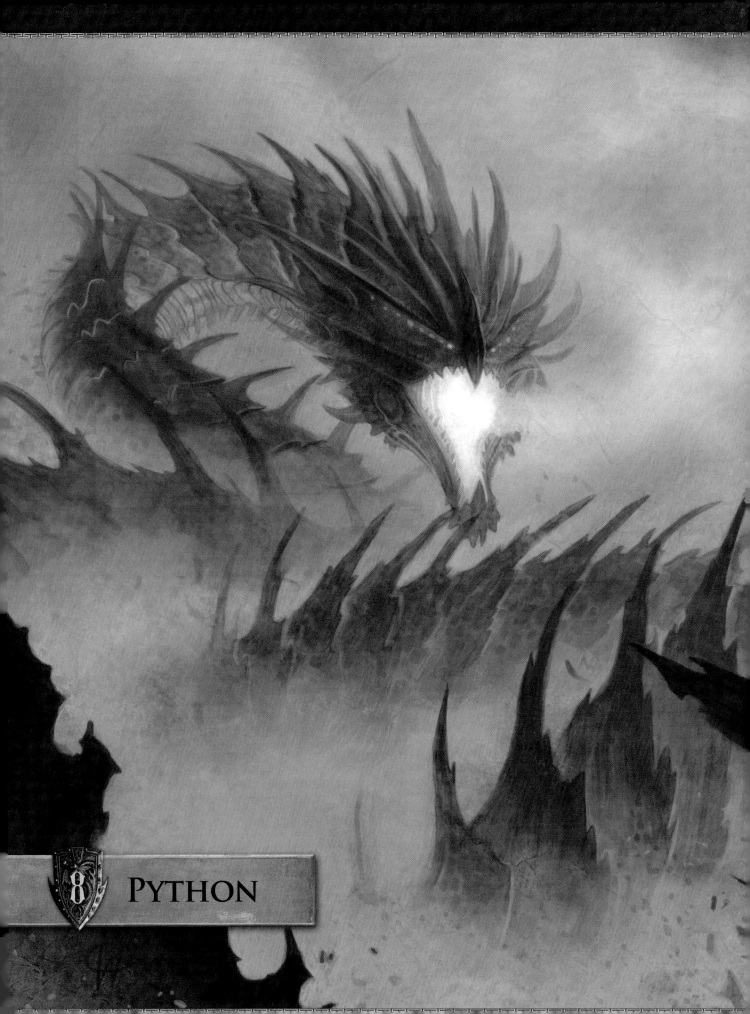

8 PYTHON

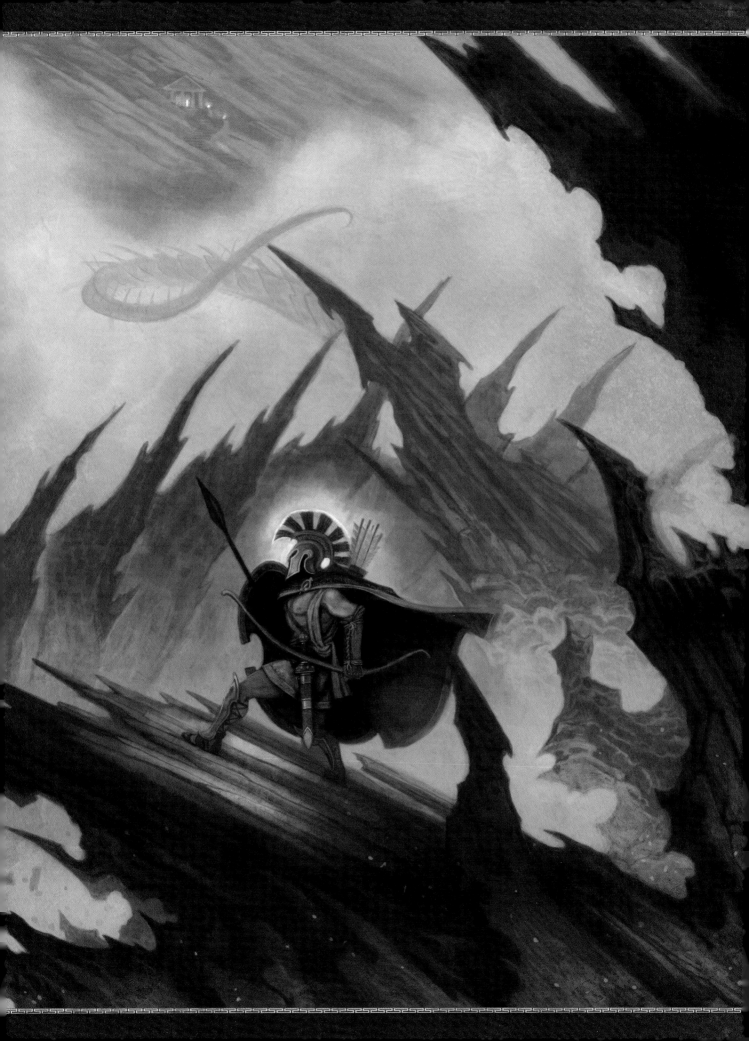

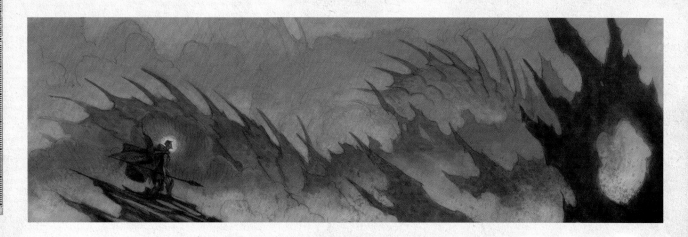

The Legend of Python

GREEK

 ERA, THE QUEEN OF THE GODS, was terribly jealous. King Zeus was an unfaithful husband, romancing the young and beautiful goddess Leta. Before long, Leta became pregnant with Zeus's child and was ready to give birth. This enraged Hera, who did not want to share her family with another woman. She was afraid of the threat the child might become, so she harassed Leta and brought forth the serpent Python, a monstrous and terrible wyrm that presided over Mount Parnassus, the home of the temple of the Oracle of Delphi. Python was a creature of destruction and poison that breathed clouds of foul, sulfurous smoke that choked all life. Fearing for her child, Leta traveled far from her home to give birth and raise her child.

Leta gave birth to twins, Artemis and Apollo. The young god Apollo was a handsome boy like his mother and powerful like his father. Growing up in exile, Apollo vowed to return to the world, but the desolation wrought by Python made the land uninhabitable. Apollo decided he would need to slay the dragon and rid the world of its wasteland.

Knowing that Python was created by Hera, Apollo understood that only the most powerful of weapons could slay him. The young god knew of only one god talented enough to create such a weapon. Apollo

traveled deep into the underworld in search of his half-brother, Hephaestus, who had been thrown out of the palace of heavens by his mother, Hera, because of his birth deformities. Apollo found Hephaestus toiling at his forge and anvil, and Apollo described what he intended to do. Any plan to undo the designs of his mother was to Hephaestus's liking, so the two brothers schemed over their mutual hatred of Queen Hera. Hephaestus agreed to make a powerful silver bow with golden arrows for Apollo.

"Seek out the oracle who lives in a cave on the slopes of Mount Parnassus in the shadow

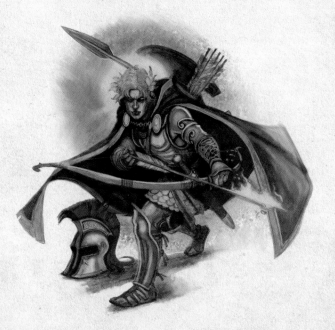

of Python," Hephaestus explained. "She will be able to help you in slaying the monster."

When it was completed, the beautiful bow and arrows gleamed in the firelight of the forge. Apollo armored himself in a breastplate and shield given to him by his brother and set out to slay Python.

The wasteland of Python was a barren expanse of jagged rocks and stinking smoke where no living thing could thrive. Not a tree or a bird lived in that valley of death. Apollo crept warily to the cave on the slopes of Mount Parnassus, where the oracle made her home, careful not to rouse the great serpent. Inside the smoke-filled temple, Apollo found the oracle sitting on her throne.

"Son of Zeus," the oracle spoke without opening her eyes. "You have come to free this land from the curse of Python."

"I have," said Apollo, "but I do not know how to slay the dragon of Hera."

"Python is a powerful creature, given life by Hera, the queen of gods herself, in order to plague this land so that Leta and her children would have no place to rest," the oracle explained. "To fell the beast, you must pierce one of its eyes with your golden arrow. Only this will destroy Python's dominion over the land."

Apollo was wary but steeled himself for the task by thinking of his beloved

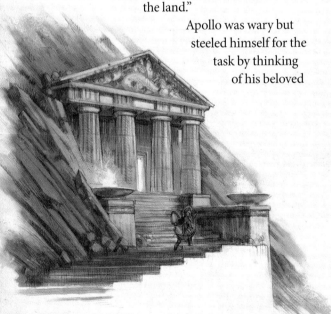

mother and his contempt for Hera. He crept from the cave of the oracle in search of the dragon. He climbed across the jagged rocks where the serpent dwelled and called the creature out. "Great and terrible Python, thrall of Hera, come out and meet your doom at the hands of Apollo, son of Zeus!" Apollo shouted.

The ground shook with the coming of Python. The giant serpent filled the landscape, and its mighty jaws boiled with fire like the volcanoes of Thera. The glowing embers of its many eyes lit the smoky darkness of the land. The coils of Python wracked the ground like an earthquake. Apollo struggled to keep his footing as the very rocks of the earth split open under the terrible serpent's armored scales.

Apollo drew forth the bow and arrow of Hephaestus and aimed unerringly at the eyes of Python as the oracle had instructed him. Before he could release the arrow, another tremor cracked a fissure open at Apollo's feet. He leapt just as the ground beneath his feet fell away, but he landed hard on the rocky ground, spilling the arrows from his pouch. Python's thundering steps pounded closer, and Apollo looked up at Python's eyes as the beast loomed over him. Apollo snatched an arrow from the rocks and deftly notched the shaft. He drew back the powerful string and released. The loosed arrow flew true to its mark and pierced the serpent's eye. The mighty serpent thrashed and whipped its powerful body in its death throes, bellowing in screams that rent the sky like crashes of thunder, before it fell lifeless to the earth at the feet of Apollo with a tremendous crash.

With the death of the titanic monster, the smoke blew out of the valley and the sun broke through the clouds. Apollo buried the body of Python at the foot of Mount Parnassus, and the site became known as Pythia. Before long, the wasteland of the serpent was transformed into a beautiful valley and a sacred temple was erected on the site. For years to come the faithful would hold games and feasts to celebrate the victory of Apollo over Python.

DEMONSTRATION
PYTHON

STAGE ONE: RESEARCH AND CONCEPT DESIGN

The legend of Python and Apollo is one of the oldest dragon myths known to man. When traveling through the Mediterranean region in Italy and Greece, it's easy to imagine ancient poets conjuring tales of horrific dragons from the harsh volcanic landscapes.

The name of Python gives rise to thoughts of giant snakes and serpents, as is derived from the family of giant snakes *pythonidae*. For the dragon, I began with the family of dragons known as wyrms, or *Draco ouroboridae*, as

reference (*Dracopedia*, pages 136–145). Python, however, was no mere dragon. Instead, he was a force of nature, an elemental of the earth created by the gods themselves.

To relay this sense of power and scale, I gave Python an almost alien visage to indicate that he comes from a different universe. Horns, scales and eyes are all increased in number and dimension, and the serpent is infused with an inner glow of fire to embody the volcanic earth where he presides and rules.

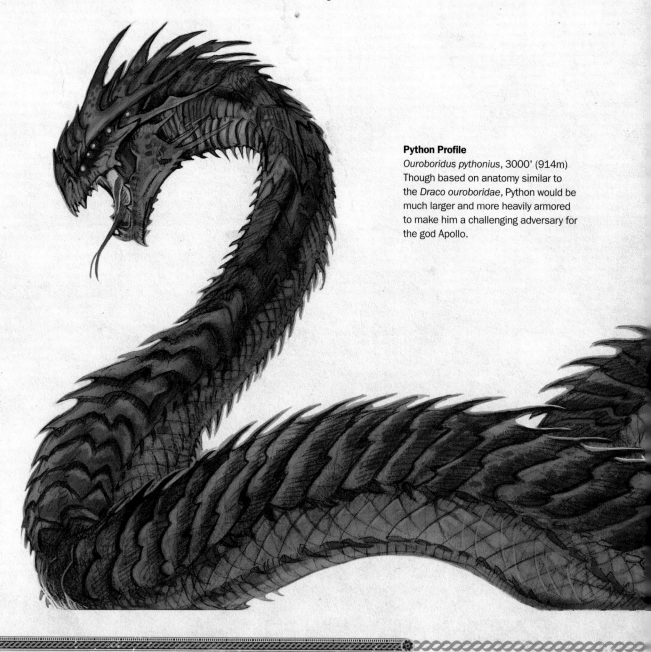

Python Profile
Ouroboridus pythonius, 3000' (914m)
Though based on anatomy similar to the *Draco ouroboridae*, Python would be much larger and more heavily armored to make him a challenging adversary for the god Apollo.

Greek Arms and Helmet Pencil Study
Using online references or visiting your local museum, practice sketching and designing arms and armor from Ancient Greece.

Greek Hoplite Soldier, circa 400 B.C.
For Apollo's design, I gathered as many historical references as I could regarding the arms and armor of a warrior from classical Greece.

STAGE TWO: THUMBNAILS

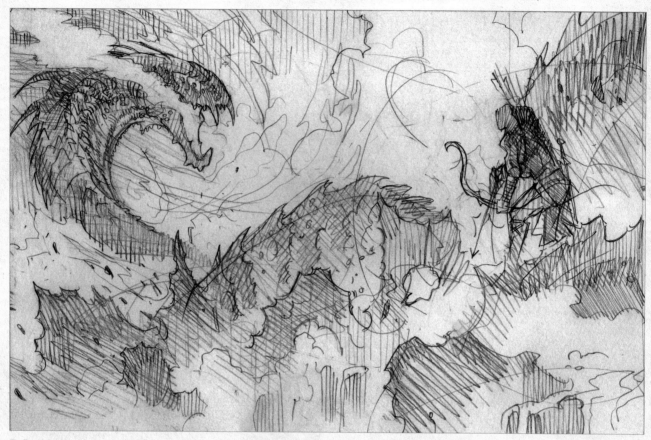

Refine Ideas
A thumbnail sketch is like a blueprint. It helps you set up the design and motion
of a piece and establish where the positive and negative forms will go.

STAGE THREE: DRAWING

Develop the Drawing
Working from the thumbnail blueprint, lightly begin by sketching the
elements of the drawing, starting with the general and moving to
the specific.

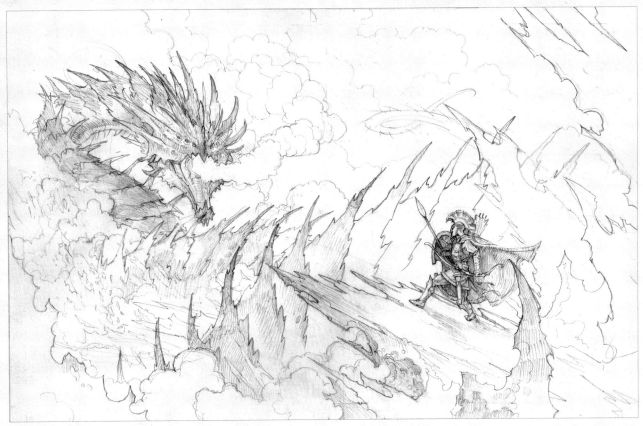

Python Finished Drawing
Pencil on paper
13" × 22" (33cm × 56cm)

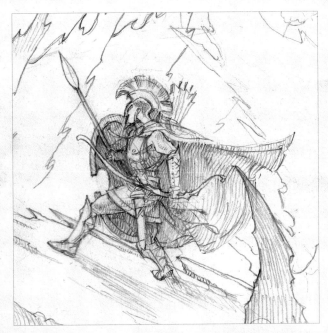

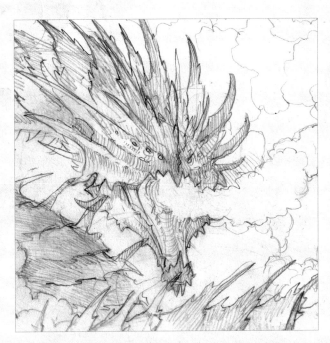

Details of Python Finished Drawing
The two focal points—Python and Apollo—are given the
most detail.

STAGE FOUR: PAINTING

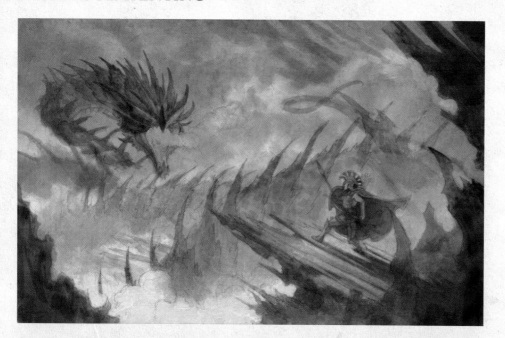

Underpainting
Bring the drawing into your painting software and create a new Multiply layer on top. Using monochromatic tonal color, lay in broad strokes of lights and darks to establish form and atmosphere.

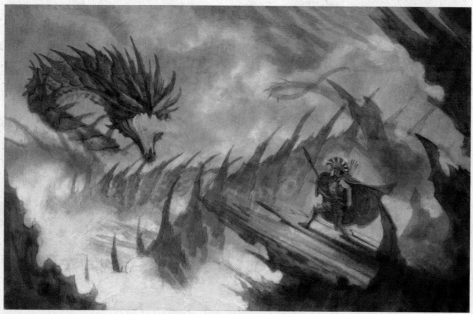

PALETTE

Python Color Palette
A palette of gray ash tones gives the environment a harsh, lifeless hue.

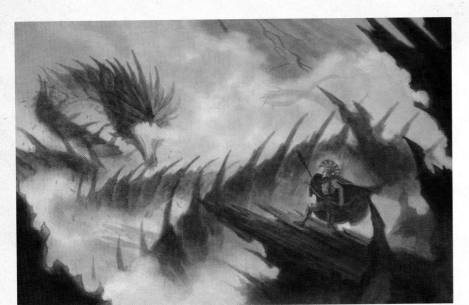

Middle Ground

On a new layer in Normal mode, begin adding color and detail to the middle ground. This is the focal point of Python. Adding bright color to his breath and scales draws the viewer's eye to the dragon.

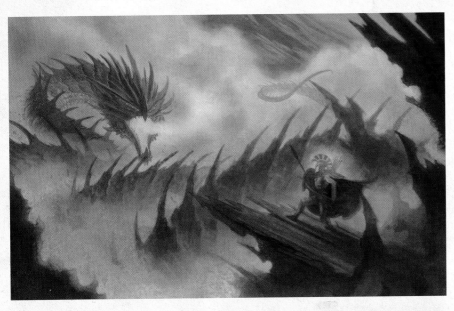

Foreground

The foreground elements of the painting establish scale and depth. The figure of Apollo has the most detail, which makes him come forward in the painting and causes the dragon to seem farther away. A bright red secondary light, emanating from an off-camera lava flow, establishes greater atmosphere and contrast against the blue palette of the painting, while also creating eerie shadows that highlight the jagged, otherworldly pumice stone of the mountainside of Parnassus. Note a tiny glow of red from the crack in the mountainside above that leads into the cave of the Oracle of Delphi. Little details like this help to add narrative to your stories.

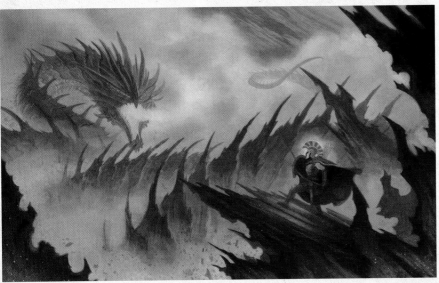

Finishing Details

The Color Dodge tool allows you to paint colors that pop brightly off the gray painting and add highlights to the three main elements of the image for visual interest.

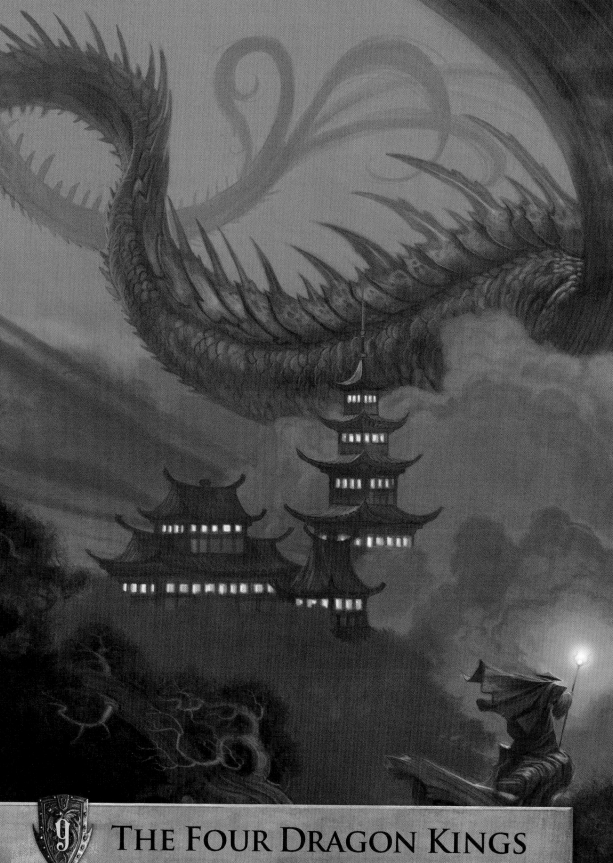

9 The Four Dragon Kings

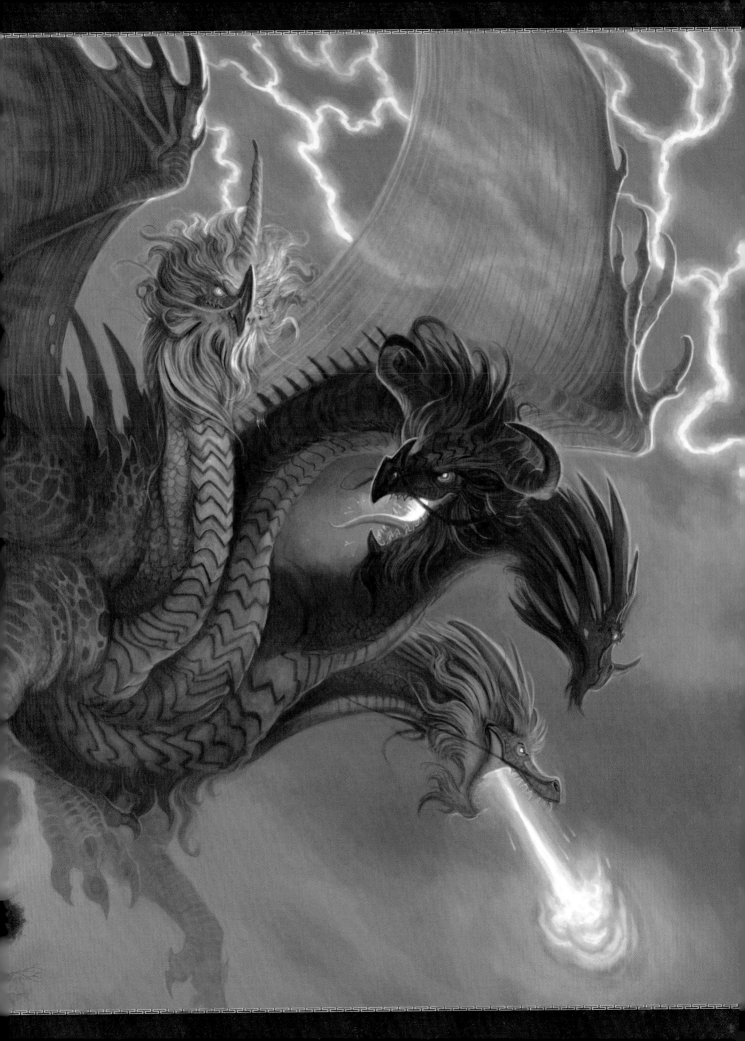

The Legend of the Four Dragon Kings

CHINESE

N ANCIENT CHINA there dwelt four brothers known as the Four Dragon Kings. Quilong the Green, who lived in his castle by the East China Sea, controlled the season of spring. Zhulong the Red, who lived in his castle by the South China Sea, was ruler of the summer. Bailong the White, who lived in his castle in the west at Quinai Lake, controlled the season of autumn. And Heilong the Black, who lived in the north at Lake Baikal, controlled the season of winter. Together, the four brothers kept peace and prosperity ruling over the many kingdoms of China, bringing rains in the spring, warm summers for the growing season, cool nights for the autumn harvest and snow in winter.

The people loved the four brothers and made offerings to them at the many temples built in their honor. In one small village lived a young girl named Lihwa who adored the Four Dragon Kings. Every sixth moon Lihwa would travel far from home to the temple of the Dragon Kings where she would burn incense, recite her vows and march in the many processions to show her love for the dragon gods. "Why do you travel so far to pray to the dragons?" Lihwa's friends teased her. "You are just one little girl. Do you think that the great and powerful dragon gods notice you and hear your offerings?"

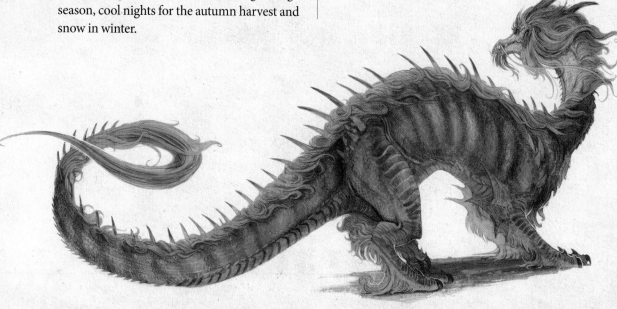

Lihwa took no notice because she knew that it was not important whether the dragon gods noticed her; it was only important that she showed them her respect, that even the smallest person could make a difference.

Not everyone loved the four brothers. An evil sorcerer named WuPeng resented the power the brothers held and was jealous of the love the people had for them. WuPeng dreamed of possessing the powers of the Four Dragon Kings and could then rule all of China himself. The sorcerer learned that there existed a powerful dragon orb that would be able to control the four brothers. So WuPeng set out on a quest to find it, and, at long last, in an ancient temple on a mountain, he found the orb set in an ornate staff.

WuPeng struck the Great Dragon Orb staff into the rock and called, "Great dragon brothers! I, WuPeng, summon you from the four corners of the world to do my bidding!"

Unable to resist the powerful lure of the orb, the four brothers were torn away from their kingdoms and brought to the mountaintop where WuPeng stood. Though their powers were mighty, the Dragon Kings were bound by the power of the orb. The dragons thrashed in torment as they struggled, but alas the terrible wizard wrestled control of the Four Dragon Kings. Anguished inside but under WuPeng's spell, the dragons followed his horrific instructions to devastate the land and bring

many kingdoms under WuPeng's rule. The people abandoned their farms and the cities to seek shelter in the mountains. The rain from Qinlong washed away the farms, the fires from Zhulong burned the trees, the icy sleet from Heilong froze the birds in the sky and Bailong breathed choking smoke that blotted out the sun. Together the four brothers terrorized the land they loved and were powerless to stop the evil sorcerer.

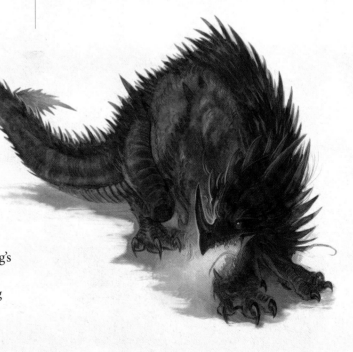

The young girl
Lihwa wished
to help the four
brothers and stayed
behind when her
parents fled the village.
"What can you do?" her
parents asked. "You are just
one little girl. You cannot make a
difference."

Undeterred, Lihwa ran through the dark
landscape to find the castle of WuPeng where
the four dragon brothers rested on the moun-
taintop. "I am here to help you," Lihwa said to
the brothers.

The Dragon Kings looked tired and
defeated. "You cannot help us, little girl. Be
gone before the wizard awakes and finds you,"
Quilong said to her.

"But there must be something I can do,"
Lihwa said.

"The Great Dragon Orb must be
destroyed," Heilong whispered. "Only that
will set us free."

In the night while WuPeng slept, Lihwa
scrambled up the mountain to the castle.
The castle was guarded by terrible demons,
but Lihwa was small and able to sneak past
them. She wandered through the halls
of the castle until she came to the hall
of WuPeng. A powerful warrior
would not have been able to break
through the iron doors, but Lihwa
was little and slipped unnoticed
through a crack in the wall.
Inside WuPeng slept on his
golden throne with the Great
Dragon Orb staff resting beside
him. Silently she crept up to the

throne, took hold of the staff and slipped it away from WuPeng's grasp.

The wizard suddenly awoke and was startled to find Lihwa holding the Great Dragon Orb in her little hands. "What are you doing, little girl?" he sneered. "Give that to me."

Lihwa lifted the orb over her head, and with all of her might smashed it at her feet. A blinding flash and crack of thunder accompanied WuPeng's shriek of horror, "No!"

Outside the castle a great roar bellowed through the air, a cry of rage from the furious Dragon Kings. At once the roof of the castle was torn off and the Dragon Kings, released from the power of the orb, turned their fury on WuPeng. He screamed as they snatched him up and swallowed him.

The four brothers were eternally grateful to Lihwa for saving them from their enslavement to WuPeng. Zhulong let Lihwa climb on his back, and the Dragon Kings flew the one who made a difference back home to her village where her parents embraced her. The Four Dragon Kings returned to their own castles where they live to this day ruling over the four corners of China and bringing prosperity and good fortune to all.

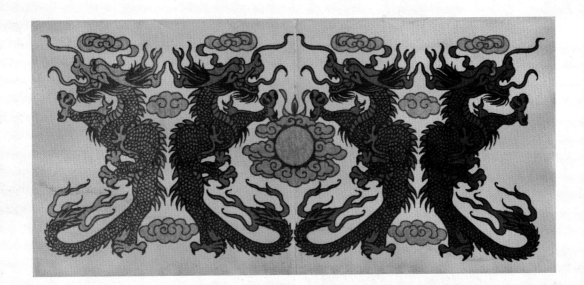

DEMONSTRATION
THE FOUR DRAGON KINGS

STAGE ONE: RESEARCH AND
CONCEPT DESIGN

During my travels to Asia, I heard many stories about dragons. Compared to Western dragons, Eastern dragons are seen as avatars of good fortune and natural power. They are often in control of storms, seas, stars and weather. People worship and respect dragons in the East.

The legend of the Four Dragon Kings represents a powerful theme in the Asian philosophy of "The Many as One." This concept is seen repeatedly in art and theology,

such as the yin and yang symbol. The four points of the compass are often embodied by the four dragons, and temples to the Four Dragon Kings can be found throughout Asia.

Among the most complicated of all the legendary dragons to depict, the Four Dragon Kings are a combination of many different dragons. As I search the pages of *Dracopedia*, I see similarities to the hydra, Arctic dragons, Asian

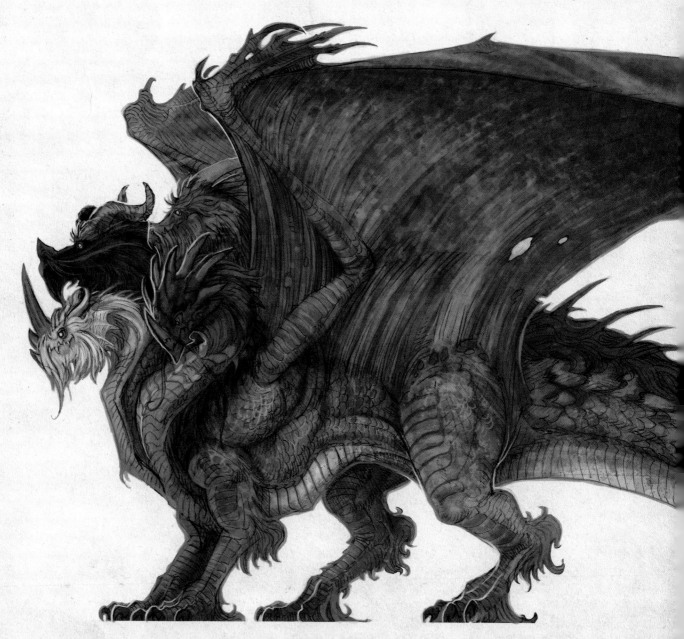

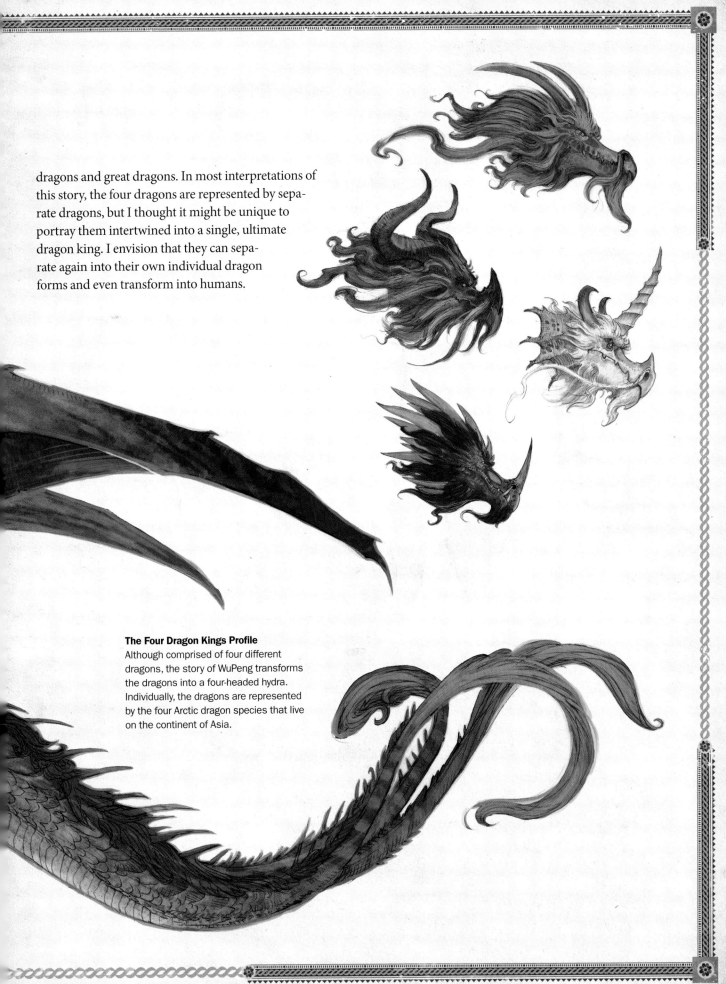

dragons and great dragons. In most interpretations of this story, the four dragons are represented by separate dragons, but I thought it might be unique to portray them intertwined into a single, ultimate dragon king. I envision that they can separate again into their own individual dragon forms and even transform into humans.

The Four Dragon Kings Profile
Although comprised of four different dragons, the story of WuPeng transforms the dragons into a four-headed hydra. Individually, the dragons are represented by the four Arctic dragon species that live on the continent of Asia.

STAGE TWO: THUMBNAILS

Refine Ideas
Before beginning the final design, sketch some small thumbnails in your sketchbook. Working small at this stage is important since the limited size makes dramatic changes easier. In this example, I originally tried to include the wizard WuPeng flying with the dragons. In the end, however, I decided to ground the story at WuPeng's castle to provide a better sense of scale.

STAGE THREE: DRAWING

Develop the Drawing
Begin with loose lines to capture the basic position and flow of the figures. Work from the general to the specific, and don't be afraid to make alterations.

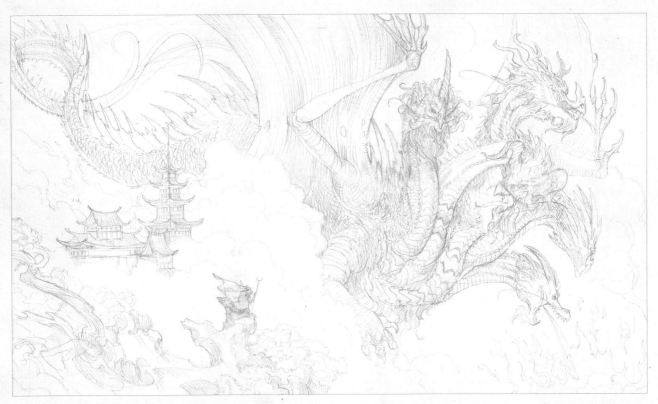

Four Dragon Kings Finished Drawing

In the original version of this drawing, I designed five dragon heads. I later removed one to better fit the story.

Pencil on paper
13" × 22" (33cm × 56cm)

Details of the Four Dragon Kings Finished Drawing

STAGE FOUR: PAINTING

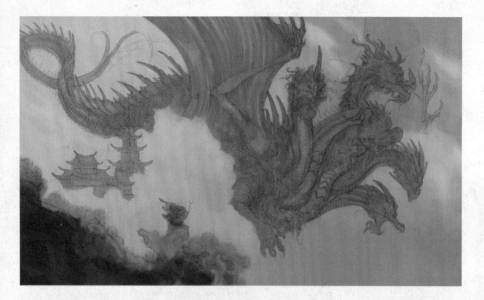

Underpainting
Place a new Multiply layer over the drawing layer and sketch in a loose underpainting to define the forms and lighting of the composition.

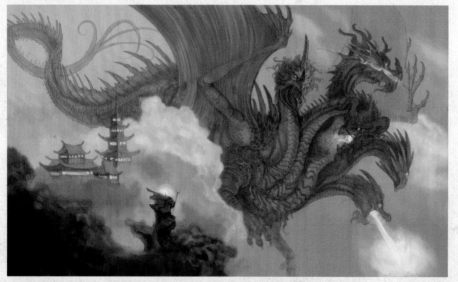

PALETTE

The Four Dragon Kings Color Palette
Working with violet allows the palette to use both warm and cool tones, and it creates an excellent counterpoint to its complement color, gold-yellow.

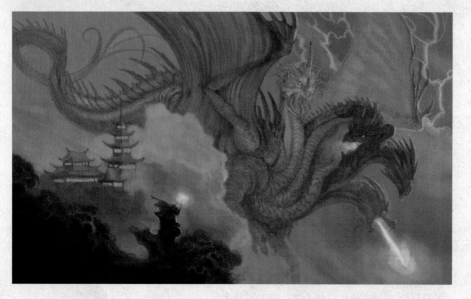

Background
Working from back to front, render the background details. Keep them low in contrast to give the feeling of distance. Here you can see where I removed the fifth dragon head to accommodate the story.

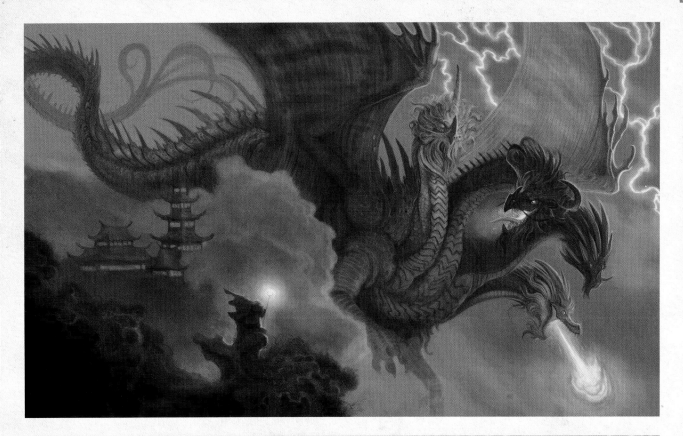

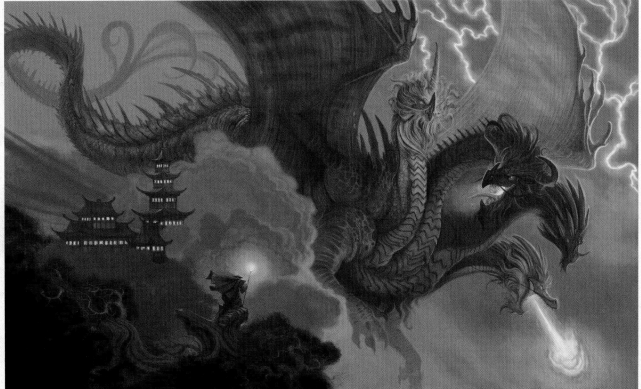

Foreground
Use smaller brushes and opaque color to add the details of each of the Four Dragon Kings. When digitally painting, lighting effects can be achieved with painting modes such as Color Dodge, as shown here to render the fire and lightning.

Finishing Details
Use detail brushes with strong light to help focus attention on the important elements of the painting.

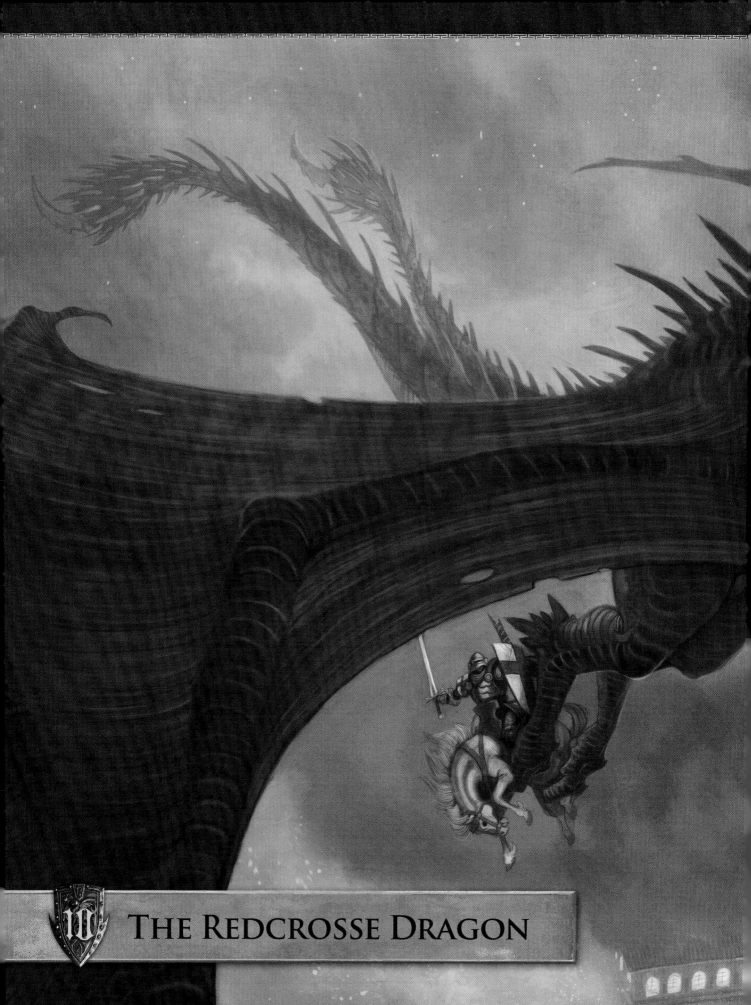

III · THE REDCROSSE DRAGON

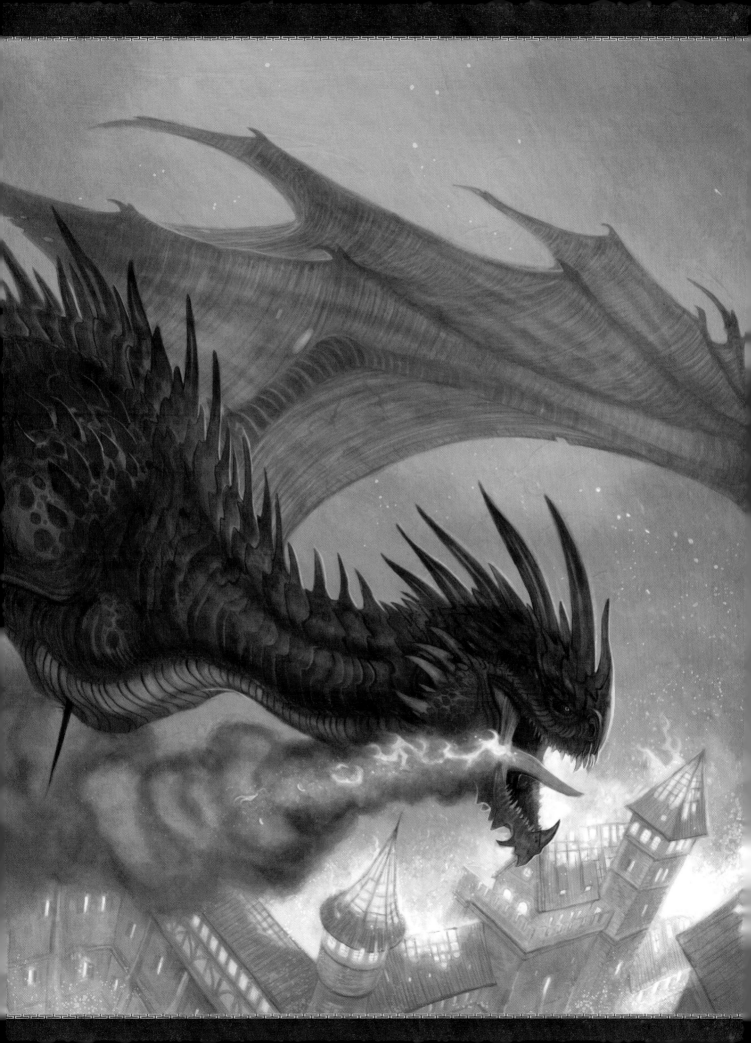

The Legend of the Redcrosse Dragon
ENGLISH

NA WAS THE PRINCESS of a faraway kingdom where a monstrous dragon rampaged through the countryside. The villagers had taken shelter inside her parents' castle while the dragon burned all the land until it was black ash. Escaping the blighted land to find help, Una traveled to the kingdom of the Fairie Queene, who charged the young Redcrosse Knight to accompany Una back to her land and slay the dragon.

Redcrosse and Una traveled for many days and nights and encountered monsters and villains along the way and, at last, arrived in the land of Una's people. As the pair crested the mountain to peer down into the valley, they found only blackened and scorched desolation caused by the dragon. The family castle still stood deep in the valley, but its stone was charred and black, the settlements and fields around them scorched and barren. Yet, the dragon itself was nowhere to be seen.

Una could see figures moving on the battlements and rushed to meet her parents, but

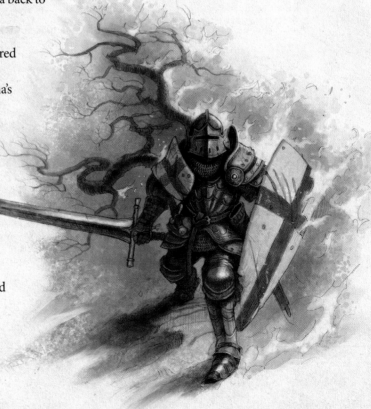

all of a sudden the ground shook and the air was filled with a terrible roar that sent their horses bucking. The knight and the princess saw the mountain ridge beyond them begin to shift, then it surged upward, lifting a smoking plume into the sky. The dragon emerged from the cloud and stretched its massive wings, which blocked out the sun. The Redcrosse

Knight told Una to flee to another mountaintop while he donned his armor and set his lance to do battle with the dragon.

The knight had never seen a beast as powerful as the dragon. It bristled with bright red scales, its wings spread so wide that they reached across the valley and flames bellowed from its jaws. Terror gripped the knight's heart, yet he spurred his horse toward the great creature. The knight and the dragon crashed together in a terrible rush, but the steel tip of the knight's lance glanced off the monster's thick, scaly hide.

Wheeling his steed to make another attack, the knight was astonished as the dragon beat its tremendous wings into a hurricane and took to the air like a great hawk, snatching the knight and his horse, and carrying them both aloft. Charger and rider fought the grasping claws of the dragon, and the weight of the heavy armor was too much for the beast. The trio came crashing back to the earth.

Crawling free from the twisted body of his noble steed, the Redcrosse Knight took up his stout lance and braced the shaft against the rocky ground as the dragon attacked with all its force. This time the lance found a crack in the fiery beast's armor, and the steel-headed lance sank into the dragon's shoulder, snapping the wooden stave and sending the knight reeling.

The dragon shrieked in fury at the wound and turned to face the young knight, who drew his sword from its scabbard and raised his shield, awaiting the onslaught. Instead of attacking, the great dragon opened its mighty jaws and spat a fiery torrent as scorching as any furnace. The knight, protected only by his armor and shield, was engulfed in the dragon fire. Writhing in the inferno, the Redcrosse Knight stumbled blindly, fell from the rocky crag and disappeared into the smoke.

The wounded dragon was unable to fly, so it limped away to nurse its wounds. All that night, Una cried for her fallen champion and dreaded the morning to come. As the sun rose above the mountain peaks, a beam of light fell upon the place where the Redcrosse Knight had fallen. There in the valley, Una saw the body of the knight sprawled on the banks of a crystal pool. Then, slowly, the knight began to rouse, and he stood with no burns or chars upon his body, completely healed by the magical waters of the Well of Life into which he had fallen. Renewed, the knight drew his blade, which now glowed with a holy radiance imbued by the waters, and crawled from the pool to search for the dragon.

Spying the knight, the dragon fell upon him again, baring its terrible fangs and slashing its scimitar claws. The knight evaded these easily—the waters of the Well of Life had not only healed his wounds but had given the knight magical strength. Redcrosse slashed and cut at the dragon, who cried in pain at the attacks. Fearing the knight's slashing blade and

unable to fly, the dragon thrust its poisoned stinger-tail at the knight. The venomous poniard stabbed through the knight's shield, and the dragon began thrashing its powerful tail about, flinging the knight like a toy. Alas, the brave warrior raised his shiny blade, and in one fell slash severed the stinger from the tail.

The knight crashed to the ground, his shield split in two. Wounded and angered, the dragon opened its powerful jaw and blew a plume of molten fire like an eruption from a volcano. The knight could not evade the burning storm and again was enveloped in wreaths of flame. Wracked with pain, he leapt from the precipice to escape and plummeted into the smoldering crevasse below.

Una let out a cry of anguish as she watched her noble knight fall a second time. All night she watched for a sign that her hero was still alive, while the gravely wounded dragon dragged itself away to rest.

As the sun rose slowly the next morning, Una saw the knight lying where he'd fallen at the foot of an old gnarled tree. She recognized it as the Tree of Life, an ancient tree that had stood in that spot since time before remembering. As its leaves gently fell upon the knight, he was healed and renewed with faith and spirit. The reborn knight, whose armor now shone silver in the sun, drew his glittering sword and searched for the dragon yet again.

Rousing himself from his slumber, the dragon, quaking in fury, came upon the knight, opened his jaws full of dagger teeth and rushed on to swallow the knight whole. As the jaws closed around him, the Redcrosse Knight thrust his shining blade upward

and skewered the dragon through the skull. With a whimper, the dragon fell to the earth and never rose again.

Watching the ordeal from afar, Una raced from the hilltop and embraced the Redcrosse Knight. Una's parents and all the citizens of the castle also came out from the gates to congratulate their savior. A great feast was held to celebrate the slaying of the dragon as well as the wedding of Una to the Redcrosse Knight.

DEMONSTRATION
REDCROSSE DRAGON AND KNIGHT

STAGE ONE: RESEARCH AND CONCEPT DESIGN

The Redcrosse Knight is the first chapter in Edmund Spenser's 1596 epic poem *The Faerie Queene*, which is considered one of the seminal poems in English literature. The story of the Redcrosse Knight can be interpreted in two ways. First, as an exciting adventure story, and second, as a metaphorical tale. This story is the classic knight in shining armor battle that so many people assume is the story of St. George. The symbolism in this story is important as it represents much of the political and religious strife that was taking place in England when it was written.

Spenser's epic tale uses many of the symbols of the past to tell his modern story. The young knight who wears the ancient armor of St. George, the patron saint of England, represents the new Anglican Church while the horrible demonic dragon that razes the countryside is the Catholic Church. Una, the pure maiden who needs to be defended, represents Faith, and the Faerie Queene is none other than Queen Elizabeth I herself. The story of the Redcrosse Knight is a metaphor for the traditional English using age-old weapons to battle modern threats to protect their land and faith.

The original text of Edmund Spenser is highly detailed in the description of the dragon. Based on that text, in which the dragon is described as having a half-running, half-flying gait, as well as a barbed tail and razor-sharp teeth, I looked to the wyvern (*Draco wyvernidae*) described in *Dracopedia* (pages 146–157) for reference for the Redcrosse dragon.

Redcrosse Knight Pencil Study
The knight of the Redcrosse is described as having a suit of plate mail embossed with a red cross, which is the symbol of St. George, the patron saint of England (see St. George on pages 152-157). Contemporary plate armor of the 16th century was ornate, but the story suggests that the armor is older than the knight, so I designed 15th-century Gothic armor for the painting. The story also describes Redcrosse wielding a lance, shield and sword, which led me to reference these weapon designs as well.

> **Use Available Resources**
> I used resources such as the library, the museum and the Internet to research medieval plate armor.

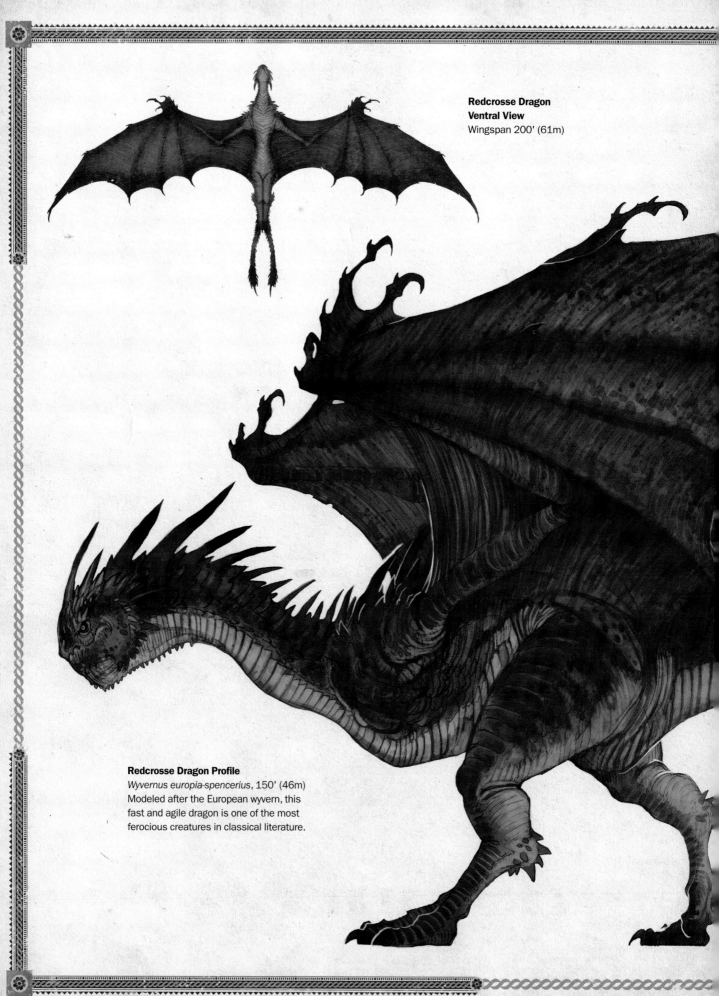

**Redcrosse Dragon
Ventral View**
Wingspan 200' (61m)

Redcrosse Dragon Profile
Wyvernus europia-spencerius, 150' (46m)
Modeled after the European wyvern, this
fast and agile dragon is one of the most
ferocious creatures in classical literature.

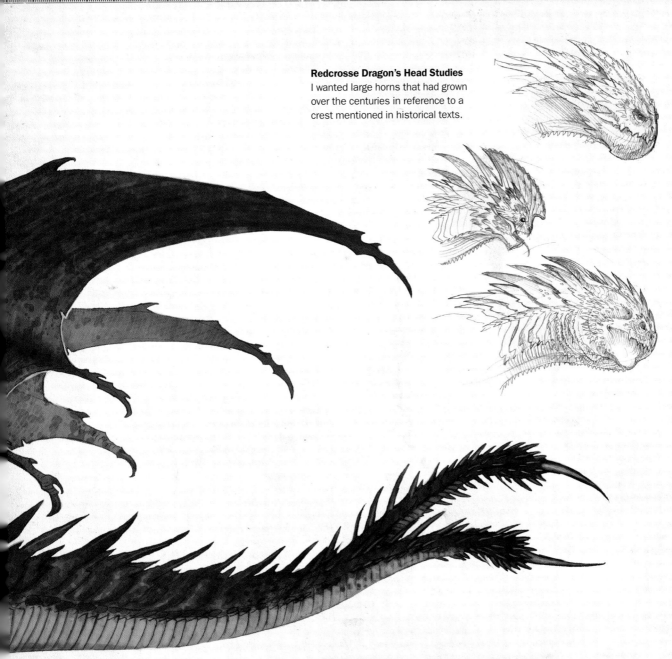

Redcrosse Dragon's Head Studies
I wanted large horns that had grown over the centuries in reference to a crest mentioned in historical texts.

English Woodcut
From *The Faerie Queene*
by Edmund Spenser

CANTO XI
The knight with that
old Dragon fights
Two days incessantly:

STAGE TWO: THUMBNAILS

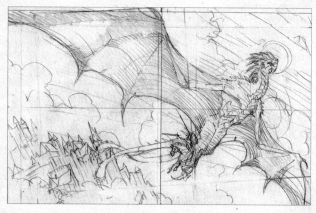

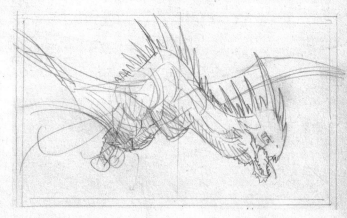

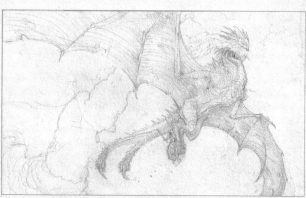

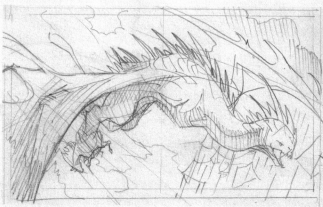

Refine Ideas

Design several compositions in your sketchbook, playing with placement of the key elements before you settle on a finished layout. The thumbnail process is an important stage for experimenting with different designs. Here I tried to compose an image that demonstrates the size and power of the dragon, along with the scope of the environment.

STAGE THREE: DRAWING

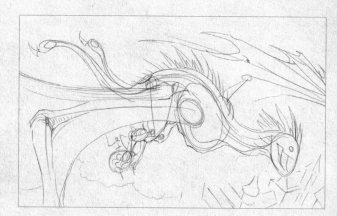

Develop the Drawing

Start with loose lines to quickly capture the position and movement of your subject. Beginning simply will allow you to make changes more easily if you don't like where things are placed.

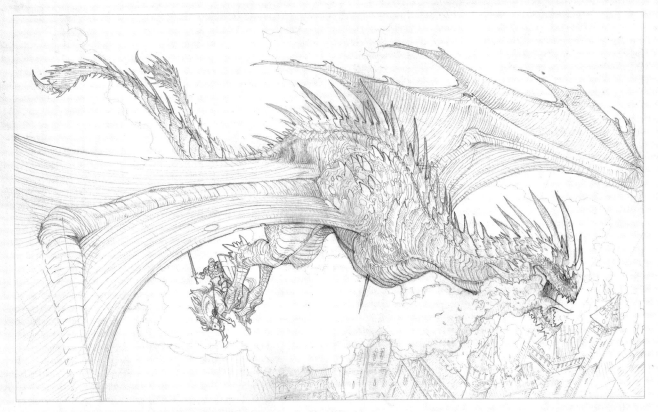

Redcrosse Dragon Finished Drawing

The environment of the story is specific, and also similar to the lands scoured by dragons described in the legends of Python and Silene—blackened rock, burned stumps of trees and ash-littered sky. I used these descriptions to inform my designs for the burning town and fiery sky.

Pencil on paper
13" × 22" (33cm × 56cm)

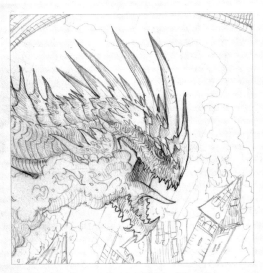

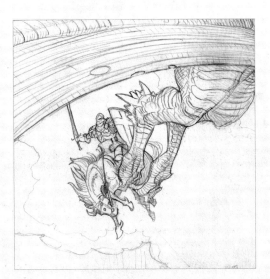

Details of Redcrosse Dragon Finished Drawing

STAGE FOUR: PAINTING

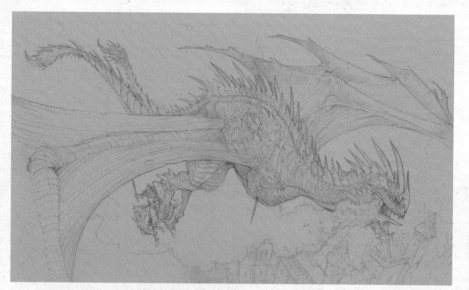

Underpainting
Bring the finished drawing into a digital painting program and shift the color balance to a sepia tone. Add a new Multiply layer on top of the drawing and fill it with a warm neutral tone to paint on. Traditional artists can achieve this technique by using toned paper and drawing with pencil and white chalk. The underpainting stage establishes the key light areas and shapes that the painting will be based on.

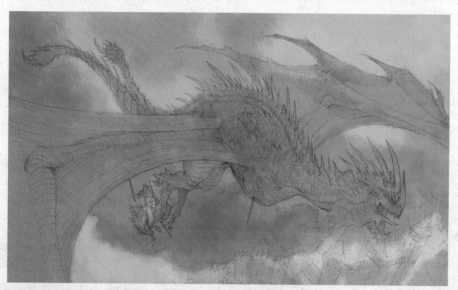

PALETTE

Redcrosse Dragon Color Palette
I chose a warm palette for the Redcrosse painting to add to the fiery atmosphere of the scene.

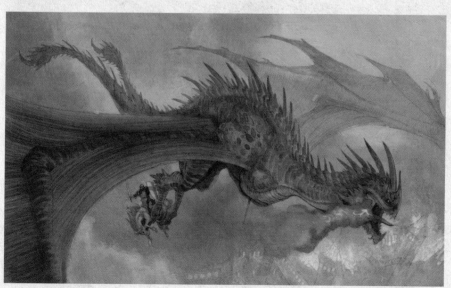

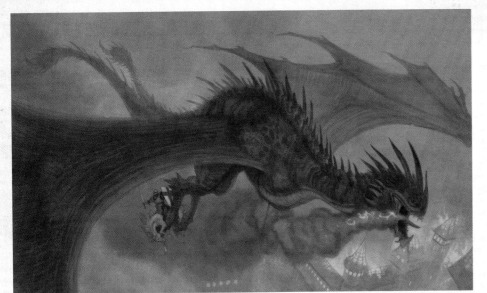

Background

Create a new Normal mode layer and work on the background elements first. Bright yellow flames silhouette the dragon's profile against the background. A touch of paint in Color Dodge mode brightens and lightens the flames to give them a glowing effect. Flying spark texture adds to the swirling, frenetic flight of the dragon.

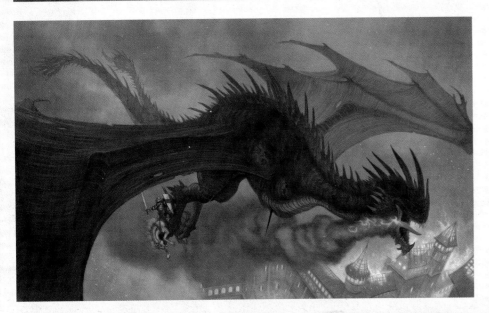

Foreground

Add a new Normal mode layer to render the foreground elements. This allows you to manipulate, apply filters, erase or blend these elements separately from the background and underpainting. Use opaque detail brushes to render the final details.

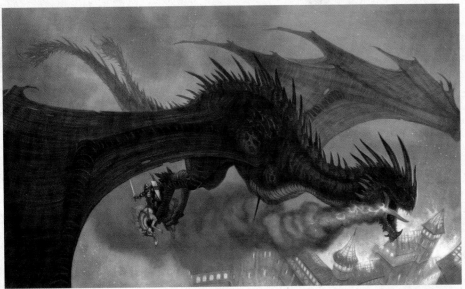

Finishing Details

Use small detail brushes to render the foreground accents of hair and scales. Painting effects, such as Color Dodge and Overlay, help enhance the fire highlights.

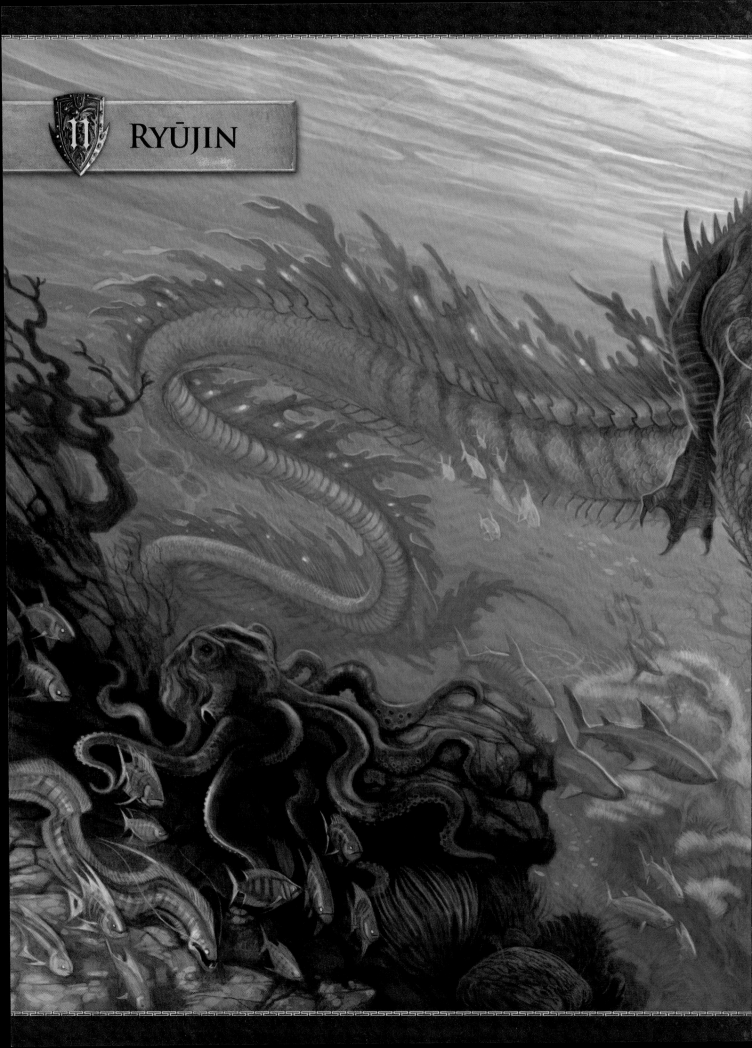

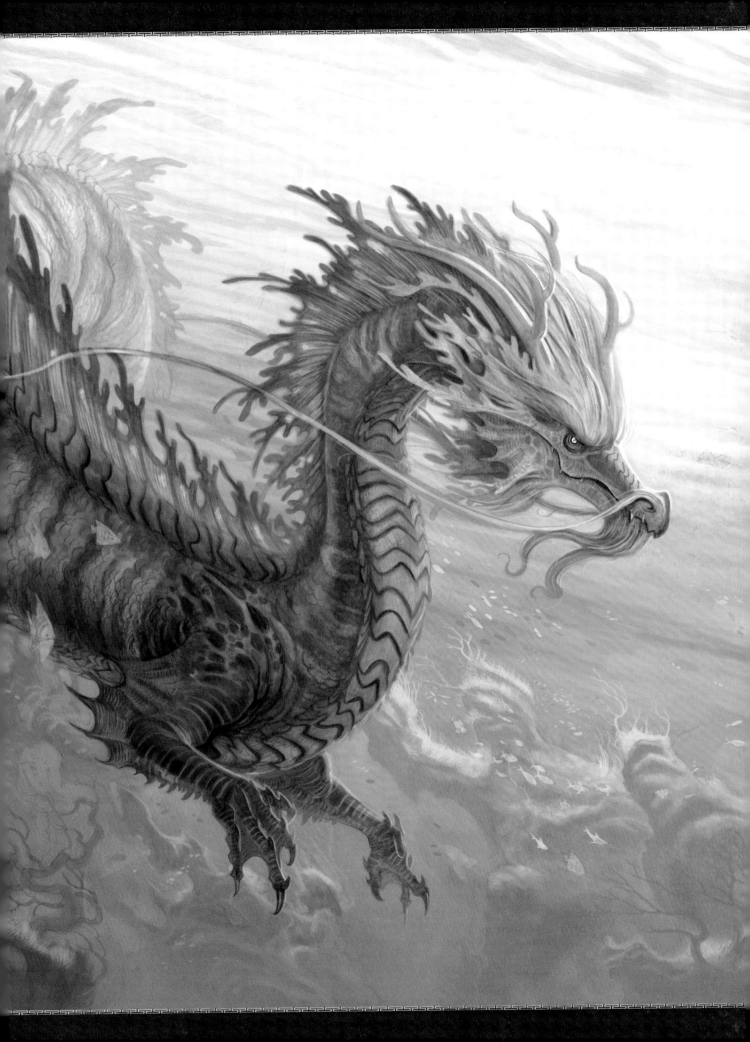

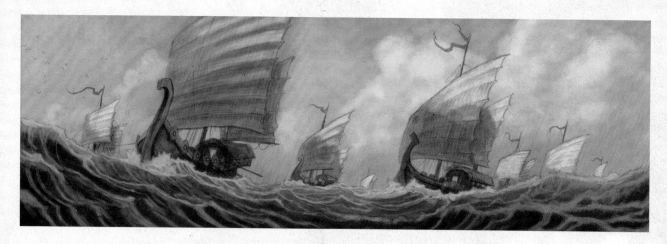

The Legend of Ryūjin

JAPANESE

NCE UPON A TIME, in the ancient kingdom of Japan, there ruled the mighty Empress Tamatori. The empress was beloved by her people for her wisdom and fairness. For many years, Japan had known only peace and prosperity. The harvests were plentiful, the cattle were strong and the sea brimmed with treasures so that everyone who lived in the empress's kingdom, even the empress herself, made offerings of thanks to the powerful sea dragon god Ryūjin for providing such bounty.

The prosperity of Japan became the envy of other rulers, however, and soon the warlords of Korea across the sea began to look on the flourishing lands of Tamatori with greed. The Korean warlords gathered and built a great armada of warships so they could sail across the Sea of Japan and conquer the islands for themselves. When word of this invading army reached the shores of Japan, the people began to panic, and they cried to Empress Tamatori to save them from the attacking navy.

Empress Tamatori gathered her council of wise elders and brave warriors in the throne room and looked for a solution. The armies of Japan were not strong enough to fend off the raiding army, and the navy did not have enough ships to stop the enemy at sea.

All seemed lost for the empress and her people when an old seer approached the council to speak. "I know of a power that can hold off this invading army," he said. The council implored him to explain. "I speak of the power of the great dragon god Ryūjin himself," the old seer explained. "Deep under the waves, Ryūjin dwells in his mighty coral palace, surrounded by his many sea creature minions.

Inside the castle sits the ancient Tide Stones that Ryūjin uses to control the ebbing and flowing of the seas. If we were to retrieve these stones from his palace, then the power of the oceans would be in our hands to crash upon this invading force and crush them."

The empress and the council agreed that retrieving the Tide Stones was the only way to save the people of Japan. The empress called for a volunteer among her bravest warriors to take the perilous journey to the palace of Ryūjin and steal the Tide Stones. Of all the mighty warriors and brave generals, none accepted the challenge. Empress Tamatori was disheartened, but then a small voice called out, "I will go."

The empress turned to see a young man step forward. "My name is Riku," said the young man. "I am only a servant, but it would be my honor to serve you, your majesty."

The empress blessed Riku for his bravery and the court moved to the seaside to send Riku off in a small boat to recover the Tide Stones.

Riku rowed his small boat out to sea, and the farther he got from land the higher the waves grew. At last he reached the center of the sea and cast his anchor into the depths. When at last the rope stopped, Riku dove into the water and followed the anchor line to the coral reef below. The young boy marveled at what he saw: sea creatures of more shapes and colors than he could fathom, coral forests that glowed in the green sea. In the distance he saw the coral palace of Ryūjin, a structure that seemed to grow right out of the reef, decorated with a rainbow of anemones, urchins and starfish. Hurrying before his breath ran out, Riku snuck past the schools of sharks that guarded the palace gate and stole into the coral castle.

Inside, Riku swam to a chamber that rose above the water's surface and was filled with air. When he emerged from the inner pool, he took huge gasps of air before he could continue. Looking around, he found that the chamber housed a giant throne made of seashells at the center. In its arms were two large pearls that glowed with inner swirling light like the ocean's waves. "These must be the Tide Stones," Riku thought. Thankfully, the throne room was empty, so he

crept to the throne, carefully lifted the stones, placed them in his pack, and quickly stole away again.

As Riku escaped the palace, the ocean creatures became alarmed. All the fish and sea life churned in a terrible storm. Riku pulled himself up along the anchor line rope to his little skiff, then used a knife to cut the rope. Riku pulled hard at the oars to get to shore as fast as he could, but the ocean grew wild. Waves swelled behind him, teeming with leaping whales, angry sharks and snapping sea creatures of every stripe, all about to crash down on Riku and wash him away. At last Riku reached the shore where Empress Tamatori waited. The boy leapt from his boat and handed the empress the Tide Stones. She held the stones aloft just as the roiling waves of angry sea creatures were about to break upon the shore, but they halted at the sight of the stones.

There then rose a dark storm cloud above the shore, and a great spout of water erupted from the sea, parting the waves of sea creatures. Emerging from the spout was a dragon. It towered over the waves and the figures on the beach, glistening with emerald scales. Its eyes glowed with fury at the empress. Riku and the Imperial Court all fell to their knees before the terrible form of Ryūjin, the sea dragon god.

"Who dares steal the Tide Stones from me, the great Ryūjin?" thundered the mighty dragon.

Riku stepped forward. "It was I, mighty Ryūjin. Please do not blame my mistress. She is a good and noble empress who only wishes to save her people from the invading army."

"What army wishes to invade this land?" growled the titanic dragon.

Empress Tamatori explained everything to the great dragon god, and Ryūjin grew angry. "I am the protector of this land, and no army shall threaten it while I live," Ryūjin said. "Return the Tide Stones to me, and I shall take care of this peril. And you will promise to never steal from my palace again."

The empress agreed and returned the stones to Ryūjin, swearing that she and all the rulers to come would respect the great Ryūjin. Returning to his coral castle with his army of sea creatures and the stones, Ryūjin called up the power of the seas and smashed the invading army's ships, sinking them to the bottom of the ocean and saving the people of Japan. Riku went to the court of the empress to live the rest of his life as an honored advisor, always giving offerings to Ryūjin, the savior of Japan.

DEMONSTRATION
RYŪJIN

STAGE ONE: RESEARCH AND CONCEPT DESIGN

Perhaps nowhere else in the world are the people spiritually tied to the sea as much as on the islands of Japan. The sea provides a cornucopia of food, as well as transport and defense, but it can also deliver devastating damage in the form of tsunamis and destructive storms. It's no wonder that the mercurial oceans, which the Japanese rely on for their daily survival, take on the capricious symbolism of a dragon. In every culture, dragons embody a force of nature, whether it be volcanoes, earthquakes, storms or ocean waves. Unlike the dragons in the European tradition, Asian dragons are seen as powerful but protective gods and spirits called *kami* in the Shinto religion. As dragon god of the sea, Ryūjin is a powerful kami that would be worshipped and honored.

Ryūjin is a mighty sea dragon living in the Sea of Japan. For more information on marine dragons, reference the *Dracopedia* chapter on sea orcs (pages 124–135). There are two families of sea orc, *Draco dracanguillidae* and *Draco cetusidae*. The *Dracanguillidae* (Dragon eel) family is more serpentine as seen in specimens such as Jörmungander (pages 42–53). The *Cetusidae* (sea lion) family of sea orcs is more heavily limbed and capable of moving on land.

Using these designs as a starting point, I create my vision of Ryūjin, not as a monster, but as a guardian and king whom the other sea creatures follow as his courtiers.

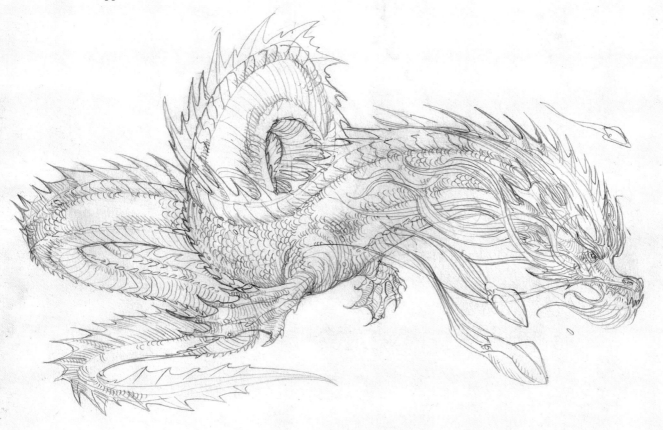

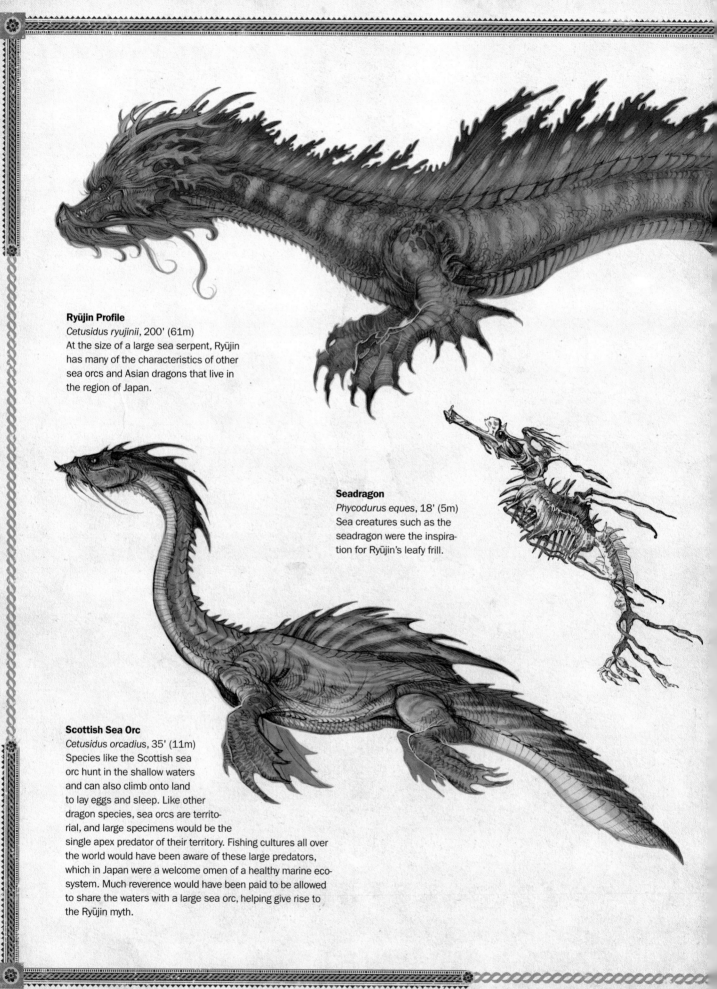

Ryūjin Profile
Cetusidus ryujinii, 200' (61m)
At the size of a large sea serpent, Ryūjin
has many of the characteristics of other
sea orcs and Asian dragons that live in
the region of Japan.

Seadragon
Phycodurus eques, 18' (5m)
Sea creatures such as the
seadragon were the inspira-
tion for Ryūjin's leafy frill.

Scottish Sea Orc
Cetusidus orcadius, 35' (11m)
Species like the Scottish sea
orc hunt in the shallow waters
and can also climb onto land
to lay eggs and sleep. Like other
dragon species, sea orcs are territo-
rial, and large specimens would be the
single apex predator of their territory. Fishing cultures all over
the world would have been aware of these large predators,
which in Japan were a welcome omen of a healthy marine eco-
system. Much reverence would have been paid to be allowed
to share the waters with a large sea orc, helping give rise to
the Ryūjin myth.

STAGE TWO: THUMBNAILS

Refine Ideas

Experimenting with a couple of quick sketches will help you decide on your design before beginning to paint. These early design sketches demonstrate the power and elegance of the dragon Ryūjin. I incorporated seahorse-like features into the dragon itself. I then added the ocean creatures, which gather around like a flock to a shepherd.

STAGE THREE: DRAWING

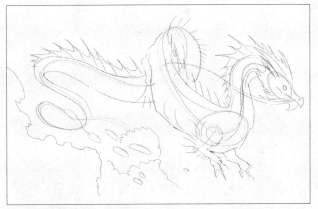

Develop the Drawing

Following the rough template of the thumbnails, begin your large-scale drawing. Start loosely to position your image before becoming more detailed.

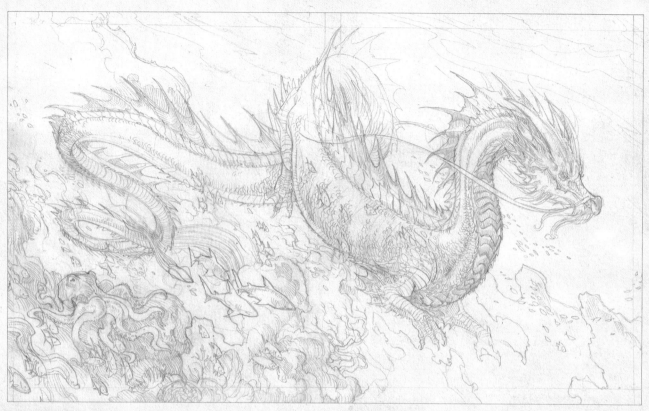

Ryūjin Finished Drawing
Pencil on paper
13" × 22" (33cm × 56cm)

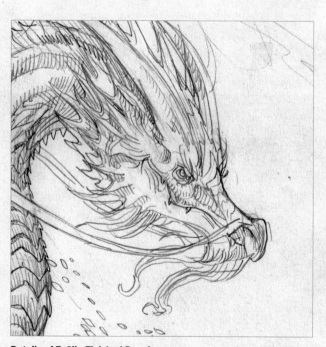

Details of Ryūjin Finished Drawing
The final drawing should include details such as rocks, sea creatures and scales.

STAGE FOUR: PAINTING

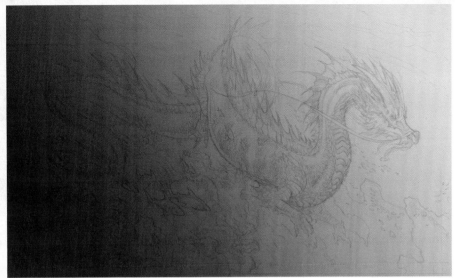

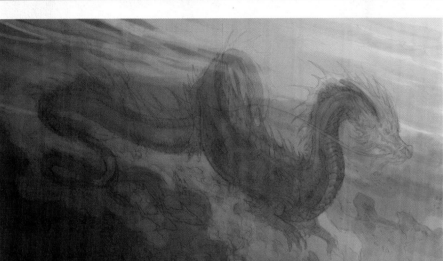

Underpainting
With your drawing open in your painting software, create a new Multiply layer above the layer with the sketch and paint with monochromatic tones to establish the lighting and structure of the painting.

PALETTE

Ryūjin Color Palette
The bright pastel blues of a coral reef inspired the color palette for the Ryūjin painting.

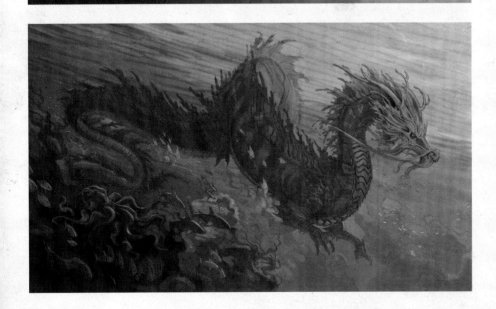

Background
In a new Normal layer, begin adding localized color (blue for the ocean, green for the dragon) and background details.

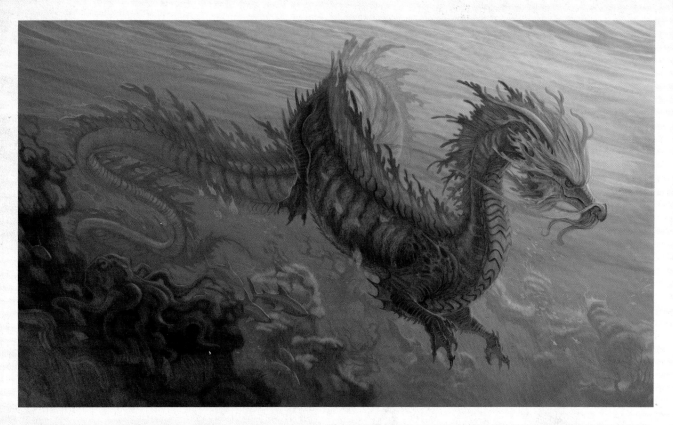

Foreground
Render the foreground details of Ryūjin and the coral reef in Normal mode using opaque paint with small brushes. Add a warm foreground highlight color to offset the blue-green palette and provide contrast.

Finishing Details
Add detail to the focal points of the painting to attract attention. Conversely, create atmospheric effects by using minimal details in places that suggest depth and distance. Create contrast using complementary colors.

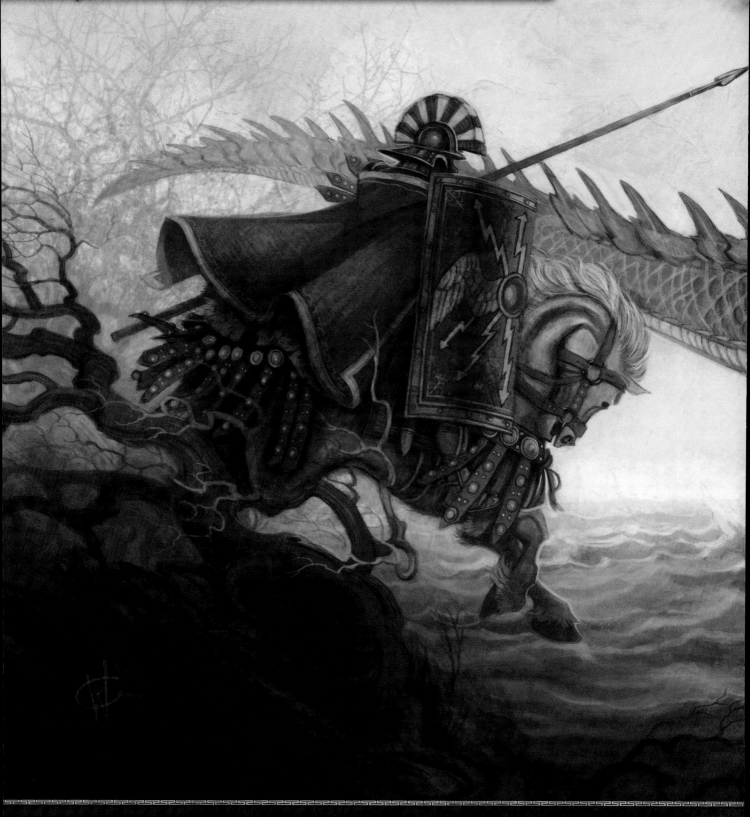

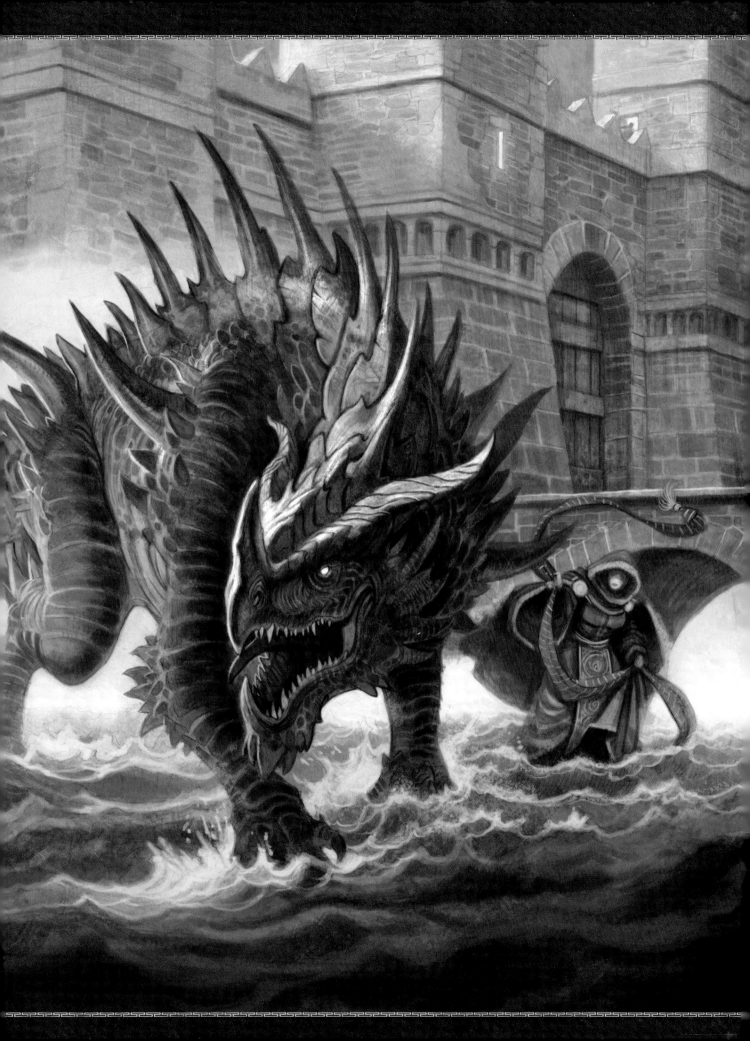

The Legend of the Dragon of Silene

CHRISTIAN

URING THE RULE OF THE ROMAN EMPIRE, the Emperor Diocletian decreed that all of the soldiers within the Imperial Army would denounce the new Christian faith and declare their loyalty to the Roman gods. Across the Empire, from Britain to Jerusalem, the legions of the Imperial Army pronounced their faith to the Emperor and the Roman gods for fear of being executed. Roman governor Gerontius was a loyal general to the Empire, who ruled in the eastern province of Syria and was beloved by the Emperor. However, the general and his wife, Polychronia, were secret converts to Christianity, and when they had a son, they named him George and raised him in the new Christian faith. George's parents knew that practicing their faith in violation of the Emperor's edict placed them in grave danger.

When George grew to a young man, he followed in his father's footsteps and became a soldier in the Roman army. George was a brave and noble soldier, quickly rising up the ranks to become a centurion. Throughout the lands of Syria where he had grown up, he was known as a fair and courageous warrior, devout in his Christian faith.

As time passed, George's adventures took him to the lands of Libya in northern Africa. One day, as George was riding through the

kingdom, he came upon the city of Silene. Where once there had been fields of crops and orchards, now he saw only blackened land and water that steamed like sulfur. He approached the city walls to see what had happened, and there he found a young noblewoman.

"Sir!" she cried. "I beg you, turn and ride away from this accursed place if you value your life."

George was dismayed and asked her what was wrong.

"A dragon!" she wailed. "A dragon has come to our city and has destroyed all of our lands."

"How is this possible?" George asked.

The lady told him her story. "A year ago, a terrible dragon came to live in our kingdom and terrorized the land, ate our livestock and destroyed our crops with his foul, poisonous breath. The beast sowed death and destruction upon our fair city of Silene. My father, the king, tried to placate the beast by feeding our livestock and animals to it, but soon they were all gone, and a terrible bargain was made. The king began a lottery to choose young boys and girls to be sacrificed to the dragon to keep it satisfied. In time, I could not abide by the lottery, so I put my own name in.

It befell that I was chosen, the princess of Silene, to be sacrificed to the dragon. My father begged me not to go, but I refused, insisting that the peril my fellow townspeople endured should be mine as well. So now I have left the city gates to be sacrificed to the dragon on behalf of my people. Please, good knight, flee, for the dragon will soon be upon us, and you would surely be destroyed as well."

All of a sudden, a fearsome growl came from the blackened river that flowed nearby. A massive, lurking drake skulked along the strand. Its eyes burned like fire, and black smoke boiled from its nostrils like a furnace. Stopping in its gait upon spying the knight on horseback, the terrible creature opened its toothed maw and issued a roar that echoed through the desolate landscape.

Without hesitation, George wheeled his horse around and set his lance

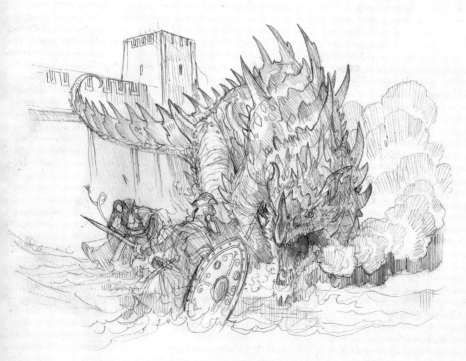

under his arm. This was no ordinary spear—the Lance of Ascalon was a holy relic originally gifted to the mighty hero Ajax, and then brought to the city of Ascalon where George acquired the sacred weapon through his piety and faith. Charging his horse toward the scaly beast, George directed the lance at the dragon's heart. With a thundering crash, George struck true into the dragon and, with a wail of pain, the creature reared up and was thrown backward, crashing into the river.

Wheeling his horse around for a second charge, George could see at once that the beast was beaten. Limping and wounded, the dragon rose tremulously to its feet and snapped and snarled at the princess and the knight.

"Your highness!" George called to the princess. "Your sash! Take your sash and throw it over the creature's head!"

The princess bravely followed the knight's command and took the long silk sash from around her waist and cast it toward the dragon where it looped itself around the creature's neck.

At first, the dragon bucked at the leash, but it soon realized it was beaten and became as tame as a house dog. Together the princess and George led the dragon toward the city gates of Silene where the whole town had stood upon the parapets watching the ordeal.

"Open the gates!" cried the princess. With a squeal of iron, the portcullis rose and the great oaken gates swung wide to let in the champions.

Every citizen of Silene gathered around the holy knight and the princess trailing the terrible dragon. The beast gave a furious shriek at the thronging crowd, which caused them all to shrink back in horror.

"Good people of Silene!" called George. "You have nothing to fear from this evil creature. With one stroke of the holy Lance of Ascalon, and with your princess's brave virtue, he has been defeated by the grace of God."

The citizens of Silene knew this to be true, that they had witnessed a miracle that day. One by one the townsfolk fell to their knees in thanks to God, and there in the town square of Silene, St. George baptized 20,000 souls.

DEMONSTRATION
THE DRAGON OF SILENE

STAGE ONE: RESEARCH AND CONCEPT DESIGN

The story of St. George is one of the oldest tales in Christianity. George was a Roman soldier of the Empire, and he remained a Middle-Eastern saint until the Crusades, when knights of England came upon the shrines and relics of St. George and adopted him as their own. Saint George's red cross became a symbol of English crusader knights. It was emblazoned on the templars' shields, and later, was adopted as the flag of England.

When visualizing the dragon in this legend, I reference my primary source material. Because the story is set in the Middle East, I looked to my other *Dracopedia* books to see what kind of dragons live in that region. I immediately saw that drakes of the family *Draco drakidae* can be found in that climate (*Dracopedia*, pages 90–99).

Nowhere else in the world are drakes as beloved as in the Middle-Eastern region formerly known as Persia. Raised from hatchlings, Arabian, Persian and other breeds are famous for their excellent speed, ability to guard, intelligence and pedigree. The specimen described in the legend of St. George would be many times larger than the common drake *Drakus plebius*, but reports of wild drakes growing to unusual sizes are not unheard of.

The crucial aspect of the story is that the princess of Silene is able to tame the dragon and lead it on a leash like a dog, which made me imagine a dragon of the approximate size and behavior of a drake. The territorial behavior of this dragon also describes the behavior of drakes.

St. George Pencil Studies
Unlike depictions of St. George that you might see in stained glass or statues, St. George was not a Medieval European knight in shining armor. As a Roman soldier of the 2nd century, his armor and kit would be very different. Be sure to do your research to get the correct historical costume for the time period.

153

Drake Head Study

When designing the drake, I wanted its appearance to reflect that it was old, large and scarred from previous battles.

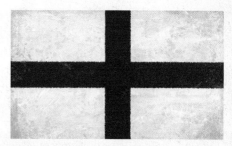

Red Cross Adopted by the English

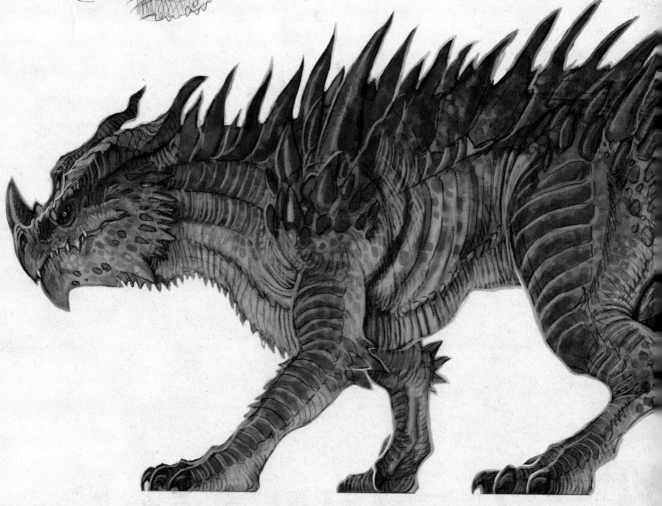

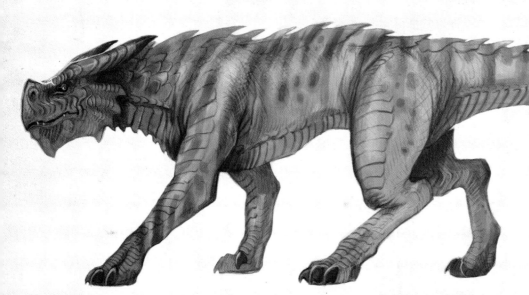

Common Drake Profile
Drakus plebius, 10' (3m)
The common drake was often domesticated throughout the Middle East for racing, hunting and security. Packs of wild drakes would roam the region in the ancient and medieval periods and were a scourge to many communities.

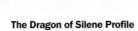

The Dragon of Silene Profile
Drakus plebius-imperatorus, 25' (8m)
The dragon for the legend of St. George is based on the drake family, *Draco drakidae*. Many other drake species exist and you should explore these to design your own.

STAGE TWO: THUMBNAILS

Refine Ideas

Working from the reference and story concept art, develop a rough pencil design of the finished painting. Like staging a film, the thumbnail gives you a rough outline of the placement, lighting, design, sets and costumes for the finished painting.

STAGE THREE: DRAWING

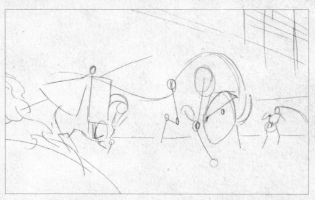

Develop the Drawing

Begin your large-scale drawing by loosely sketching in the positions of your main subjects.

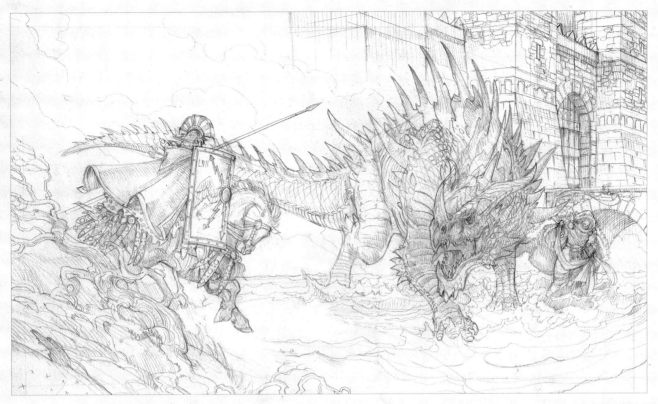

The Dragon of Silene Finished Drawing
Working with the reference material and concept art created from the story of St. George, develop a finished drawing based on the original thumbnail sketch. The finished drawing should include all the details—armor, scales, rocks—that you intend to render.

Pencil on paper
13" × 22" (33cm × 56cm)

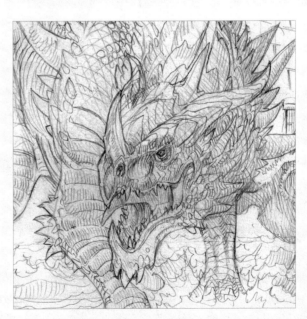

Details of Dragon of Silene Finished Drawing

STAGE FOUR: PAINTING

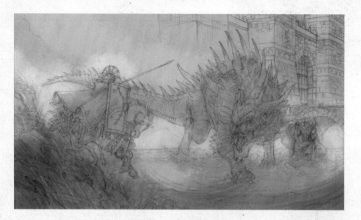

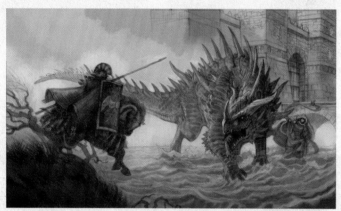

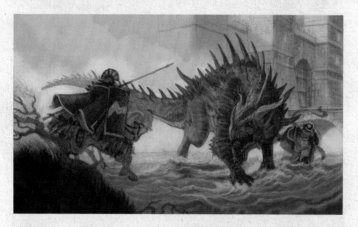

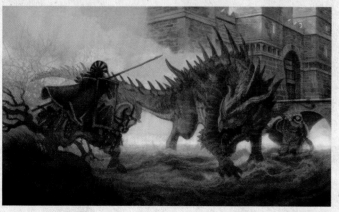

Underpainting

Begin by painting in cool blue tones on a Multiply layer placed over the drawing. If working traditionally, the technique is the same. Use a watered-down paint as a wash over the drawing. This stage lends the painting mass by establishing form and light.

PALETTE

The Dragon of Silene Color Palette

For this painting, I chose a cool gray palette to illustrate the miasmic fumes that plague the land of Silene.

Background

In the background, work on establishing the details of the castle of Silene. Approach buildings as simple blocks and add the desired detail on top of those shapes. You can import images to create background textures, similar to the tree seen in the background on the left.

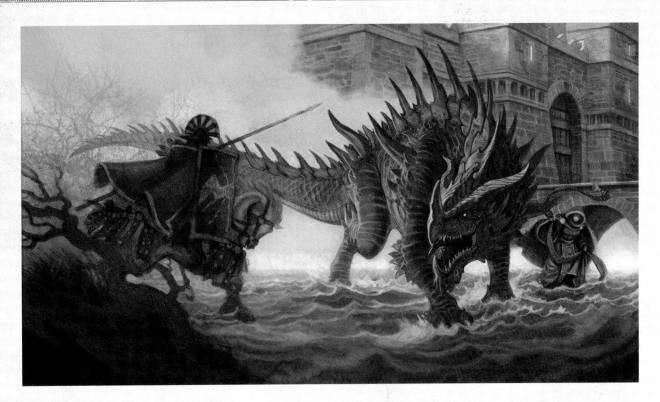

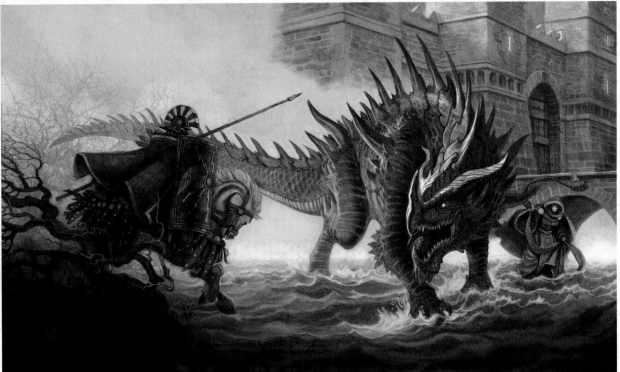

Foreground

At the center of both the story and the painting is the dragon. Render the details of scales and texture in a new Normal layer to add depth and realism to your painting. In the new Normal mode layer, use dark colors and values to anchor the foreground and frame the action. If working digitally, zoom in to render any fine details.

Finishing Details

Use Color Dodge and Overlay to add finishing highlights to the painting. Rivets and buckles, as shown on the armor, add additional textural details.

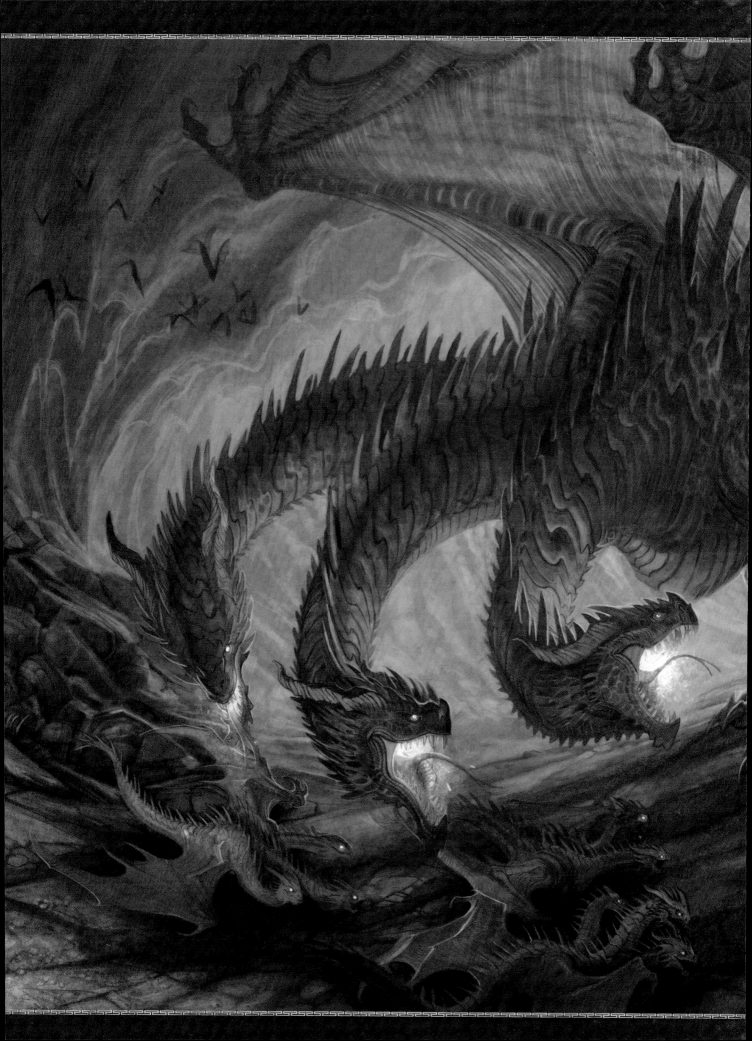

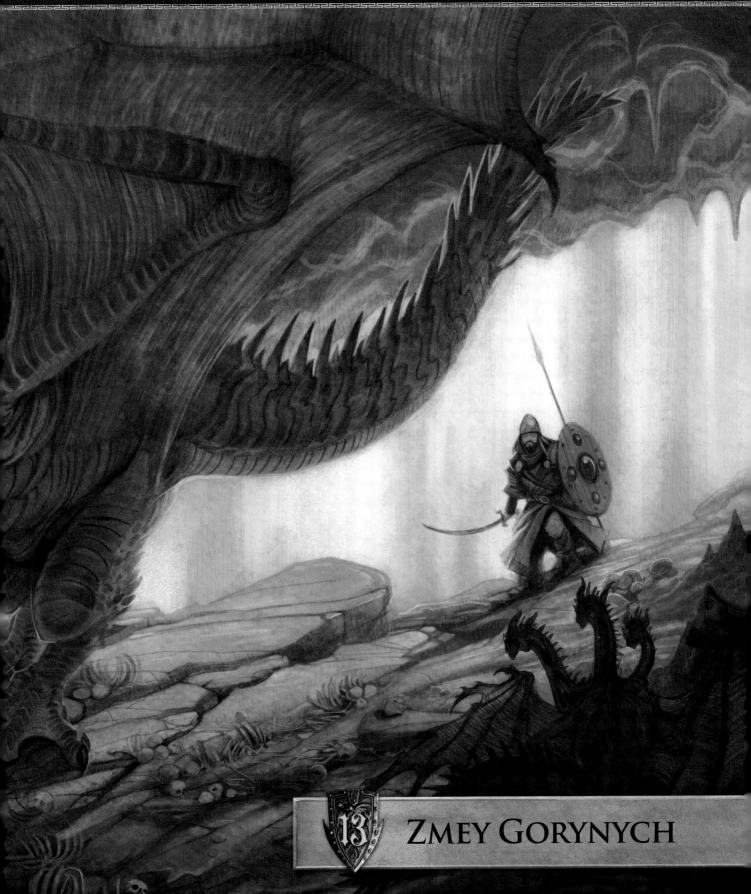

13 ZMEY GORYNYCH

The Legend of Zmey Gorynych
RUSSIAN

NCE UPON A TIME, in the windswept steppe of Russia, there lived a shepherd boy named Dobrynya Nikitich. Dobrynya was like most boys in that he loved to run and play in the fields and mountains around his home. "Be careful, Dobrynya," his mother told him. "There are many dangerous animals living in the wild. Wolves that bite and dragons that breathe fire."

"I'll be careful, Mother," he said, but he paid no heed to her warnings.

One day Dobrynya was exploring the mountains far from his home and came upon a cave near a waterfall. It was a sunny day and Dobrynya was hot from his trekking, so he decided to take a swim. Stripping off his clothes, he plunged into the pool and splashed joyfully under the waterfall. The boy's laughter echoed in the mountains and attracted the attention of the three-headed dragon Zmey Gorynych that lived in the cave where she had laid a clutch of eggs. To hide from the six eyes of the ferocious dragon, the terrified boy dove deep to the bottom of the pool.

Holding his breath among the reeds, Dobrynya caught sight of something shining among the grass and mud. He reached out his hand and discovered a gleaming golden helmet decorated with shining carvings. Without thinking, Dobrynya placed the helmet on his head, but he realized that he was quickly running out of air on the bottom of the pool, and so he had to surface.

Once above the water he could see the dragon Zmey Gorynych prowling along the edge of the water. Dobrynya held very still, and although it seemed that the dragon was looking right at him, he was not seen. Eventually the dragon went back into his cave, and Dobrynya jumped from the water and raced home with the helmet.

"Mother! Mother!" Dobrynya called as he burst through the door. The boy's mother leapt in fright and looked around for her son, but he

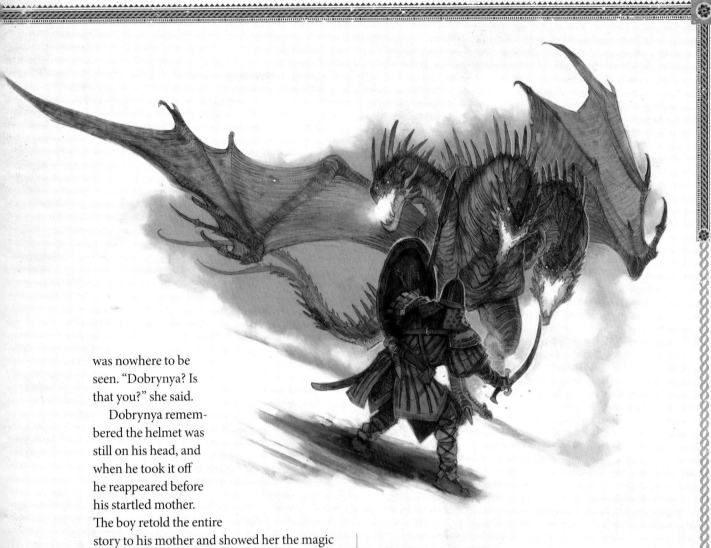

was nowhere to be seen. "Dobrynya? Is that you?" she said.

Dobrynya remembered the helmet was still on his head, and when he took it off he reappeared before his startled mother. The boy retold the entire story to his mother and showed her the magic helmet from the bottom of the pool. Dobrynya's mother was very afraid of a dragon and made him promise that he would not go up to the cave ever again, and that magic helmets were not toys to be played with.

"I promise, Mother," he said. But the promises of young boys are not often remembered.

Years passed and Dobrynya grew up. After his mother passed away, he left the small cottage of his boyhood and went to the capital city of Kiev. Dobrynya joined the army, and through his bravery and wit, grew into a knight in the court of Prince Vladimir.

One day the court was in an uproar as it was learned that Princess Zabava had gone missing. The servants and the guards searched far and wide, and it was finally discovered that the princess had been taken by the dragon Zmey Gorynych while she was out riding. Prince Vladimir called all of his knights

together and asked for volunteers to rescue his niece. Dobrynya raised his hand. "I will go, my lord," he said. "I know this dragon named Zmey Gorynych and where she keeps her cave. I will rescue the princess."

Dobrynya was given the finest armor and warhorse to do battle with the dragon, and he rode out to the mountains. Dobrynya returned to the cave of the dragon where he had encountered her before and called out, "Zmey Gorynych! It is I, Dobrynya! Come out and face me!" Dobrynya waited, hoping to lure the dragon out, then sneak into the cave unseen while wearing his helmet to rescue Princess Zabava unharmed. Dobrynya waited, but the dragon did not come at his bidding.

At last, Dobrynya could not wait. Placing the helmet on his head, he skulked toward the entrance of the cave. Inside there was the dragon as big and fire-breathing as ever, its

three heads casting about in every direction. After many years of waiting, her brood had hatched into little dragonlings. From beyond the dragons, deep in the cave, the knight could hear the princess call, "Is someone there? Please help me!"

Dobrynya was at once attacked and was swarmed by the small dragonlings, who nipped and scratched at the knight. Swinging his sword, Dobrynya slew the small hatchlings. When Zmey Gorynych saw her brood had been killed, she flew into a furious rage and attacked the unseen intruder. She unleashed her fire breath and slashed her deadly tail, but every attack was in vain since Dobrynya was invisible wearing his magic helmet. Swinging his powerful sword, the brave knight severed a head from the dragon's neck, and screaming in anguish, Zmey Gorynych coiled away, only to grow a new head back in its place. The two warriors battled each other for three

days, and every slashing blow of Dobrynya's sword removed one of the dragon's heads only for a new one to grow in its place. At long last the dragon was skewered through the heart by the knight's lance, and Dobrynya burned the dragon's body and buried the ashes so that it would never bring harm to anyone again.

Deep inside the cave the knight found Princess Zabava and returned with her to Kiev to be reunited with her uncle. The whole city rejoiced, and Dobrynya and Zabava were married.

DEMONSTRATION
ZMEY GORYNYCH

STAGE ONE: RESEARCH AND CONCEPT DESIGN

The myths and legends of the Russian wilderness are filled with magic, adventure and danger. The tale of Dobrynya Nikitich slaying the powerful Zmey Gorynych has been told in Russia for generations and exemplifies the region's rugged history. As with the dragon lore of other countries, this legend tells the tale of a peasant boy who rises up to become a hero through cunning, bravery and a little help from a magic helmet.

Designing the dragon Zmey Gorynych began with the important fact that it possesses three heads, making it a hydra. Beginning by referencing the chapter of hydras in *Dracopedia* (*Draco hydridae*, pages 111–123), I realized that hydra do not fly, so I combined the design with a wyvern (*Draco wyvernidae*, pages 146–157). This slim design allows Zmey Gorynych to be a fearsome three-headed, fire-breathing, flying dragon.

Dobrynya Pencil Study
Do as much research as possible to capture the look of medieval Russian arms and armor.

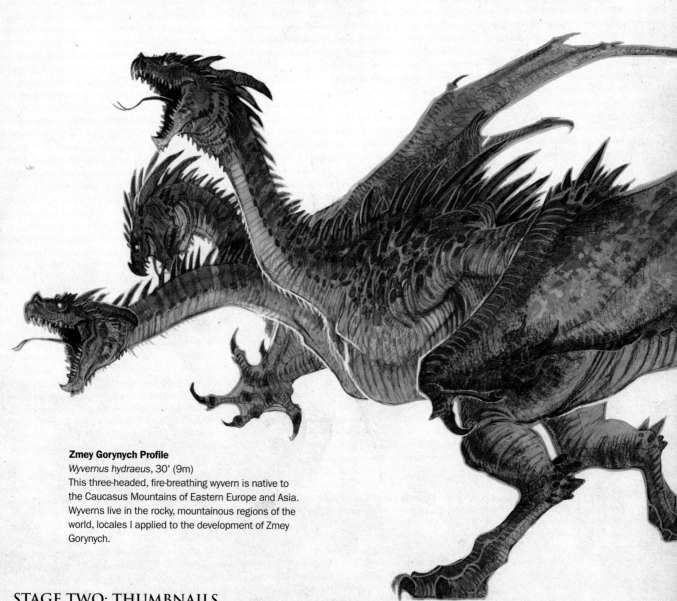

Zmey Gorynych Profile

Wyvernus hydraeus, 30' (9m)
This three-headed, fire-breathing wyvern is native to
the Caucasus Mountains of Eastern Europe and Asia.
Wyverns live in the rocky, mountainous regions of the
world, locales I applied to the development of Zmey
Gorynych.

STAGE TWO: THUMBNAILS

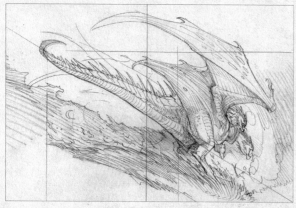
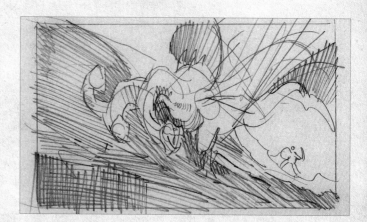

Refine Ideas

Working quickly in pencil, I develop several simple design concepts. This stage allows the com-
position to be established before committing to a complex drawing. Here the major elements
are Dobrynya, Zmey, the dragonlings and the cave.

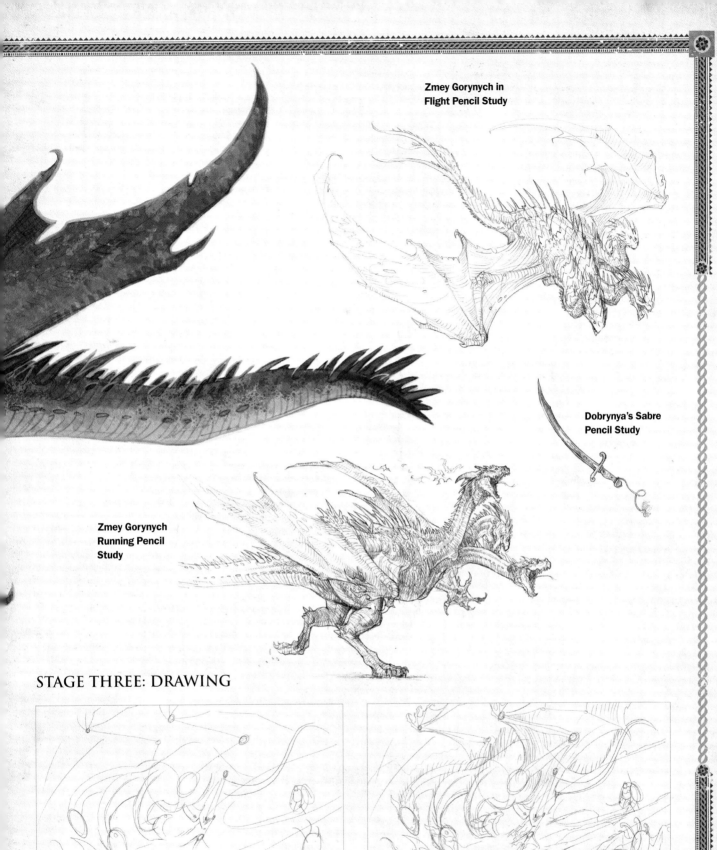

Zmey Gorynych in Flight Pencil Study

Dobrynya's Sabre Pencil Study

Zmey Gorynych Running Pencil Study

STAGE THREE: DRAWING

Develop the Drawing
Loosely establish where your key figures will be in your final drawing. Use the thumbnails as a blueprint and work with loose, general shapes, leaving the details until last.

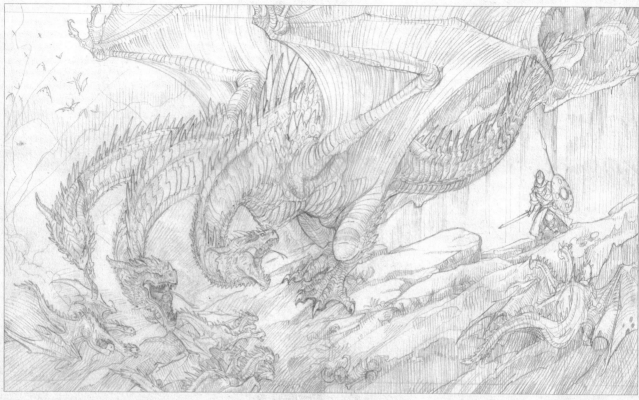

Finished Zmey Gorynych Drawing

Working in loose, broad shapes, and using the thumbnails and references as a guide, develop the composition. Make sure all the elements fit in the design and flow through the page before developing any details. Once the design has been established, render the fine details of the drawing using smaller pencils and harder graphite.

Pencil on paper
13" × 22" (33cm × 56cm)

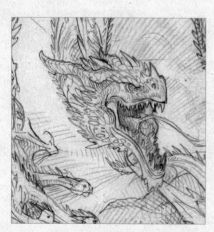

Details of Zmey Gorynych Finished Drawing

STAGE FOUR: PAINTING

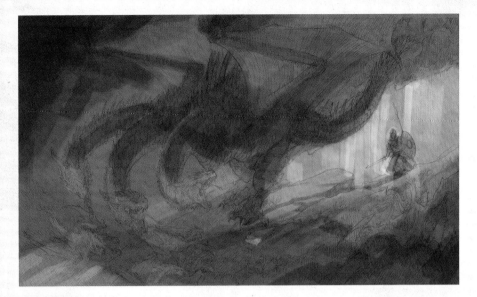

Create Color Comparisons
Either on the computer or by using watercolor on top of printouts, experiment with color and light before committing to a color design.

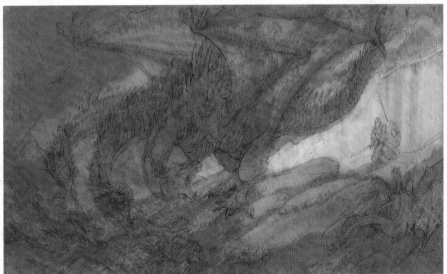
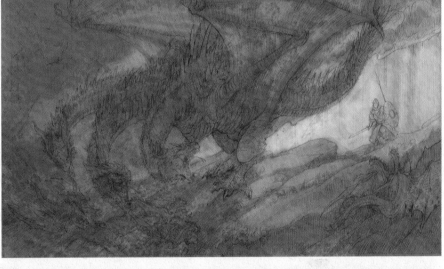

Underpainting
Place a Multiply layer over your drawing and create a monochrome under-painting to establish light and form. If working traditionally, use light washes of paint.

PALETTE

Zmey Gorynych Color Palette
Working with a dark, cool gray color gives the composition a solid base to add bright golden highlights, which will contrast with and accent the dragon.

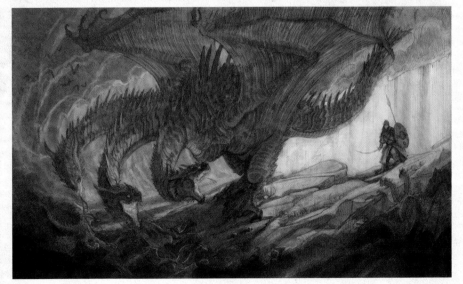

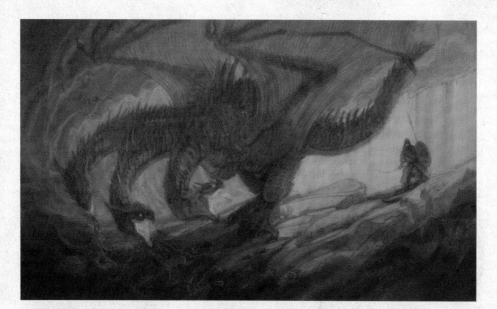

Add Local Color
Add a semiopaque layer of local color on top of the underpainting. This step establishes the color of the objects in the painting, which you will build on.

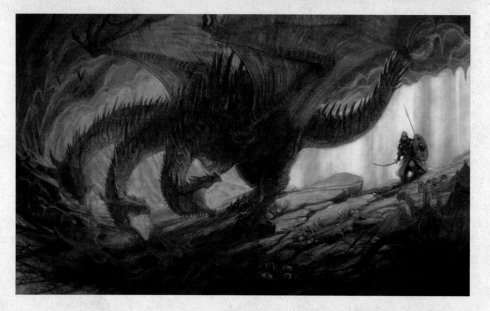

Background
In the background, render the rock and water details. Remember to keep the color, detail and contrast low since this is the background and should seem distant.

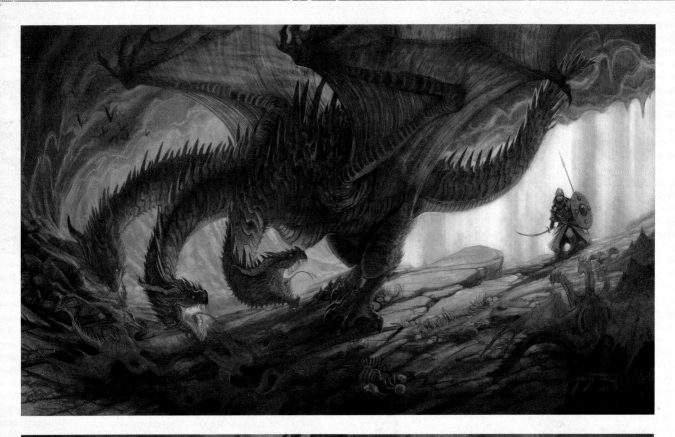

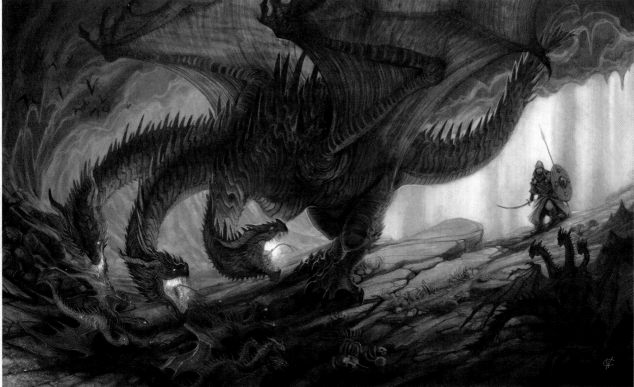

Foreground

In the foreground, establish more detail when rendering the scales on the dragons and the cave debris. The rich red light source should help bring the foreground element into sharper focus.

Finishing Details

Use small brushes and opaque paint to render the finishing details. Brush colors using Color Dodge can create bright lighting effects.

INDEX

Dracopedia Legends. Copyright © 2018 by William O'Connor. Manufactured in the United States of America. All rights reserved. No part of this book may be reproduced in any form or by any electronic or mechanical means including information storage and retrieval systems without permission in writing from the publisher, except by a reviewer who may quote brief passages in a review. Published by IMPACT Books, an imprint of F+W Media, Inc. 10151 Carver Road, Suite 300, Blue Ash, Ohio, 45242. (800) 289-0963. First Edition.

a content + ecommerce company

Other fine IMPACT books are available from your favorite bookstore, art supply store or online supplier. Visit our website at fwmedia.com.

22 21 20 19 18 5 4 3 2 1

Distributed in the U.K. and Europe
by F&W Media International LTD
Pynes Hill Court, Pynes Hill, Rydon Lane, Exeter, EX2 5AZ,
United Kingdom
Tel: (+44) 1392 797680
Email: enquiries@fwmedia.com

ISBN 13: 978-1-4403-5091-7

Content Edited by Noel Rivera
Production Edited by Jennifer Zellner
Designed by Clare Finney
Production coordinated by Jennifer Bass

Copyright and royalty-free images courtesy of Dover Publications. Images appear on pages 23, 82, 107, 117, 129, 131, 141, and 154.

ABOUT THE AUTHOR

William O'Connor, a father of two, lives in New York. He sometimes comes out of his Hobbit hole, where he makes books and paintings, to travel the land and explore. Author and artist of the best-selling *Dracopedia* book series, as well as illustrator of more than five thousand illustrations for the gaming and publishing business, William O'Connor's 25-year career has allowed him to work with such companies as *Wizards of the Coast, IMPACT Books*, Blizzard Entertainment, Sterling Publishing, Lucas Films, Activision and many more. In addition, he has won more than 30 industry awards for artistic excellence including 10 contributions to *Spectrum: The Best in Contemporary Fantasy Art* and 10 Chesley Nominations. William has taught and lectured around the country about his unique and varied artwork as well as being a regular contributor to the popular art blog Muddy Colors and exhibiting his work at such industry shows as Illuxcon, New York Comic Con and Gen Con.

For more information about William O'Connor, his books and art visit: www.wocstudios.com

To see more art and videos about **Dracopedia** *visit these online sites:*
Dracopedia at Facebook: facebook.com/dracopedia
The *Dracopedia Project:* dracopediaproject.blogspot.com
Dracopedia YouTube Videos: youtube.com/user/
 wocstudios1

METRIC CONVERSION CHART

To convert	to	multiply by
Inches	Centimeters	2.54
Centimeters	Inches	0.4
Feet	Centimeters	30.5
Centimeters	Feet	0.03
Yards	Meters	0.9
Meters	Yards	1.1

DEDICATION

To Madeline. May your journey be filled with adventures.

ACKNOWLEDGMENTS

To all the authors of all the poems and epics from all over the world and throughout the centuries who inspired these stories. To Jeff Suess who helped with my storytelling. To Mona Clough, Sarah Laichas, Noel Rivera and the entire F+W team who, through uncounted hours, turned a pile of art and words into a book. To my wife and family who are my inspiration.

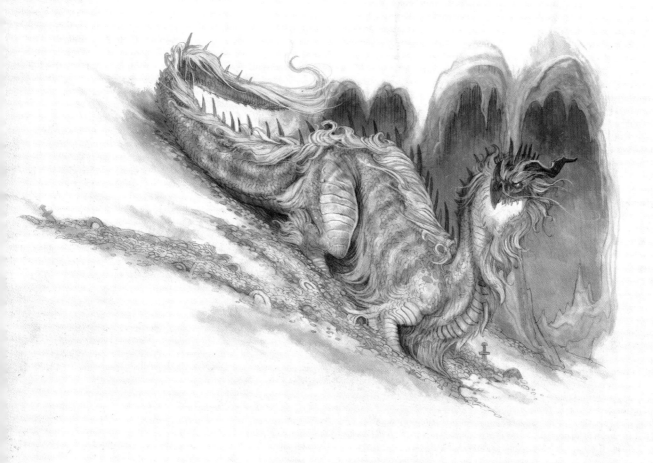

IDEAS. INSTRUCTION. INSPIRATION.

Check out these IMPACT titles at IMPACTUniverse.com!

These and other fine IMPACT products are available at your local art & craft retailer, bookstore or online supplier. Visit our website at IMPACTUniverse.com.

Follow IMPACT for the latest news, free wallpapers, free demos and chances to win FREE BOOKS!

 Follow us!

IMPACTUNIVERSE.COM

- Connect with your favorite artists

- Get the latest in comic, fantasy and sci-fi art instruction, tips and techniques

- Be the first to get special deals on the products you need to improve your art

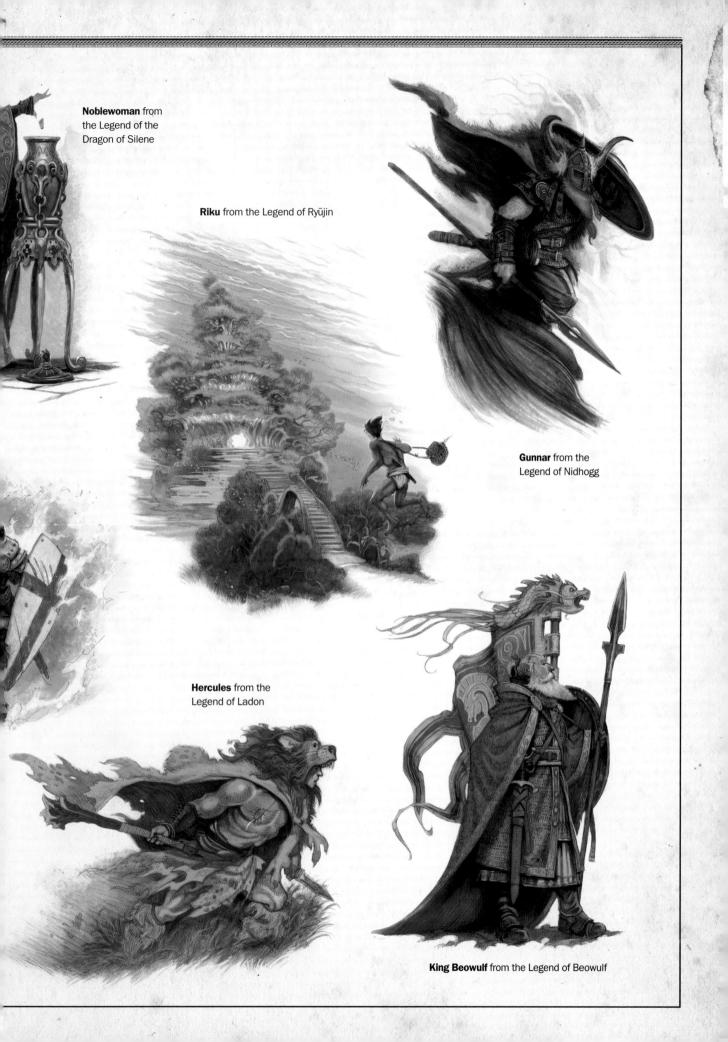

Noblewoman from the Legend of the Dragon of Silene

Riku from the Legend of Ryūjin

Gunnar from the Legend of Nidhogg

Hercules from the Legend of Ladon

King Beowulf from the Legend of Beowulf

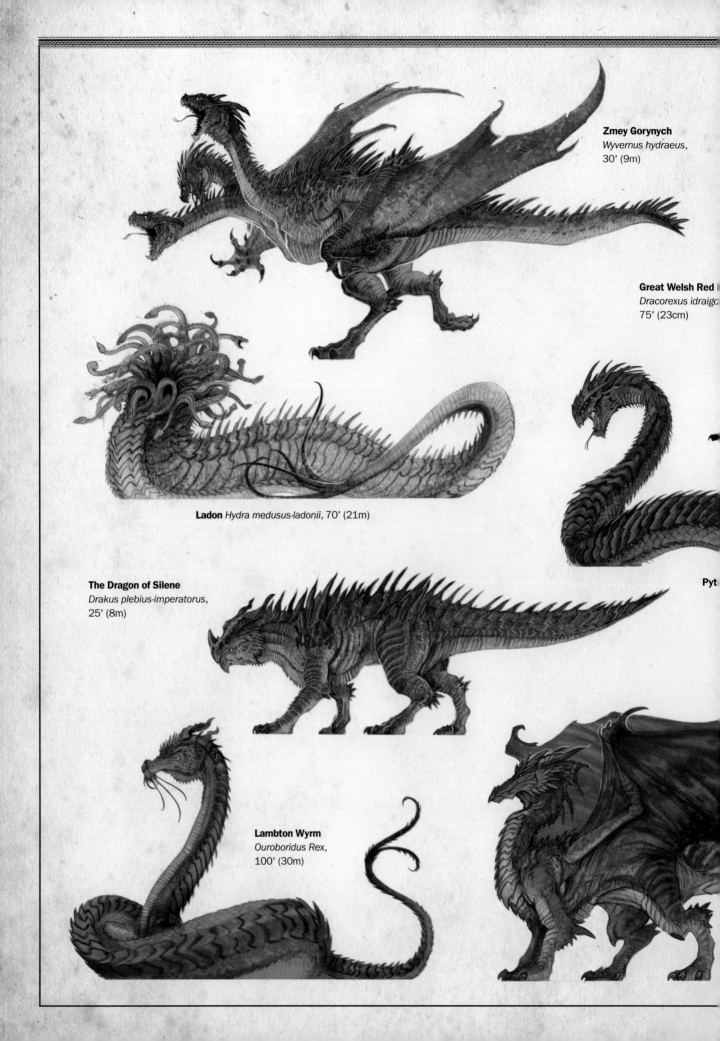

Zmey Gorynych
Wyvernus hydraeus,
30' (9m)

Great Welsh Red
Dracorexus idraigo
75' (23cm)

Ladon *Hydra medusus-ladonii*, 70' (21m)

The Dragon of Silene
Drakus plebius-imperatorus,
25' (8m)

Pyt

Lambton Wyrm
Ouroboridus Rex,
100' (30m)

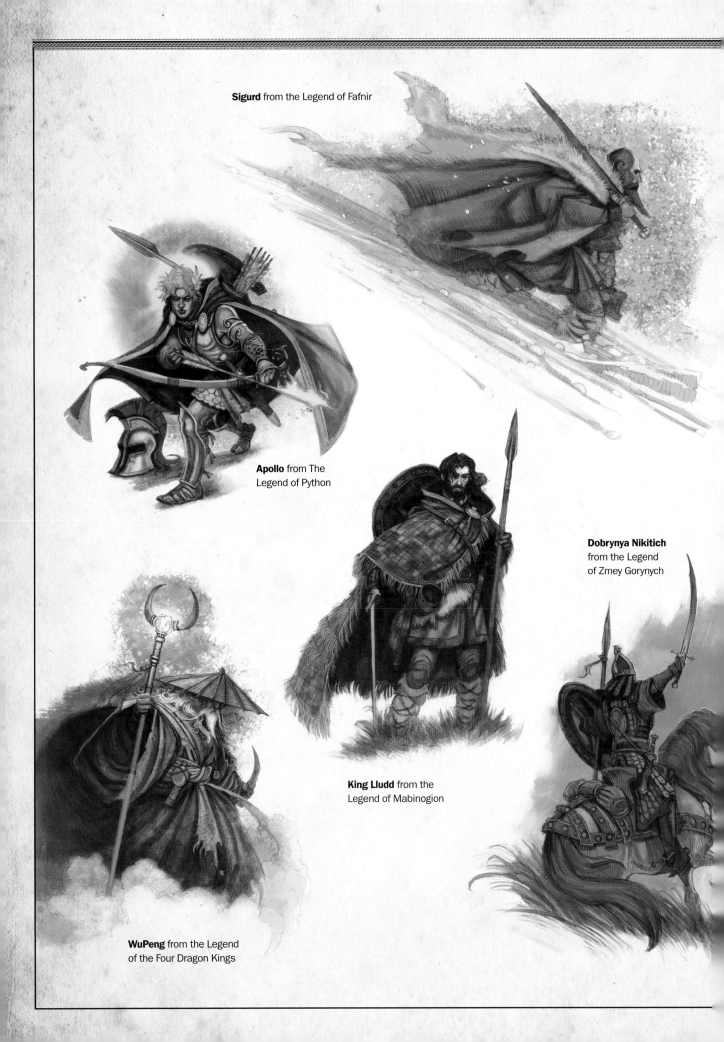

Sigurd from the Legend of Fafnir

Apollo from The
Legend of Python

Dobrynya Nikitich
from the Legend
of Zmey Gorynych

King Lludd from the
Legend of Mabinogion

WuPeng from the Legend
of the Four Dragon Kings

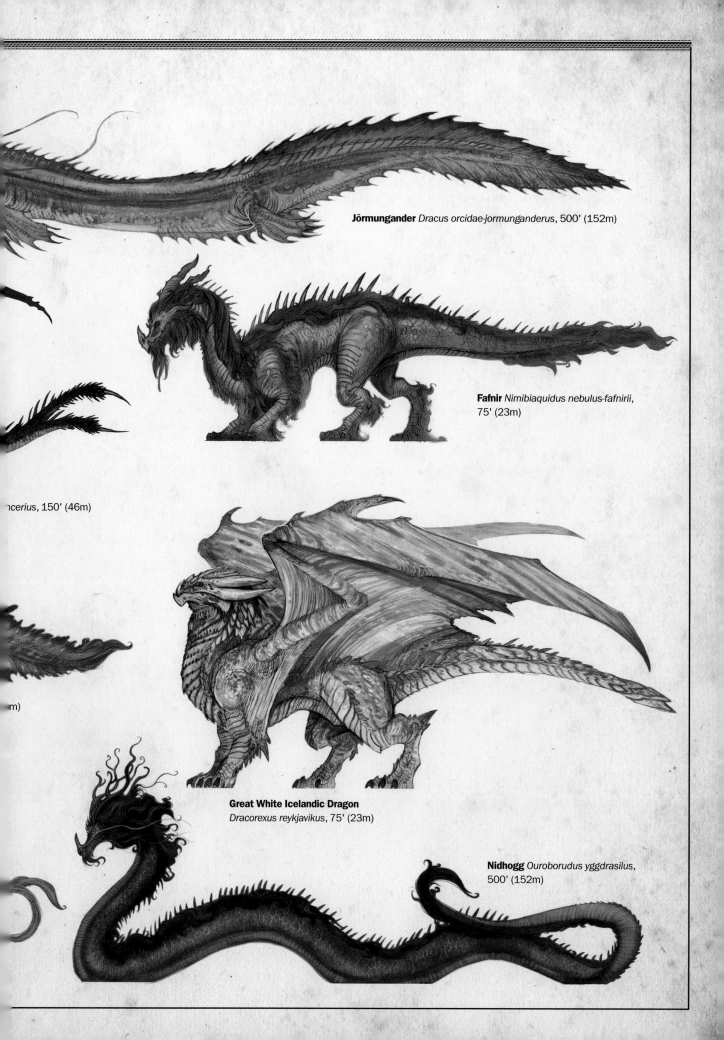

Jörmungander *Dracus orcidae-jormunganderus*, 500' (152m)

Fafnir *Nimibiaquidus nebulus-fafnirii*, 75' (23m)

ncerius, 150' (46m)

m)

Great White Icelandic Dragon
Dracorexus reykjavikus, 75' (23m)

Nidhogg *Ouroborudus yggdrasilus*, 500' (152m)

Dragons of Legend

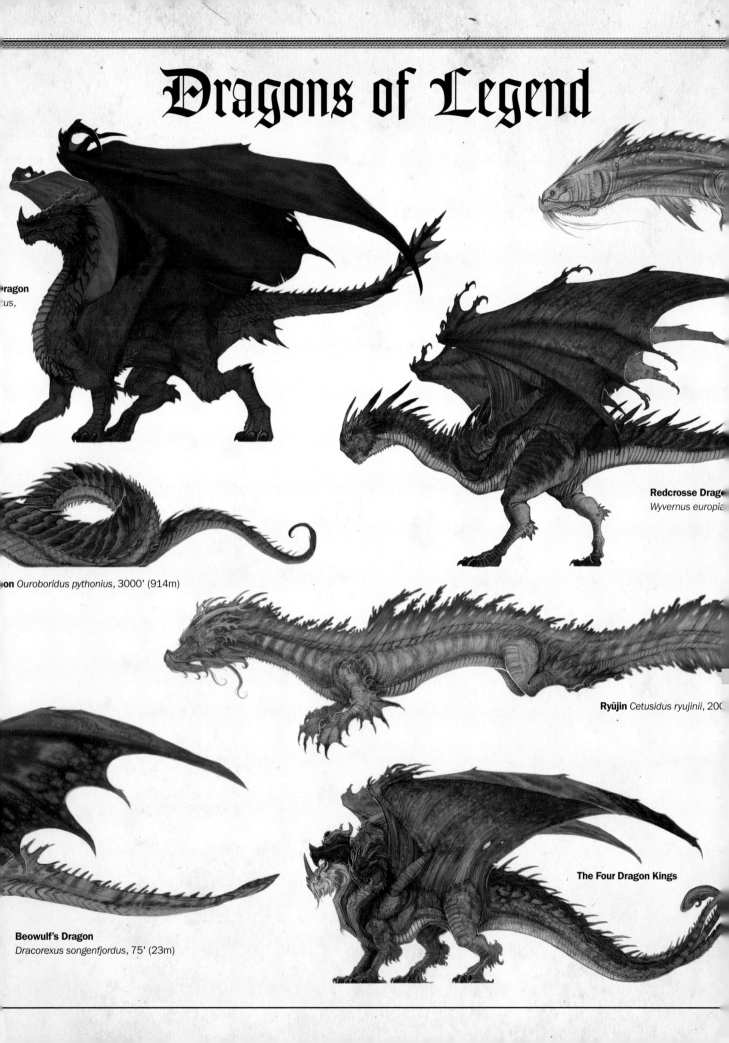

[D]ragon
...us,

...on *Ouroboridus pythonius*, 3000' (914m)

Redcrosse Drag[on]
Wyvernus europia[...]

Ryūjin *Cetusidus ryujinii*, 20[0...]

The Four Dragon Kings

Beowulf's Dragon
Dracorexus songenfjordus, 75' (23m)

Characters of Legend

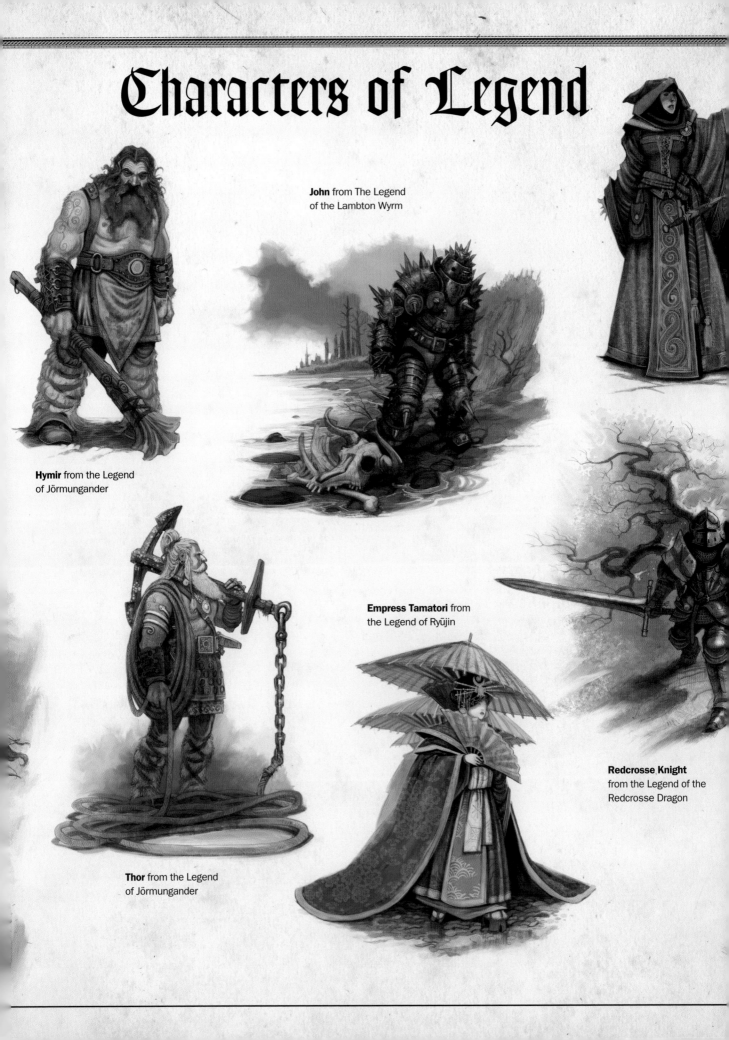

Hymir from the Legend
of Jörmungander

John from The Legend
of the Lambton Wyrm

Thor from the Legend
of Jörmungander

Empress Tamatori from
the Legend of Ryūjin

Redcrosse Knight
from the Legend of the
Redcrosse Dragon